Пролетарии всех стран, соединяйтесь!

Пролетарі всіх країн, єднайт

Пралетары ўсіх краёў, злучайцеся!

პროლეტარებო ყველა ქვეყნისა, შეერთდით!

Bøten dønja praletarlarь brləşegez!

Çer çvzynyn pьroletarlarь birikkile!

Bøtə dønja pьralitardarь beregegeđ!

Bytyn dynja proletarlarь, birləşiŋiz!

Быдэс дуннеись пролетар'ёс, агазе кариське!

Cir ystynyŋ prolətarlarь pьrьklənər!

Пĕтĕм тĕнҗери пролеттарисем, пĕрлешĕр!

Çer ysyniŋ prolətarlarь birikkleger!

פראָלעטאַריער פון אלע לענדער, פאַריײניקט זיך!

Barь dojdu вьralьtaarьjata, qolbolun

Workers of the world unite!

Prolétaires de tous les pays, unissez-vous!

Proletarier aller Länder, vereinigt euch!

Proletärer i alla länder, förenen eder!

Proletarer i alle land foren dere!

Kaikkien maiden proletaarit, yhtykää!

Visu zemju proletareeši saveenojatees!

Világ proletárjai egyesüljetek!

ՊՐՈԼԵՏԱՐՆԵՐ ԲՈԼՈՐ ՅԵՐԿՐՆԵՐԻ, ՄԻԱՑԵ՛Ք:

Prolətarhoj həmməj hylom jək boşit!

Пролетариju д‘gylle әтрәвәти, хаjuдуп!

Весе масторонь пролетарийтне пурнаводо вейс!

萬 國 無 產 社 團 結 セ ヨ

全 世 界 無 產 階 級 聯 合 起 來

ERSCHEINT WÖCHENTLICH EINMAL ● PREIS 20 PFG., Kc. 1,60
30 GR., 30 SCHWEIZER RP. ● V. b. b. ● NEUER DEUTSCHER
VERLAG, BERLIN W8 ● JAHRGANG XI ● NR. 42 ● 16.10.1932

DER SINN DES HITLERGRUSSES:

Motto:
**MILLIONEN
STEHEN
HINTER MIR!**

Kleiner Mann bittet um große Gaben

Montage: JOHN HEARTFIELD

THE ART INSTITUTE
OF CHICAGO

YALE UNIVERSITY
PRESS, NEW HAVEN
AND LONDON

Avant-Garde Art

EARLY-TWENTIETH-CENTURY EUROPEAN MODERNISM

in Everyday Life

EDITED BY
MATTHEW S. WITKOVSKY

WITH ESSAYS BY
JARED ASH, MARIA GOUGH,
JINDŘICH TOMAN, NANCY J. TROY,
MATTHEW S. WITKOVSKY,
AND ANDRÉS MARIO ZERVIGÓN

Avant-Garde Art in Everyday Life: Early-Twentieth-Century European Modernism has been published in conjunction with the exhibition *Avant-Garde Art in Everyday Life*, organized by and presented at the Art Institute of Chicago from June 11 to October 9, 2011.

Major funding is provided by Robert and June Leibowits.

Generous support is provided by the Exhibitions Trust: Goldman Sachs, Kenneth and Anne Griffin, Thomas and Margot Pritzker, the Earl and Brenda Shapiro Foundation, Donna and Howard Stone, Mr. and Mrs. Paul Sullivan, and an anonymous donor.

First edition
Printed in Canada
Library of Congress Control Number:
2011905516
ISBN: 978–0–300–16609–5 (cloth)

Published by
The Art Institute of Chicago
111 South Michigan Avenue
Chicago, Illinois 60603–6404
www.artic.edu

Distributed by
Yale University Press
302 Temple Street
P.O. Box 209040
New Haven, Connecticut 06520–9040
www.yalebooks.com/art

Produced by the Publications Department of the Art Institute of Chicago, Robert V. Sharp, Executive Director

Production by Sarah E. Guernsey, Joseph Mohan, and Clo Pazera

Photography research by Joseph Mohan and Molly Heyen

Index by Lori Van Deman-Iseri, *IndexOutdex.com*

Designed by Margaret Bauer, Washington, D.C.

Typeset in Adobe Garamond Pro and Zwo Pro by Duke & Company, Devon, Pennsylvania. Separations by Professional Graphics, Inc., Rockford, Illinois. Printed and bound by Friesens Corporation

This book was produced using paper certified by the Forest Stewardship Council.

Jacket front: John Heartfield, cover for Jaroslav Hašek, *The Good Soldier Schweik [Dobrý voják Švejk]*, 1936 (plate 9); **Jacket back:** Gustav Klutsis, *Under Threat by Them Were Built . . . [Pod ugrozoj imi . . .]*, 1932 (plate 76). **Endsheets:** El Lissitzky, design for *USSR Builds Socialism [SSSR stroit sotsializm]*, 1933 (plate 77B). **Frontispiece**: John Heartfield, *Workers' Illustrated Magazine [AIZ, Arbeiter-Illustrierte-Zeitung]*, October 16, 1932 (plate 14B). **Page 5:** Ladislav Sutnar, advertising brochure for his stainless steel flatware [*Sutnarův jídelní příbor z nerezavějící oceli*], 1934 (plate 46). **Page 6:** El Lissitzky, *Record or Runner in the City [Rekord]*, 1926 (plate 40). **Page 9:** El Lissitzky, *Of Two Squares [Pro 2 ■]*, 1922 (plate 12A). **Page 12:** Gustav Klutsis, Study for poster *We Shall Fulfill the Country's Coal Debt [Vernem ugol'nyi dolg strane]*, 1930 (plate 74).

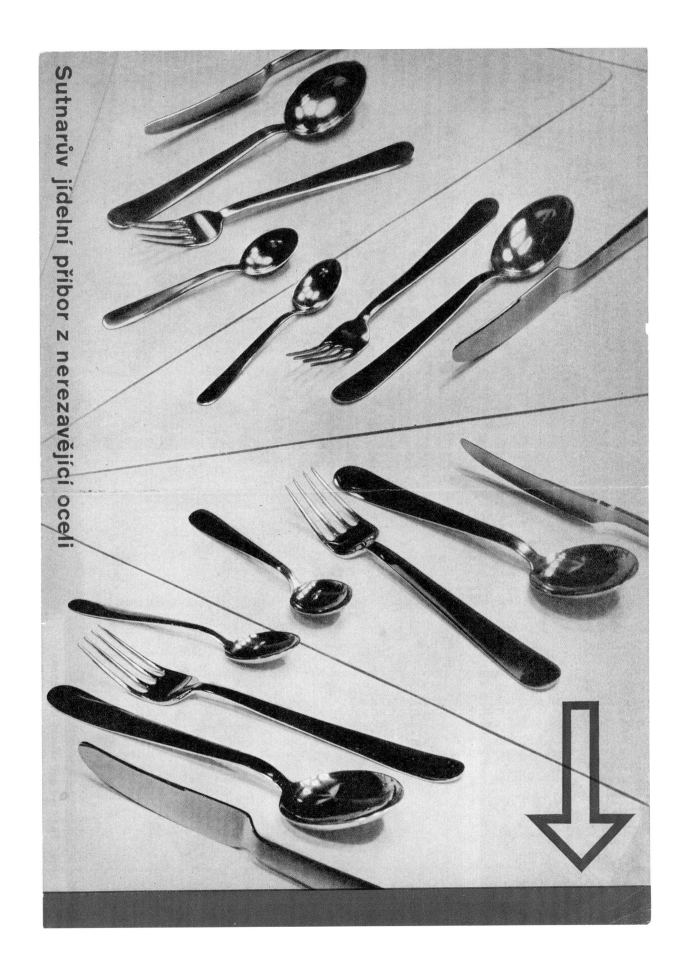

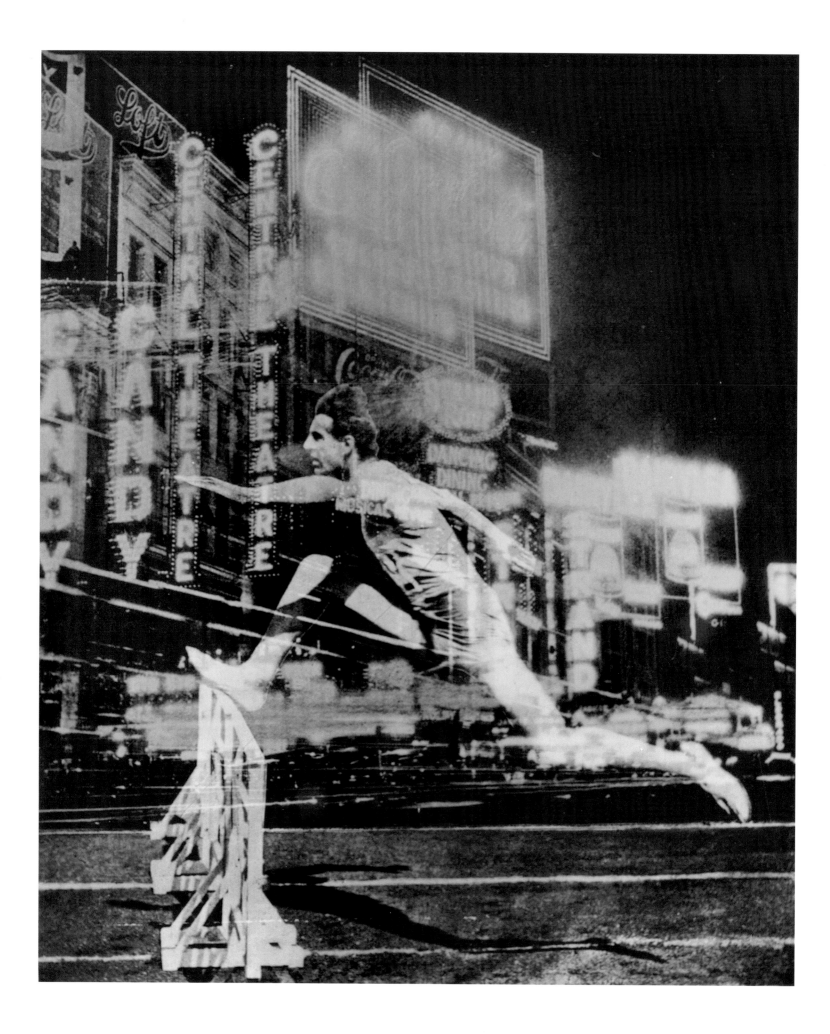

Avant-garde art from the 1920s and 1930s, particularly in central and eastern Europe, provides a model of erudition and inclusiveness that is especially welcome in an encyclopedic museum with a vital civic mission. Fully informed about the history of art and the state of the world around them, artists from Germany to Russia, and the lands in between, formed networks to circulate ideas for changing that world through creative interventions of all kinds. Books, prints, posters, table settings, postage stamps, illustrated magazines, clothing, exhibition installations, building proposals—these artists reached into every conceivable creative domain. They traded ideas through the mail, sharing published journal essays and original works in photography and graphic design. Across the boundaries of medium, discipline, or nationality, avant-gardists in this part of the world were communications specialists.

Avant-Garde Art in Everyday Life builds on a tradition at the Art Institute—admittedly "underground" for long stretches—of engagement with the restlessly innovative movements of Dada, Surrealism, and Constructivism. In exhibitions such as *Photo-Eye of the Twenties* (1972), and in its embrace of the collections of Mary Reynolds (1951), Julien Levy (1975), and Lindy and Edwin Bergman (1991), this museum has shown an understanding for those artists deeply committed to rethinking the bases of art and its place in an age of technology and the mass media. With the exception of a show of Soviet porcelain in 1993, however, the present exhibition is the very first at this museum, whether monographic or thematic, to address any aspect of art east of Germany during the interwar decades. It opens just weeks before a mammoth exhibition on World War II posters produced by the Soviet propaganda agency TASS, and it follows on the heels of one of the most significant painting acquisitions in the entire history of the Art Institute: Kazimir Malevich's *Painterly Realism of a Football Player—Color Masses in the 4th Dimension* (1915). Clearly, a new tradition has begun.

The magnificent collection that the Art Institute has recently acquired from Robert and June Leibowits, which forms the backbone of the present exhibition, fits superbly within these developments. Like those

mentioned above, the Leibowits collection consists largely of works on paper, from printed matter to posters, drawings, and photographs (although it contains exceptionally fine sets of porcelain and glass as well). It also includes many more items than can be presented in a single exhibition. Not shown here, for example, are a group of three dozen Russian Futurist artist's books from the 1910s, as well as contemporaneous propaganda posters by the Russian poet and artist Vladimir Mayakovsky. Russian Constructivist, Czech Surrealist, and rare Bauhaus publications—these are among the treasures acquired from the Leibowitses that permit the Art Institute to address some of the most significant artists and tendencies in east-central Europe between the World Wars.

Additionally, the Leibowits acquisition does something of terrific importance for the Art Institute and its new Modern Wing: it unites several curatorial areas in a project to preserve the history of modern art in its fullest extent. Curators of Photography, Prints and Drawings, Architecture and Design, and the Ryerson and Burnham Libraries came to a common accord in accepting these new holdings into their respective departments. That joint undertaking epitomizes, in microcosm, the core mission of the Modern Wing, whose separate areas open onto a common understanding of art's potential across the disciplines.

James Cuno
President and Eloise W. Martin Director
The Art Institute of Chicago

ПРО

2

Эл Лисицкий

ACKNOWLEDGMENTS

I first met Robert and June Leibowits, whose collection forms nearly the entirety of the contents of this book and the exhibition it accompanies, in 2004. Bob's joyous passion to "tell the story" of European avant-gardism through its printed matter and photographica is infectious and rewarding. And June's sincerity and organizational prowess kept the collection manageable. To them I owe the utmost thanks for bringing so much together, and then for ceding a portion of what they had assembled to the Art Institute.

No fewer than four departments have been involved in the acquisition of the Leibowits collection, a testimony to broad collegiality among the curators, and to the interdisciplinary vision of James Cuno, President and Eloise W. Martin Director. Douglas Druick, Prince Trust Curator of Prints and Drawings; Joseph Rosa, formerly Chair and John H. Bryan Curator of Architecture and Design, and Zoë Ryan, Acting Chair and Neville Bryan Curator of that department; and above all Jack Perry Brown, Executive Director of the Ryerson and Burnham Libraries, where most of the collection now resides, showed remarkable flexibility in preparing the acquisition and accepting it into their respective domains. Additional thanks for their participation in this mammoth undertaking go to Mark Pascale, Curator of Prints and Drawings; conservators Christine Fabian, Dana Oliveri, and Harriet Stratis; archivist Mary Woolever; Julie Getzels, General Counsel, and Associate General Counsel Jennifer Sostaric; and the registrars, led by Patricia Loiko. Anstiss Krueck, Chair, and the members of the Committee on Photography showed notable enthusiasm for a venture unlike any they had previously been asked to ratify. A very special note of recognition is reserved for Newell Smith, at that time Collections Manager in the Department of Photographs, who spent many months in a herculean effort to coordinate the particulars of this thousand-piece acquisition.

Significant assistance with the acquisition has come from Don and Judy Opatrny, with additional support provided by Radoslav and Elaine Sutnar, George and Beth Drost, Eric Ceputis and David Williams, Mary and Roy Cullen, and nearly five dozen other guests at a gala celebration of Ladislav Sutnar in 2010, generously hosted by Jaroslav Kynčl, Kay Bucksbaum, and Kristyna Driehaus, and cosponsored by the Czech Consulate of Chicago, led by the Honorable Marek Skolil, former Consul General. Many thanks to them and to Kimberly Masius, Associate Director of Development, as well as Katherine Bussard, Associate Curator of Photographs, for helping to organize that singular event.

Great as the Leibowits collection is, the ambition to mount a six-part monograph benefited enormously from judicious additional loans. *Avant-Garde Art in Everyday Life* features a rare pairing of positive and negative prints of El Lissitzky's iconic self-portrait *The Constructor*, borrowed from two generous collectors in Chicago. To them and to additional anonymous private owners, as well as to the Bank of America and its curator, Whitney Bradshaw, I extend heartfelt appreciation. Important advice regarding the works came from rare book and poster dealers Michael Weintraub, Howard Garfinkel, and David Stang, as well as Steven A. Mansbach, Professor of the History of Modern Art, University of Maryland. I would like to acknowledge here as well Sarah Greenough, Senior Curator of Photographs, and Neal Turtell, Executive Librarian, both of the National Gallery of Art, Washington, D.C., for their encouragement of this exhibition project in its initial guise.

For further research I am utterly indebted to my coauthors: Jared Ash, Librarian, Special Collections, Newark Public Library (and archivist of the Leibowits collection); Maria Gough, Joseph J. Pulitzer Jr. Professor of Modern Art, Harvard University; Jindřich Toman, Professor of Slavic Languages and Literature, University of Michigan; Nancy J. Troy, Victoria and Roger Sant Professor in Art, Stanford University; and Andrés Mario Zervigón, Assistant Professor of Art History, Rutgers University. Each of these contributors has deepened my understanding at many levels; their essays in the present volume cohere remarkably, moreover, to address the problems and promise of "everyday life" in a holistic, interconnected way that is the goal

of every multiauthor book on a single subject. Additional assistance came from Yvonne Brentjens, author of a Dutch-language monograph on Piet Zwart, whose career is examined in English here practically for the first time.

Robert V. Sharp, Executive Director of Publications, and Sarah E. Guernsey, Director, have guided the publication skillfully to completion, with unflagging enthusiasm and assurance in the face of pressing deadlines. Photography Editor Joseph Mohan; Publications Assistant Molly Heyen; photographers Robert Lifson, Robert Hashimoto, and Jamie Stukenberg; and Troy Klyber, Intellectual Property Manager, have each discharged an important role in providing the book's many beautiful illustrations. Finally, designer Margaret Bauer captured the spirit of this project in an elegant and informed presentation of its texts and images. In my own department, I am grateful for research and organizational assistance provided by Alison Boyd and Rachel Rossner, doctoral candidates at Northwestern University and the University of Chicago, respectively. To Rachel I give special thanks for marathon editorial sessions and her preparation of faultlessly clear reference materials in the book. Kate Brown, a yearlong intern in Photography, coordinated the conservatorial examination of many exhibition objects. Above all, Michal Raz-Russo, Exhibitions Coordinator, deserves unstinting praise for handling the manifold complexities of loans spread across several museum departments, as well as every aspect of this exhibition's catalogue and installation. Michal is the rare person who demonstrates that organizational problems and diplomatic setbacks are simply challenges awaiting a creative solution.

Viennese artist Florian Pumhoesl contributed fundamental suggestions on the presentation of the show, held in the Abbott Galleries in the Art Institute's Modern Wing. Thanks as always go to Dorothy Schroeder, Vice President for Exhibitions and Museum Administration, who handles the intricacies of each show with generosity and good humor. Markus Dohner, Exhibition Designer, and a very able team of painters and carpenters supervised by Tom Barnes, Associate Director, under the purview of Bernice Chu, Associate Vice President of Design and Construction, successfully handled a complex installation of many vitrines. Douglas Severson, Conservator of Photographs, and Jim Iska, Preparator in the Department of Photography, two unflappable colleagues, handled the placement of nearly 300 exhibition objects, aided to a terrific degree by Christine Fabian, Conservator of Books and Manuscripts.

Janine Mileaf remains my closest reader and critic, and to her, as well as our two daughters, Thalia and Mina, I extend fond appreciation. These acknowledgments necessarily end where they began—with Bob and June Leibowits. Not only has their collection mightily enriched this museum's holdings, but a significant grant from them has made possible this exhibition and publication. On a family visit to their home in upstate New York, our elder child, who was then nearing four, engaged Bob and June in a game of Go Fish. When Bob began in his customary way to question the terms of play, Thalia called him sternly to order: "There are *rules*!" Thank you, Bob, for consistently breaking the rules.

Matthew S. Witkovsky
Chair and Curator of Photography
The Art Institute of Chicago

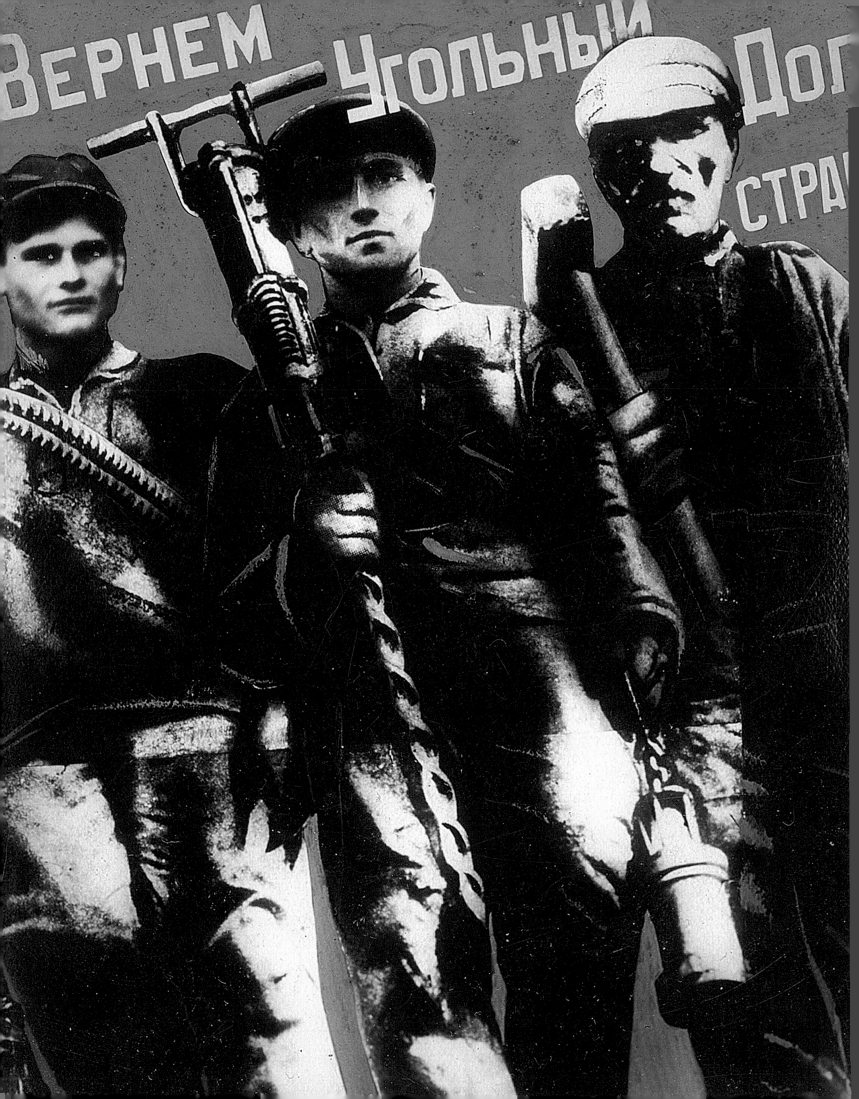

MATTHEW S. WITKOVSKY **Introduction** ART AND LIFE IN CONVERSATION

Addressing an audience of politically committed academics in Paris in 1961, the French theorist Guy Debord made clear his impatience with research unconnected to revolution: "To study everyday life," he began, "would be a completely absurd undertaking, unable even to grasp anything of its object, if this study was not explicitly for the purpose of transforming everyday life."[1] Debord's salvo echoed a tradition of idealistic engagement with the everyday that has its roots in the 1920s and 1930s, the time of the six artists presented on these pages: John Heartfield, Gustav Klutsis, El Lissitzky, Ladislav Sutnar, Karel Teige, and Piet Zwart. These artists—two Russian, two Czech, one German, and one Dutch—sincerely believed that they could help restructure society by designing common or utilitarian items, from mass-produced book covers and housewares to political imagery, vast public exhibitions, or even office skyscrapers. Their utopian commitment to revolutionizing the things and spaces of daily life has proved inspirational ever since.

The early-twentieth-century avant-garde project of "art into life" is regularly held up, nevertheless, as a glorious failure; it is impossible to imitate yet continually important to revisit. Any attempt at revivalism would be doomed; "the point," as scholar Andreas Huyssen opined already in 1980, "is rather to take up the historical avant-garde's insistence on the cultural transformation of everyday life and from there to develop strategies for today's cultural and political context."[2] This book and the show it accompanies willingly extend that invitation once again. Ironically, however, our Internet age seems precisely to prioritize and obsess over everyday life. To attend to the overlooked, to celebrate the mass media or banal items of daily use, are merely commonplace ambitions in a world of webcam-generated reality shows, tweets, and the 86,400-second news cycle. One could

1

Karel Teige (Czech, 1900–
1951), cover for Stanislav
K. Neumann, editor,
Headlight [*Reflektor*],
May 15, 1925; lithograph,
37 × 27.6 cm.

2

Piet Zwart (Dutch, 1885–
1977), calendar for the
Netherlands Cable Factory
[NKF, Nederlandsche
Kabelfabriek], 1934;
letterpress and steel
stand, 17.4 × 12.3 cm,
on 20 × 13 × 3.6 cm stand.

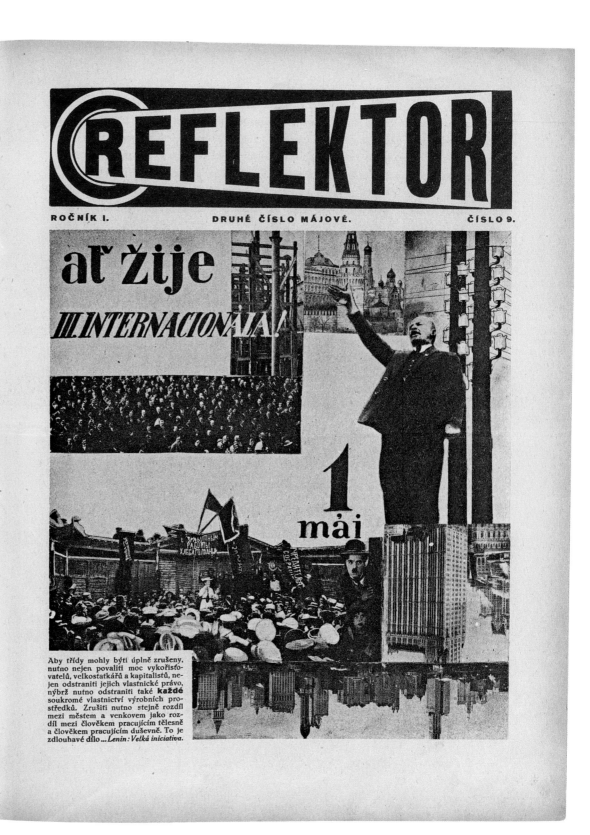

add that design and advertising, idealized in the 1920s, are ubiquitous today, while dreams of animating a collective conscience have been travestied, abandoned, and recuperated many times over.

The constitution of new forms of collectivity, more fragmented and targeted than was ever previously imaginable, remains the great aleatory promise of the wireless world. This may be the strongest parallel between our own time and that of nearly a century ago, for it turns out that much of the work discussed here engages "everyday life" principally as an innovative sphere of communications. Beyond the actual objects they made or proposed to make, it is problems in communication that really captured the imaginations of these six artists and many others in the 1920s and 1930s. Moreover, their model of communications will seem remarkably familiar to contemporary readers in its cultivation of specialized networks for discussion and information sharing. In an era best remembered today for its masses and monologues—whether Adolf Hitler declaiming at the Nuremberg rallies or Franklin Delano Roosevelt broadcasting speeches over the radio that were misleadingly labeled as "fireside chats"— these six artists attempted to differing degrees to hold a genuine conversation, using media such as printed matter and photographic imagery to affirm both solidarity and points of contention with one another. At the same time, they did not wish to converse as lay citizens or generalists. Having rejected the fine arts and its elite specialties, these artists nevertheless enthusiastically embraced a professional, even marketable identity as technical experts, particularly in the field of graphic design.

Such pursuit of professional status runs counter to the communist utopia of classless unity, and it goes against the abhorrence of territoriality in all its forms expressed by many thinkers on everyday life as well.[3] Yet a network of specialists—particularly ones who reached out, as these artists did, to forge international ties and thus transcend the confines of their local environment—uncannily anticipates the structure of our own fully networked age. In spatial terms, the

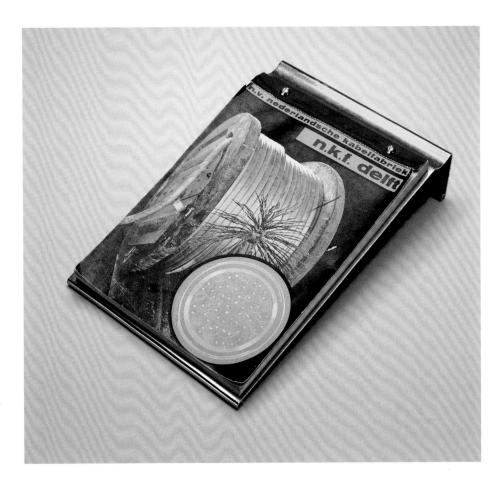

Web is unbounded, but it can permit no uncharted territories, no borderlands or no-man's-lands. Everything and everyone resides there in a registered domain. Much idealism in the Internet era seeks to share domains for the common good—not to abolish private property, as it were, but instead to allow free trespass upon it. That model of domain sharing mirrors an understanding embodied in much of this work— a defining example by Karel Teige (plate 1) is discussed at the end of this introduction—that the practical, constructive goal should be to have a publicly accessible conversation among specialists, rather than attempt to do away with specialization entirely.

The slogan "art into life" is principally associated with the Soviet Union, a revolutionary state in which the artist became an engineer, the easel picture dissolved into an agitational film, and the erection of sculptures or monuments was superseded by the construction of habitable buildings.[4] The inclusion in this exhibition catalogue of such minor items as a calendar, table settings, and product advertisements (plates 2–4) might seem to vitiate the polemical force of left-wing magazine montages or Communist Party posters also presented

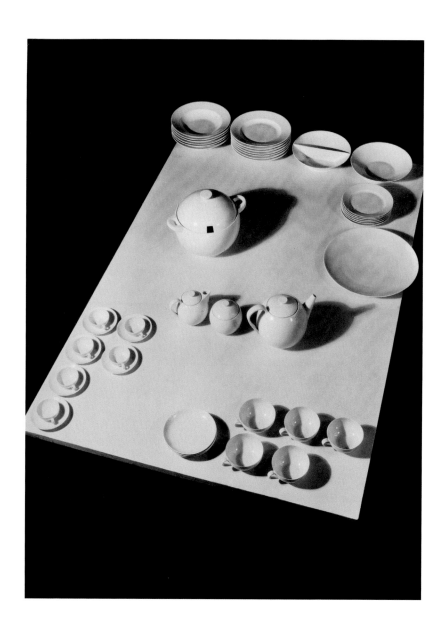

here. Yet all these items shared space in the everyday realm of the urban street, with its billboards, kiosks, theater marquees, and merchandise displays. The measure of grand political ambitions in the 1920s—quite different from today—was evident on the street; when the German intellectual Walter Benjamin visited Moscow in 1926, toys, candies, and arcades occupied his interest as fully as ominous anecdotes about Stalin or shifting theories of art.[5] As the art historian Christina Kiaer has noted, Benjamin shared with many Russian avant-gardists a surprisingly great faith in "the utopian political promise of the mass commodity."[6] Instead of denigrating items from everyday life—*byt*, the Russian word for this term, had come to connote unreflective behavior and resistance to change—members of the Russian vanguard (Vladimir Tatlin, Liubov' Popova, and Aleksandr Rodchenko, among others) concentrated on the everyday as the field of activity most likely to shift society and move it forward.

The exaltation of everyday commodities in this manner was understood not to extend the reach of capitalism (for example, into revolutionary Russia) but to critique its deadening, atomizing effects. The "problem of commodities" posed by Karl Marx, as Georg Lukács noted in opening his historic discussion of "reification" in 1923, is "the central, structural problem of capitalist society in all its aspects.... Its basis is that a relation between people takes on the character of a thing and thus acquires a 'phantom objectivity,' an autonomy that seems so strictly rational and all-embracing as to conceal every trace of its fundamental nature: the relation between people." This, Lukács posited, "is a *specific* problem of our age, the age of modern capitalism."[7] To restructure society, it became necessary to reflect on the fetishism of commodities.

Most of the objects discussed in these pages were, however, made to be sold, and nearly all of them were made on commission. A range of positions on work for hire is identified in these chapters: from the unwavering devotion by Klutsis to the Soviet state as his client, or Heartfield's commitment to publishers of political imagery; to Teige's enthusiasm for poetry,

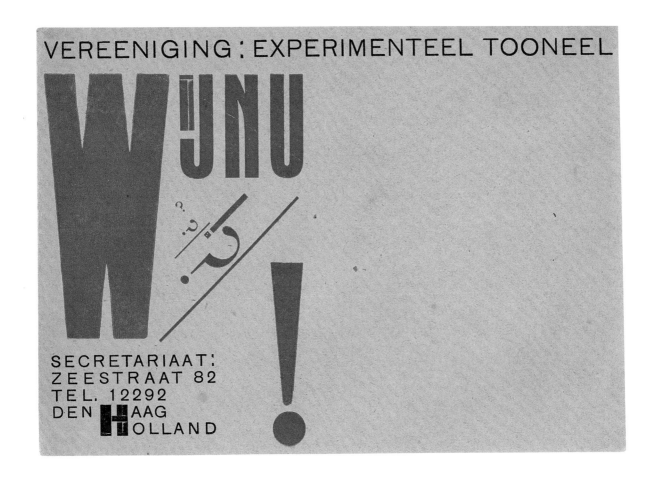

3

Josef Sudek (Czech,
1896–1976), advertising
photograph for Ladislav
Sutnar china (coffee
and dinner set), c. 1932;
gelatin silver print,
23.3 × 17.6 cm.

4

Piet Zwart (Dutch,
1885–1977), envelope for
Us Now: Experimental
Theater [Wij Nu.
Experimenteel Tooneel],
c. 1925; letterpress,
11.4 × 16.1 cm.

literature, film, painting, and other cultural media, provided his work was for friends or politically sympathetic outfits; to the "exceptional" flexibility shown by Lissitzky in accepting advertising commissions from Pelikan Ink Company, and finally, the manifold commercial jobs completed by Sutnar and Zwart. Across the spectrum of their convictions, all six of these artists courted professional assignments.

Already by the 1950s, a faith in professional expertise would seem naive among other reasons in regard precisely to commodity fetishism, an idolatry (in Marxist terms) that, as became abundantly apparent in corporate boom times, would never be overcome through the production of new merchandise, however well intentioned. Avant-garde labor, moreover, is traditionally viewed as intentionally unproductive, an expression of critical resistance to the modern labor economy.[8] No such resistance will be found here. These artists sought, with undeniable innocence, to reunify laborer and product on ideological grounds (Klutsis's repeated insertion of his own image or body — most famously his outstretched hand [plate 5; see also plate 31, p. 63] — into his poster designs exemplifies this aim). Additionally, as Maria Gough points out about Lissitzky, the very constraints imposed by commissioned work were seen as liberating, because they gave both focus and a purpose to creative activity that was lacking in the artificial setting of the atelier.

The new products were naturally meant to defy capitalist mechanisms, even when they circulated in the marketplace. Sutnar may have achieved this more effectively than any of the other artists presented here. His main employer, Družstevní práce (or DP; Cooperative Work), marketed and distributed its modernist goods and socialist views to a membership, spread around Czechoslovakia, that numbered ten thousand individual consumers in 1930 and twenty-five thousand by 1937.[9] The members sustained DP and gave it feedback; they helped shape its line, as Jindřich Toman explains, by voting on product choices and offering opinions on their appearance and practicality that the magazines Sutnar edited would regularly publish.

DP survived with apparently few difficulties through the Depression because of this alternative and interactive sales circuit.

Beyond such localized strategies, it seems that the new objects counted for their makers less in themselves than as instruments of communication. Such a reading meshes with theoretical pronouncements of the time in central and eastern Europe, as in, for example, the 1925 essay "Everyday Life and the Culture of the Thing," by the Russian Productivist artist Boris Arvatov. Arvatov spent most of his essay implicitly arguing for a revaluation of "things," but what he ultimately pointed to were the thoroughly dematerialized networks of electricity and the radio: "technical systems in which the productive process is realized in the work of directly connected, spontaneous activities organized by human labor."[10] Most of the objects produced by the artists in this book trade in communications systems as well: posters and covers to literature, or designs for pens, pulpits, and stationery. Zwart's mature career, for example, featured advertising and product design for cable used in the electrical and telephone industries, exhibition and journal layouts for projects in cinema, and campaigns for the Dutch postal service — all telecommunications projects, taken one way or another. His delight in designing letterheads (see plate 4), and his use of zipping diagonals or pointing arrows and fingers, evince a desire to connect, while his strident call to make photography a tool for "honest enlightenment of the masses," as Nancy Troy quotes, implies a conception of camera work as an aid to distance learning.

Lissitzky, whose work in design was formative for Zwart and every artist in this book except perhaps Heartfield, prized communication in ways both mechanized and endearingly old-fashioned. His marketing ideas for Pelikan products remind us — as do his photographs of Hans Arp and Kurt Schwitters, and his self-portrait, *Der Konstrukteur* (The Constructor) (plates 6–8) — how productive the counterpoint of handmade and readymade can be. The Pelikan images (see plate 38, p. 79) delightedly cast fountain pens and inkwells as phantasmagorical objects in a newfangled

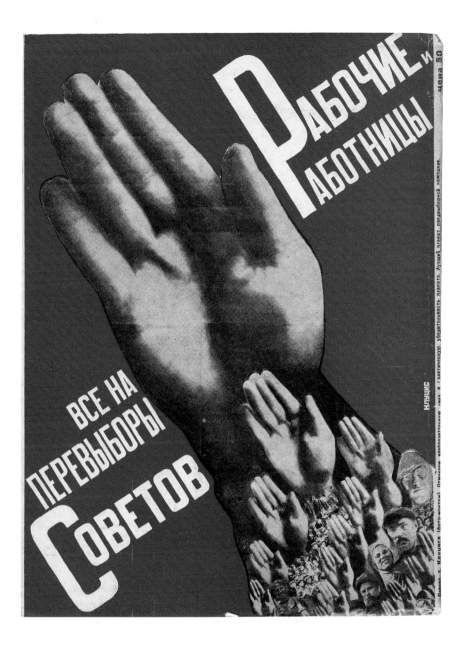

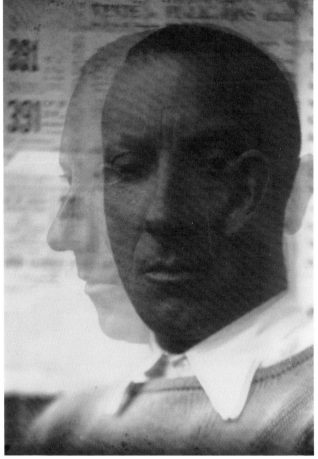

5

Gustav Klutsis (Latvian,
1895–1938) and Solomon
Telingater (Russian,
1903–1969), back cover
for Pavel Novitskii, editor,
Artist's Brigade [*Brigada
Khudoznikov*], no. 1,
1931; letterpress, 21.5 ×
18.9 cm.

6

El Lissitzky (Russian,
1890–1941), *Hans Arp*,
1924; gelatin silver
print, 17.9 × 12.9 cm.

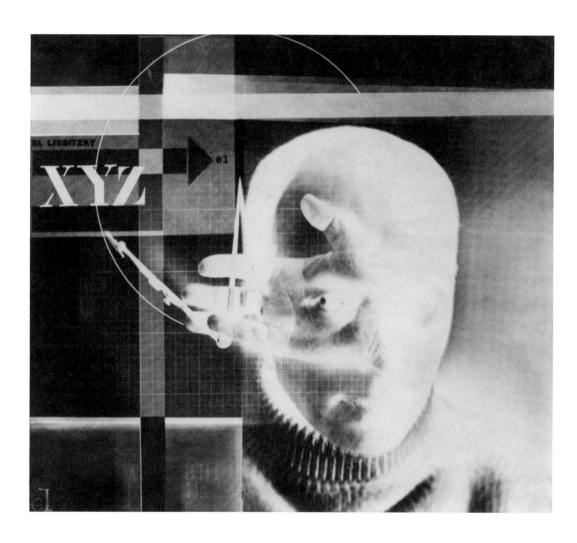

7

El Lissitzky (Russian,
1890–1941), *Self-Portrait:
The Constructor* [*Selbst-
bildnis. Der Konstrukteur*],
1924; gelatin silver print,
12.6 × 14.4 cm.

8

El Lissitzky (Russian,
1890–1941), *Self-Portrait:
The Constructor* [*Selbst-
bildnis. Der Konstrukteur*],
1924; gelatin silver print,
9.8 × 11.4 cm.

photomechanical marketing campaign. In the portraits, meanwhile, hand-lettered broadsides (used as wallpaper in the Arp photograph) or the artist (Schwitters) declaiming poetry, two examples of "primitive" communication, are pictured through the utterly modern camera effect of double exposure; and Lissitzky figures his own ethereal countenance as the ghost in a machinic grid of graph paper and scientifically precise drafting tools.

Although they labored to connect humanity, these artists understandably spoke most easily to one another. The sextet kept in touch by letter, less among themselves than through other hubs such as Theo van Doesburg or the guiding figure of New Typography, Jan Tschichold. They were at least as likely, however, to mail one another examples of their graphic-arts creations as personal correspondence (Lissitzky's prototype for Pelikan packaging, reproduced on page 79, is stamped as Tschichold's personal property). Professional activity thus became a conduit for collegial interaction. In his recent book about Tschichold, Christopher Burke discusses his subject's penchant for typing up distribution lists to share his publications. Burke reproduces a list from 1930 of intended recipients of Tschichold's latest lowercase work, *noch eine neue schrift* (another new typeface), that includes Teige, Sutnar, Zwart, Klutsis, and Lissitzky—five of the six figures considered here.[11]

Heartfield, the one artist who was not on Tschichold's gift list, was nevertheless among the most influential graphic artists in Europe. His conception of seamless montage coupled to punning texts—an artificially unified composition made to expose false political unities—became an anticapitalist trademark.

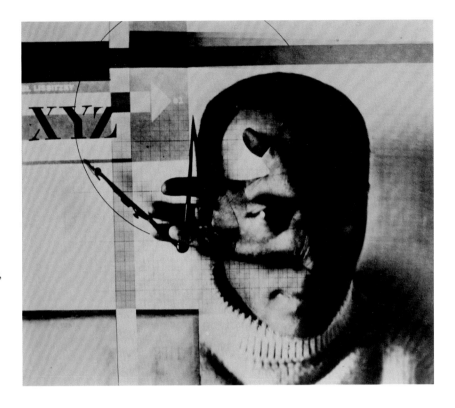

His creations were seen to vast effect with left-wing book and magazine sellers and at exhibitions across the continent; his style was also lovingly imitated or excerpted in local publications (see plates 17 and 18, p. 40). "I would have become the designer of socialism if they had only let me," a late-life lament by the artist, seems, as Andrés Zervigón notes, to have actually happened in the 1930s, and not just in his native Germany.

Not all exchanges took place at a distance. During his years of exile in Prague, Heartfield produced some covers for Czech novels, including an edition of Jaroslav Hašek's *Dobrý voják Švejk* (The Good Soldier Schweik) (plate 9). Heartfield also provided a cover, with a bloody hand reminiscent of his "five fingers" poster (see plate 13, p. 31), for the 1937 reprint by Sutnar and DP of a Czech novel called *Petrolejáři* (The Oil Men), first published in 1930, about British and

9

John Heartfield (German, 1891–1968), covers for Jaroslav Hašek, *The Good Soldier Schweik* [*Dobrý voják Švejk*], 1936; A. volume 1; B. volume 3; C. volume 6 (completed by Karel Vaněk); letter-press, 20.8 × 13.5 cm, 20.8 × 28 cm (open).

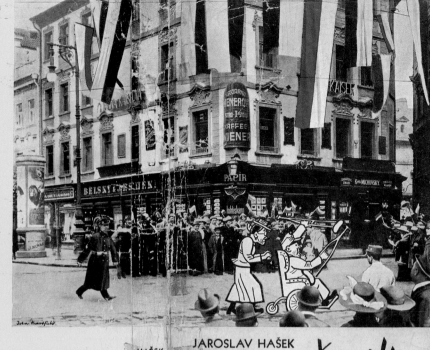

„Osudy dobrého vojáka Švejka" jsou českým apoštolským dílem pro celý svět.

Jaroslav Durych

Událostí byl pro mne „Dobrý voják Švejk", kterého jsem četl v ruském, německém a částečně i ve francouzském překladě. Skvělé dílo!

Ilja Ehrenburg

Hašek byl humorista největšího formátu. Pozdější doba porovná ho snad jednou s Cervantesem a Rabelaisem.

Max Brod

KAREL SYNEK / PRAHA

Švejk nesabotuje skutečný heroism a skutečný patriotism, nýbrž jen heroism a patriotism kašírovaný

F. X. Šalda

Humor Haškův má skutečně rozměry evropské, že bez nadsázky možno ho stavěti do řady s Don Quijotem

Dr. Giusti v Rivista di litterature slave

Na dvanácti stránkách Švejka je více humoru a děje než v polovině románů, napsaných za posledních 10 let. Je to unikum ve světové válečné literatuře

Daily News

KAREL SYNEK/PRAHA

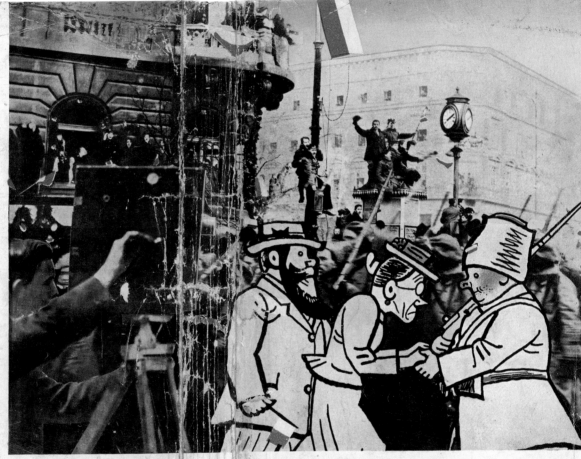

"Osudy Švejka jsou kni-
hou specificky českou...
Její českost vyvěrá z pra-
typické českosti hlavní
postavy, která byla vytvo-
řena s jedinečným talentem
a uměním z nejzákladněj-
ších vlastností a složek
malého českého člověka."

J. O. Novotný v Cestě r. 1927.

"Kdyby Československo
mělo jen Haška, přece by
poskytlo tím dílo trvalé
ceny pro dědictví lidství."

J. R. Bloch, význačný francouzský
spisovatel v Přítomnosti r. 1931.

"Hašek je lepší četbou
než slavný Rabelais
i Cervantes."

New York Herald r. 1930.

KAREL SYNEK/PRAHA

VANĚK
ŠVEJK

VI

KAREL VANĚK

DOBRÝ

VOJÁK

Švejk

VI

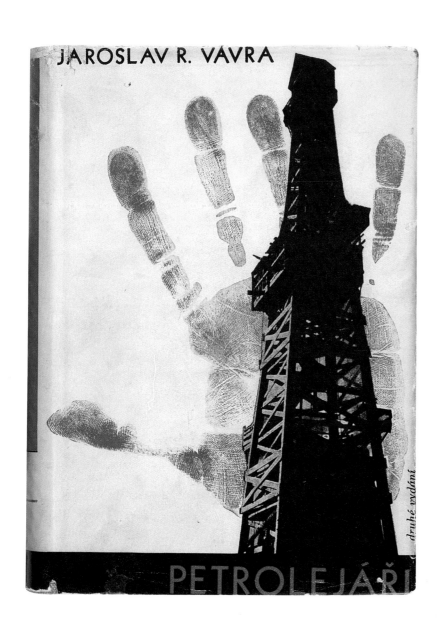

U.S. machinations over Soviet petroleum reserves (plate 10). The project recapitulated not only Heart-field's earlier treatment, in Germany, of Upton Sinclair's *Oil!* but also Sutnar's designs for this and other Sinclair books issued by DP from 1929 through the early 1930s (see plate 15 and plate 80, pp. 33 and 146). Heartfield spent half of 1931 in the Soviet Union as well, where he encountered Klutsis at a public lecture that Heartfield was delivering; they subsequently exhibited together in a group show, and met up again in Georgia. These two men were the least "conversational" artists among those discussed here, in the sense that each focused resolutely on his own approach and did not actively seek a back-and-forth from the international network of like-minded peers. At the same time, the two artists formed exceptionally close creative partnerships, as Zervigón and Jared Ash explain: Wieland Herzfelde, Heartfield's brother, acted also as his collaborator, and Valentina Kulagina did the same for Klutsis.[12] And there are important traces of exchange between Heart-field and Klutsis as well. As Maria Gough has pointed out elsewhere, Klutsis saw his work compared unfavor-ably to that of Heartfield during the latter's Moscow stay, and made alterations to his style that likely reflect such critical comparisons. For Heartfield, meanwhile, one result of the lengthy Russian sojourn was work for the luxurious propaganda journal *SSSR na stroike/ USSR in Construction,* including a montage (plate 11), widely circulated thereafter in Europe, that in its diagonality and treatment of Lenin's body as a monu-mental shadow owes a real debt to formal innovations by Klutsis (and Lissitzky).[13]

Lissitzky for his part traveled extensively in central Europe, where he not only processed and produced influences but collaborated as well—though not always to his satisfaction. The account of his children's book, *Pro 2* ■ (Pro dva kvadrata or Of Two Squares), shows the creative misunderstandings that are in fact constitutive of communication (plate 12). Designed in Vitebsk in 1920, the Russian book was published in Berlin in 1922, with a second, Dutch edition appearing later the same year in The Hague,

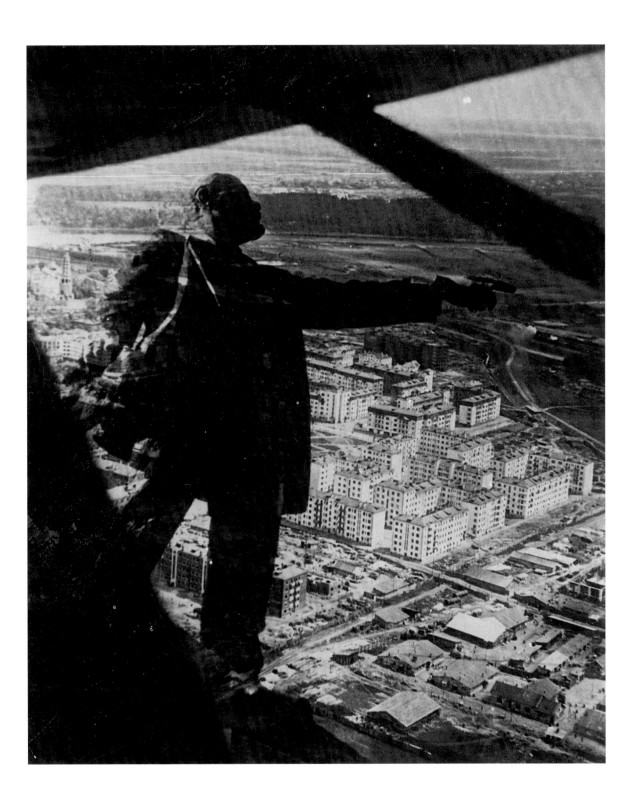

10

John Heartfield (German, 1891–1968), cover for Jaroslav R. Vávra, *The Oil Men* [*Petrolejáři*], 1937; letterpress, 18.8 × 13.8 cm.

11

John Heartfield (German, 1891–1968), *Untitled (Lenin over Moscow)*, 1931; gelatin silver print, 19.2 × 16.1 cm. The picture was published in *SSSR na stroike/USSR in Construction* in September 1931. (This print carries a Soyuzfoto stamp and additional markings related to the publication, and may have served in its layout.)

courtesy of Theo van Doesburg and the artistic move-
ment he founded, De Stijl. Van Doesburg did not
merely reprint the book in translation, however—
he redesigned it. *Van 2* ■ (Van twee kwadraten) is
horizontal not vertical in format, its "red" square has
an orange tint, and it drops young people from its
intended audience; the book, presented in Russian
as a fable for "all, all children," is now addressed in
the most declarative type simply to "all." Lissitzky
was reportedly unhappy with the Dutch version of
his work, and later commentators have dismissed it as
reducing Lissitzky's concise yet masterful tale of the
October Revolution to mere promotional literature
for international Constructivism.[14]

Van Doesburg's interventions may not match
or even live up to the intentions of his Russian col-
league. But they are not unreflective. Distinct yet side
by side, word and image carry a conjoined pictorial
force in the Dutch version that is more difficult for the
reader-viewer to ignore than in Lissitzky's original,
where the text lines might be mistaken for captions or
footnotes. Van Doesburg followed Lissitzky well,
moreover, in the attempt to animate language optically,
using capital letters to join together words such as
"black" (*zwarT*, in Russian *cherno*) and "tumult/com-
motion" (*onrusT*, in Russian *trevozhno*) that could
have been similarly connected in the Russian but
were not. Tidier in its page layouts, the Dutch book is
perhaps less open-ended than the Russian. But van
Doesburg, with his transgressions, disappointments,
alterations, or even improvements, does no less than
enact Lissitzky's appeal on the first page of his revolu-
tionary tale: "don't read it, build your own." Conver-
sation—a back-and-forth, or literally, "turning about
with" one another—necessarily involves reinterpre-
tations, miscommunications, and other productively
incomplete exchanges.

As an emblem of conversation in this produc-
tive, conflict-laden sense, no single image works better
than the cover by Teige for the May 15, 1925, issue of
Reflektor (Headlight), a biweekly communist magazine
with high literary and artistic aspirations (see plate 1).

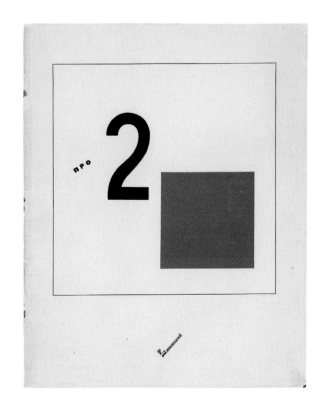

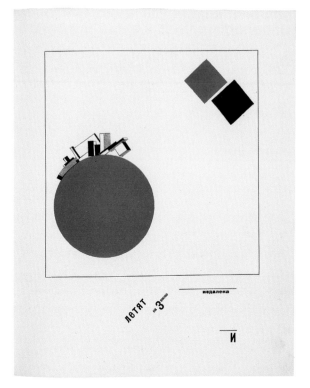

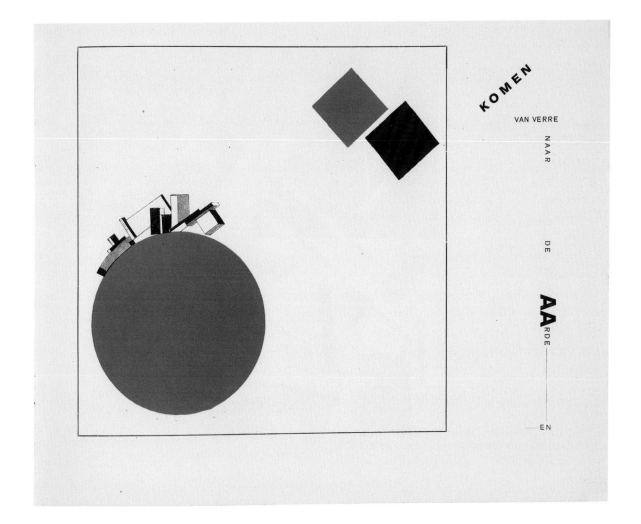

KOMEN
VAN VERRE
NAAR
DE
AA RDE
EN

12

El Lissitzky (Russian,
1890–1941), *Of Two
Squares [Pro 2 ▪]*, 1922;
A and B: Cover and inside
page of the Russian
edition; C: Inside page
of the Dutch edition
[*Van twee kwadraten*]
redesigned by Theo
van Doesburg (Dutch,
1883–1931); litho-
graphs and letterpress,
stapled along spine,
21.5 × 26.8 cm (a and b);
27.9 × 22.3 cm (c).

The crudely stitched elements of this agitational photo-montage, which depends from the equally primitively lettered slogan "Ať žije III. *INTERNACIONÁLA!*" (Long Live the Third International!), ostensibly illustrate a typed citation at lower left from Lenin (pictured in his *arringatore* pose at center right), calling for the confiscation of property from the ruling classes as well as the elimination of all social differentiation (urban and rural, physical and intellectual labor). The inversion of American urban skylines along the bottom of the montage fulfills Lenin's appeal with terrific literality: down with a world of private domains. Yet the picture seems a patchwork made of nothing but domains. Each boxed or silhouetted image sits visibly in its discrete world. There are crowds and their leaders, contrasts

of Russian and Western buildings, a concatenation of typefaces, and one symbol of "good" modernization, by 1925 as familiar an image as that of Lenin himself: a pair of electric poles with insulators and wires disappearing into the void.

The assemblage of fragments, mix of lettering styles, and disparities in scale—all made starker by the prominence of a large, blank white background that splits the picture horizontally in two—cause this purposeful jumble to bear an unexpected resemblance to a typical computer screen, crowded with chat windows, banners, pop-up ads, and tiles all clustered around a central space kept free for user input. To contemporary viewers, accustomed as we are to constant distraction and multitasking, the call in this

montage for workers to unite is not nearly so strong as the appearance it gives of an inviting *dis*unity, an interactive openness. Some version of media-based interactivity would likely have been desirable to Teige. White space is the space of the page or screen, the self-reflexive space, and it can also be a point of entry into historical events. Teige makes clear that this is a montage of attractions by positioning, next to Lenin's missing feet and directly under the key phrase "May 1," an equally classic image of Charlie Chaplin watching over Jackie Coogan in the 1921 feature film *The Kid*. The Tramp and his young charge peer watchfully around the corner of a building, humorously reimagined as an upside-down skyscraper. Their appearance may seem discordant, but it is effective: the holiday rally and the movies, two forms of leisure spectacle, meet on the printed page to produce us, the new readers. What is more, these forms do not fuse. Rather, like Chaplin and Lenin, they "meet up" without directly addressing each other, to generate a conversation across their separate domains.

Notes

1. Guy Debord, "Perspectives de modifications conscientes dans la vie quotidienne" (1961); reprinted as "Proposals for the Conscious Alteration of Everyday Life" in *The Everyday Life Reader*, ed. Ben Highmore (London and New York: Routledge, 2002), p. 238. This book contains a terrific selection of writings on everyday life from across the twentieth century.

2. Andreas Huyssen, "The Hidden Dialectic: Avantgarde—Technology—Mass Culture" (1980); reprinted in *After the Great Divide: Modernism, Mass Culture, Postmodernism* (Bloomington: Indiana University Press, 1986), p. 7.

3. Henri Lefebvre, one of the best-known theorists of everyday life, claimed the term encompasses "'what is left over' after all distinct, superior, specialized, structured activities have been singled out by analysis" (cited in Highmore, *The Everyday Life Reader*, p. 3). Highmore agrees (p. 4) that the potential of everyday life for critical inquiry "is essentially anti-disciplinary . . . [it is] not a field at all, more a like a para-field, or a meta-field."

4. For earlier treatments of this moment, see, among others, Richard Andrews and Milena Kalinovska, eds., *Art Into Life: Russian Constructivism, 1914–1932* (Seattle: Henry Art Gallery, 1990); Matthew Teitelbaum, ed., *Montage and Modern Life, 1919–1942* (Cambridge, Mass.: MIT Press and Institute of Contemporary Art, Boston, 1992); or in literature, Stephen C. Hutchings, *Russian Modernism: The Transfiguration of the Everyday* (Cambridge: Cambridge University Press, 1997).

5. Walter Benjamin, "Moscow Diary," *October* 35 (Winter 1985): 9–135.

6. Christina Kiaer, *Imagine No Possessions: The Socialist Objects of Russian Constructivism* (Cambridge, Mass.: MIT Press, 2005), p. 224. For a history of the key term *byt*, see Svetlana Boym, *Common Places: Mythologies of Everyday Life in Russia* (Cambridge, Mass.: Harvard University Press, 1994).

7. Georg Lukács, *Geschichte und Klassenbewusstsein* (1923); reprinted as *History and Class Consciousness* (London: Merlin Press, 1971), cited from http://www.marxists.org/archive/lukacs/works/history/hcc05.htm, accessed December 2010.

8. A lucid account of the relation of labor to vanguard art, grounded in work of the 1960s and after, is given by Helen Molesworth, ed., *Work Ethic* (University Park: Penn State University Press / Baltimore: Baltimore Museum of Art, 2003). One summary statement of resistance to systematized labor, already current in the 1950s, is the Situationist slogan: "never work."

9. Lucie Vlčková, ed., *Letra y fotografía en la vanguardia checa. Sutnar-Sudek y la editorial Družstevní práce* (Valencia: Campgràfic, 2006), pp. 123–24.

10. Boris Arvatov, "Byt i kul'tura veshchi" (1925); reprinted as *Everyday Life and the Culture of the Thing (Toward the Formulation of the Question)*, trans. and intro. Christina Kiaer, *October* 81 (Summer 1997), p. 128.

11. Christopher Burke, *Active Literature: Jan Tschichold and New Typography* (London: Hyphen Press, 2007), p. 130.

12. On the subject of these artists' creative partnerships, see also Nancy Roth, "Heartfield's Collaboration," *Oxford Art Journal*, 29, no. 3 (October 2006), pp. 395–418, and Margarita Tupitsyn, *Gustav Klutsis and Valentina Kulagina: Photography and Montage after Constructivism* (New York: International Center of Photography/Gottingen: Steidl, 2004).

13. Maria Gough, "Back in the USSR: John Heartfield, Gustavs Klucis, and the Medium of Soviet Propaganda," *New German Critique* 107, 36, no. 2 (Summer 2009), pp. 133–83, especially pp. 146–51.

14. See N. Khardzhiev, "El Lissitzky, Book Designer" (1962); reprinted in Sophie Lissitzky-Küppers, ed., *El Lissitzky: Life, Letters, Texts* (Greenwich, Conn.: New York Graphic Society, 1968), pp. 380–81. Lissitzky is quoted with a disparaging comment on van Doesburg in the book (p. 56), but does not write directly about *Of Two Squares* there or elsewhere; the two men continued to collaborate, so Lissitzky's reported unhappiness may have been exaggerated.

John Heartfield

WALLPAPERING THE EVERYDAY LIFE OF LEFTIST GERMANY

ANDRÉS MARIO ZERVIGÓN

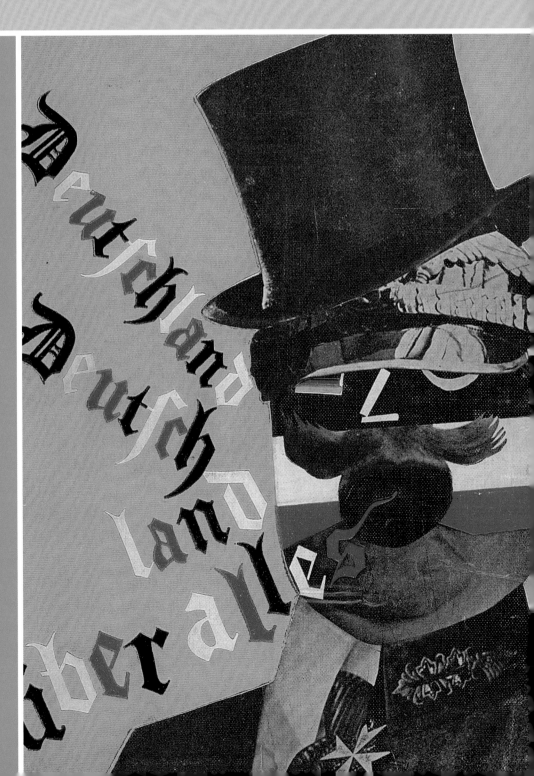

In Germany's turbulent Weimar Republic, political orientation defined the daily life of average communists and their fellow travelers. Along each step of this quotidian but "revolutionary" existence, the imagery of John Heartfield offered direction. The radical-left citizen, for instance, might rise from bed and begin his or her morning by perusing the ultra-partisan *Die rote Fahne* (The Red Banner); at one time, Heartfield's photomontages regularly appeared in this daily newspaper of the German Communist Party (KPD).[1] Opening the folded paper to its full length on May 13, 1928, waking communists would have been confronted by the artist's unequivocal appeal to vote the party's electoral list. Later in the day, on the way to a KPD-affiliated food cooperative, these citizens would see the identical composition—*5 Finger hat die Hand* (The Hand Has Five Fingers) (plate 13)— catapulting from posters plastered throughout urban areas.

At an afternoon rally for the Red Front Fighters' League, the KPD's paramilitary organization, Heartfield's photo-based emblem of a clenched fist would be flourished. A didactic communist play with a stage set he had created might run at a local theater that evening.[2] Indeed, no matter what time of day, members of Germany's leftist circles during the 1920s and early 1930s would have found John Heartfield's imagery inescapable. Even *Die Arena*, the unofficial sports and leisure magazine of the KPD, sported jumping and sprinting photomontage covers by Heartfield.[3] After January 1930, the weekly photo-filled *Arbeiter-Illustrierte-Zeitung* (or *AIZ*, Workers' Illustrated Magazine) featured some of his most compelling montages, including *Alle Fäuste zu einer geballt* (All Fists Clenched into One) (1934, plate 14). Nearly a hundred novels specifically published for a leftist readership with free time boasted covers that Heartfield composed from appropriated or commissioned photographs, such as the one he designed for a 1923 German edition of Upton Sinclair's grim 1906 saga, *The Jungle* (plate 15).[4] Even children of radical families could enrich their day with political books penned for young readers and bearing covers or interior illustrations created by this same German avant-garde artist. In fact, through the second half of the Weimar Republic and into the 1930s,

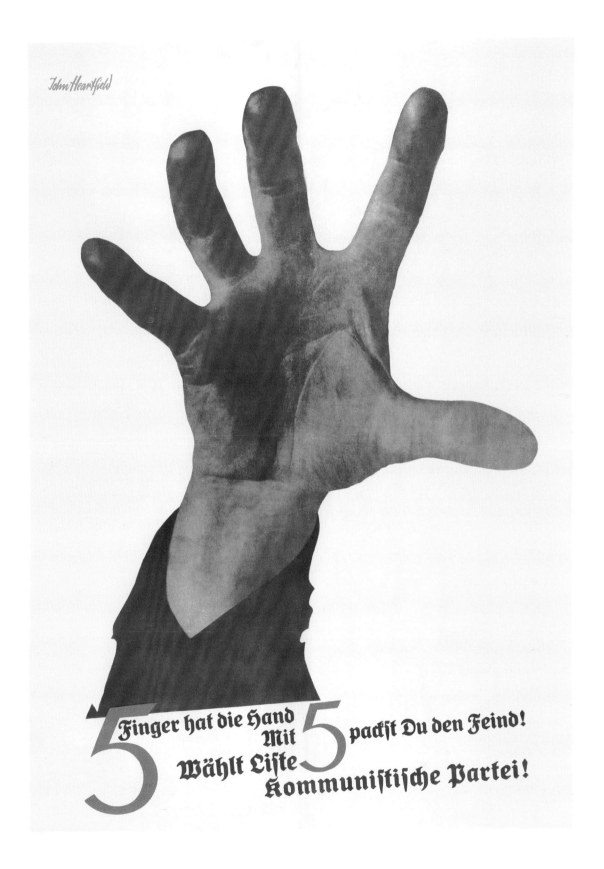

13

John Heartfield (German, 1891–1968), *The Hand Has Five Fingers [5 Finger hat die Hand]*, 1928; gravure, 98.4 × 71.3 cm.

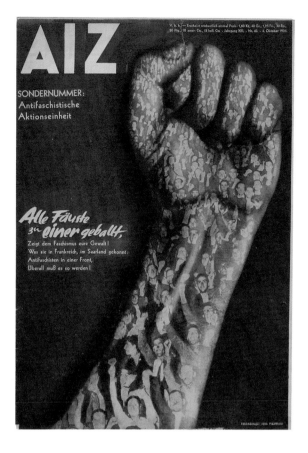

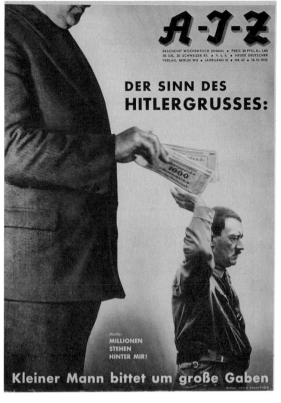

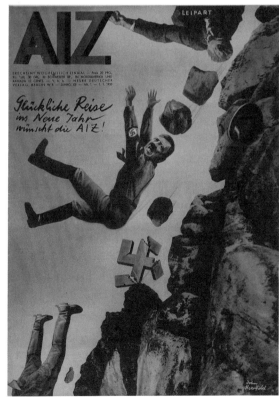

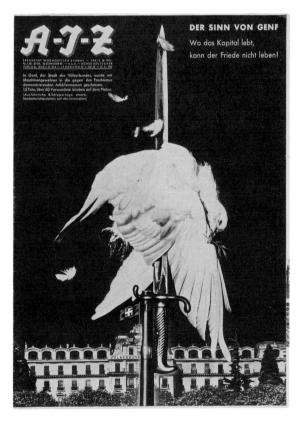

14

John Heartfield (German, 1891–1968), four issues of Workers' Illustrated Magazine [AIZ, Arbeiter-Illustrierte-Zeitung]: A. *All Fists Clenched into One* [*Alle Fäuste zu einer geballt*], October 4, 1934; B. *The Meaning of the Hitler Salute. Motto: Millions Stand behind Me!* [*Der Sinn des Hitler-grusses. Motto: Millionen stehen hinter mir!*], October 16, 1932; C. *AIZ Wishes You Happy Travels into the New Year* [*Glückliche Reise ins neue Jahr wünscht die AIZ*], January 1, 1933; D. *The Meaning of Geneva: Where Capital Lives, Peace Cannot Survive* [*Der Sinn von Genf. Wo das Kapital lebt, kann der Frieden nicht leben*], November 27, 1932; gravures, 38.1 × 28 cm.

15

John Heartfield (German, 1891–1968), covers for four novels by Upton Sinclair: A. *100%: The Story of a Patriot* [*Hundert Prozent: Roman eines Patrioten*], 1921; B. *The Jungle* [*Der Sumpf*], 1928; C. *They Call Me Carpenter* [*Man nennt mich Zimmermann*], 1922; D. *Oil!* [*Petroleum*], 1927; lithographs and letter-press, 18.9 × 13 cm, except *Hundert Prozent*, which is 18 x 12.9 cm.

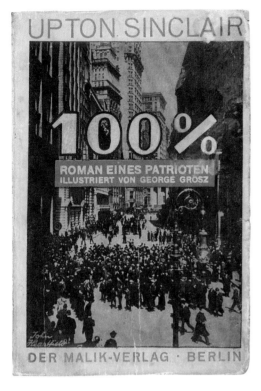

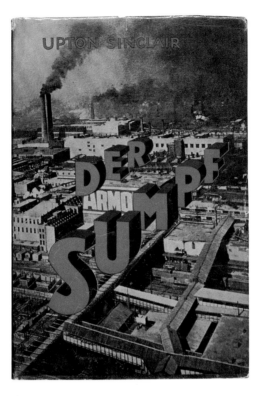

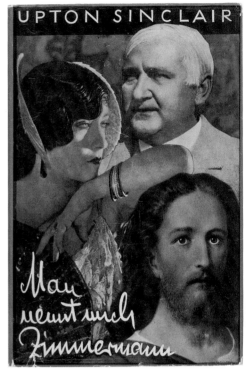

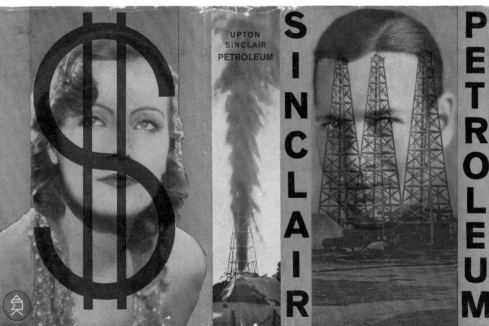

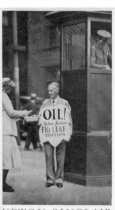

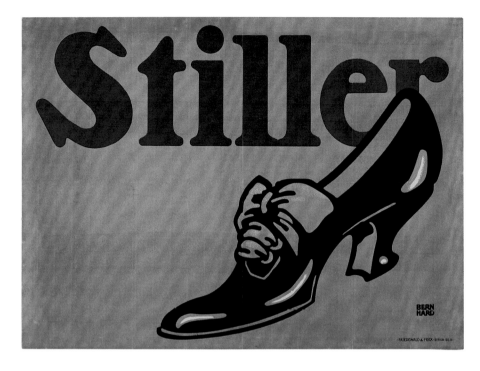

1.1

Lucian Bernhard
(American, born Germany,
1883–1972), *Stiller*, 1908;
lithograph, 69 × 95.2 cm.
The Museum of Modern
Art, New York.

Heartfield's pictures and those of his many followers wallpapered this alternative society to such an extent that he became the pictorial designer of Germany's everyday socialist life.[5]

How did Heartfield achieve this success? How could an artist who trained in corporate advertising and first won fame in Berlin Dada—an art movement pilloried by the far left as "decadent"—pictorially conquer the ordinary spaces of that political class? Factors such as his extraordinary artistic talent and his deeply felt commitment to communism clearly played a role. But it was chiefly his pioneering use of photography that won him the approval of party leaders and a mass audience alike. Adapting the medium from both his advertising training and his experiments in Dada, Heartfield fashioned a photographic style that was widely accessible and intensely moving for those committed to leftist causes. Curiously, however, his success at this adaptation depended not on his faith in the medium's representational accuracy but on his anxiety-fueled determination to manipulate photographs until they revealed the jarring truths that they normally obscured. This persistent ambivalence enabled

Heartfield to accommodate difficult and sometimes unpopular innovations in avant-garde photography to the quotidian world of Germany's radical left.

I

Born in Berlin in 1891, his father a socialist playwright and his mother a radicalized textile worker, Helmut Herzfeld was trained early in the photographically based advertising techniques that many fine artists would only discover years later. In 1908 he entered the Königliche Akademie der Kunstgewerbe (Royal Bavarian Academy of Applied Art) in Munich to study the relatively new field of graphic art. Upon completing the program four years later, he accepted a job as a packaging designer in Mannheim but soon moved to Berlin to continue his studies with Ernst Neumann, one of Germany's most renowned professors of advertising design. Under his mentor's guidance, the young Helmut learned to produce what the increasingly professional world of German advertising called the *Blickfang*. Literally translated, the word means eye-catcher and describes an image, packaging, or object that attracts the attention of potential customers by means of an optical surprise. Its key features are simplicity, often achieved by minimizing visual distractions and the pairing of two often-outsized figures.[6]

Around the time Heartfield began his studies, the most common form of the *Blickfang* was a poster called the *Sachplakat*. Meaning "object poster" and suggesting *Sachlichkeit*, or objectivity, these compositions generally highlighted a company's trademark or commodity but without the biomorphic flourishes of *Jugendstil* (Art Nouveau's emanation in Germany and Austria), which had been popular at the turn of the century. They also avoided allusions to complex allegories and scenarios. The Berlin poster artist Lucian Bernhard is credited with introducing this distinctive advertising vehicle by limiting his images to an essential text and product image. A classic example of his style is *Stiller* (1908, fig. 1.1), in which a schematically rendered shoe surprisingly obscures a portion of its manufacturer's oversized trademark name; word and

image float tantalizingly over a field of gold.[7] "These two hieroglyphs suffice entirely," Bernhard told the critic Adolf Behne in 1919, suggesting that a legible and alluring pictographic vocabulary lay at his disposal.

The poster should stimulate the eye through a perplexing appearance in its entirety, and already at the moment in question the passerby should be able to extract from the poster: . . . a boot, or chocolate, or wicker furniture . . . ! [And] the passer-by, without needing to detain himself any longer, one — two — three — should also have already read the name of the firm: Schultze, Müller, Lehmann.[8]

Under Neumann's tutelage, Heartfield learned to master this technique. His 1928 KPD poster *The Hand Has Five Fingers* vividly illustrates how this advertiser of Communism grasped the *Blickfang* approach. In it, the photograph of a splayed hand — chosen from scores of prints Heartfield had commissioned of factory workers' hands — thrusts forward from a blank white background. Below the hand, a bold red 5 appears twice — first to signify the number of fingers and, second, to denote the KPD's list of candidates, through whom the voter can — as the poster declares — "seize" the bourgeois "enemy." According to Heartfield's wife, Gertrud, the poster had such an impact throughout Germany that "comrades and many other people in [conservative] Bavaria" began greeting one another with the same open-handed gesture.[9] True to the bold "one — two — three" impact that Bernhard attributed to an effective *Sachplakat*, Heartfield had forcefully and unequivocally broadcast his party's message from walls and poster columns nationwide. And he had even managed to transform, however temporarily, the daily gesture of mutual recognition among members of his intended audience. Whether he chose to focus on a hand, a number, or even a bit of text, Heartfield was able to pinpoint and intensify either the affirmative or the negative power of any motif he selected. But more specifically, he had adapted the pairing, distillation, and deformation of the *Blickfang* to photography. This allowed him to power his images through the sudden enhancement or overturning of a given photograph's

first flush of meaning. This innovation in fact resulted from his ambivalence toward photography, fraught feelings generated by his disheartening experience of World War I propaganda — an experience that also taught him a welcome lesson on exploiting the photograph's persuasive potential.

II

Conscripted into military service in mid-September 1914, six weeks after the outbreak of World War I, Heartfield had to abandon his studies with Ernst Neumann and undergo the notoriously demeaning Prussian barracks drill in Berlin. His fervent opposition to the war soon provided a fresh focus for his talent: subverting the aggressive dissemination of pro-war propaganda, much of which used photography, to reassure the German populace of a victorious outcome. Together with his new friend, the painter George Grosz, Heartfield began sending postcards manipulated with photomontage to soldiers at the front — sympathetic acquaintances and strangers alike. As his brother, the poet and publisher Wieland Herzfelde, later recalled, these "photographic clippings had been assembled such that they said in pictures what would have been censored had it been said in words."[10]

Unfortunately, none of these compositions survives.[11] Yet their creation suggests that Heartfield and Grosz learned a bitter lesson about the effectiveness of photographic propaganda: "You can lie to people with photos, really lie to them," Heartfield observed near the end of his life. "Photos of the war zones were being used to support the policy of persevering long after the conflict had been settled on the Marne and Germany's army had been beaten."[12] The postcards he and Grosz assembled no doubt juxtaposed images such as these with sharply ironic captions, gruesome amateur pictures taken at the front, or even kitschy pro-war images whose heavy-handed intentions were easy to ridicule. The two men had come to see that the meaning of any photograph is fluid and, therefore, contingent upon its context. By altering that context, they could suggest an alternative "veiled" reality —

16

John Heartfield (German, 1891–1968), *Self-Portrait* [*Selbstporträt*], 1919; letterpress, 19.3 × 13.5 cm. Markings on the reverse indicate that this image was intended for reproduction in the anthology *Dadaglobe*, planned in 1920 by the Dadaist Tristan Tzara, but never realized.

1.2

John Heartfield (German, 1861–1968), cover for *Der Dada, The Tire Travels the World* [*Das Pneuma umreist die Welt*], 1920; newsprint, 23.2 × 15.7 cm. The Art Institute of Chicago.

as Heartfield later called it—and do so in a visually stunning manner and in a form that could conceivably be mass-produced. Thus political resistance could tap the logic of the *Blickfang* and succeed in ways similar to popular advertising. Heartfield even applied this subversively attention-grabbing ploy to his personal identity—by informally anglicizing his given name, Helmut Herzfeld, in or just before August 1917.[13] At a time in the war when Germans regularly greeted each other with the salutation "God punish England!," the artist's new name boldly announced his resistance to his nation's xenophobia.

In his photographic work, Heartfield continued injecting a bracing dose of manipulated corrective. He had developed what might be termed photo-ambivalence—a simultaneous suspicion of and attraction to the medium's documentary capacity. These conflicting sentiments prompted him to experiment with a medium whose persuasive capacity fueled its effectiveness as a propaganda tool. Before long, Heartfield's embrace of Dada would push this investigation to an extreme. Conceived in the neutral safe haven of Zurich in 1916, Dada reached wartime Berlin a year later. Always politically motivated at some level, the movement developed an expressly politicized wing in the starved and depressed German capital. "Instead of continuing to produce art," Zurich cofounder Richard Huelsenbeck declared from Berlin in 1920, "Dada... went out and found an adversary."[14] A primary goal of Berlin Dada, which Heartfield joined in 1918, was to provoke a large and passive population with shocking reflections of the war's repressed traumas.

The upheaval that key members of Berlin Dada were hoping for actually took place, if only momentarily, when the German Revolution erupted in November 1918, replacing the imperial government with a republic and thereby hastening the end of the war. Swept along by this short-lived uprising, Berlin Dada sought to aid in the dissolution of the Wilhelmine monarchy. Heartfield, his brother, and Grosz all joined the country's newly founded KPD and began fashioning images and staging performances to reflect

and accelerate the national upheaval. They and other Berlin Dadaists began to recognize the invaluable contribution photography would make to their artistic and political aims. It would greatly enhance their efforts to affront public taste in art and position the camera as a modern, more democratic alternative to the conventional work of academically trained artists.

Some of Heartfield's pictures from this time call to mind the methods of the soapbox agitators who were ubiquitous fixtures in postwar urban Germany. In a photographic self-portrait of 1920, the artist opens his mouth as if to roar and clenches his fist in apparent rage (plate 16). He intended this photograph to shock viewers and jar convention at a time of nationally jangled nerves. Heartfield achieved similar effects in Futurist-inspired collages that jumbled photographic fragments and clippings from illustrated newspapers and advertising posters. In his widely reproduced *Das Pneuma umreist die Welt* (The Tire Travels the World) (1920, fig. 1.2), a careening tire appears to batter the component fragments of once forceful advertisements for products or party agendas, all of which have lost their original message. The resultant wreckage constitutes a deliberate political and antiartistic act.

Heartfield's output of scrambled photomontages, which peaked in late 1919 and the first half of 1920, reduced mass-media signification to primitive building blocks. This breakdown served to mirror an "unutterable age, with all its cracks and fissures," as the Dada poet Hugo Ball declared of an aggressive Zurich-era performance by Huelsenbeck.[15] Heartfield's brazen attempts to dismantle entrenched perceptions were intended to help speed the larger dissolution of Germany's old order. For this advertiser-turned-Dadaist, applying avant-garde techniques to the popular culture of the street and the market amounted to an assault on the status quo. Suspicious of photography's ability to convey truth and produce meaning, he attempted to expose the conditions under which it might fail to do so.

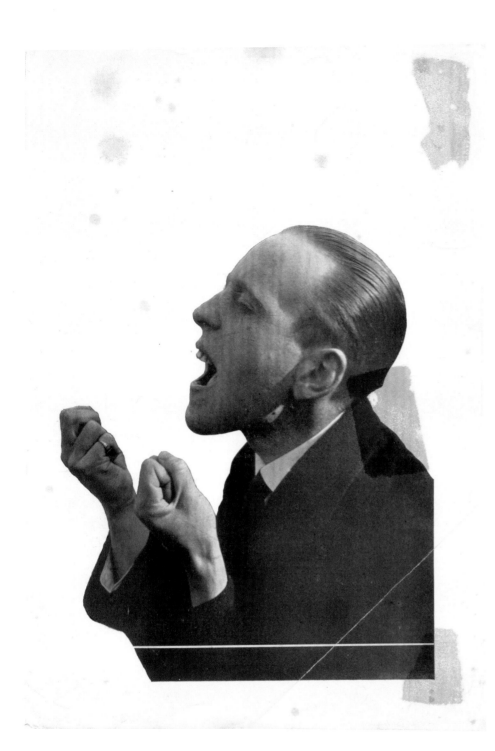

III

Less than a year after it erupted, the German Revolution—to which Heartfield linked his new art—had failed, enabling the new Weimar Republic to consolidate itself in the summer of 1919. Similarly, by the fall of 1920, Berlin Dada had dissipated. Rather than embrace Dada as a revolutionary assault on the old order, moreover, the fledgling KPD condemned it as childlike and "bourgeois." Dada was nothing more than a minor irritant to what the KPD deemed the West's valuable "cultural inheritance." The movement's photomontages and other "assembled" works were "glued together silly kitsch" that, far from assisting rebellious workers, posed a "degenerate" danger to them.[16] This hostility to Dada never changed. Yet the KPD abandoned its praise for the West's cultural inheritance shortly after the inflation of 1923 had been halted. In the fleeting episode of stability that followed, the KPD began fostering an autonomous and pointedly "proletarian" culture in its ranks.[17] This was part of its larger effort to develop a cultlike following among its members, whom it engaged in a perpetual frenzy of Party activities. In June 1924, for example, the KPD chapter in Essen provided its officers with a list of events that included at least one activist meeting every weekday evening; toward the end of 1927, the Halle-Merseburg chapter reported to Berlin's Central Committee that it would have staged 640 talks, rallies, and discussions between November 1, 1927, and January 31, 1928.[18] Affiliated clubs and societies such as Red Aid, Artists' Aid, and the Workers' Gymnastic and Sports Association added their own cultural offerings to these routines, making for a busy parallel society within the broader Weimar Republic. Even language developed a distinctive socialist phraseology; the Austrian author Karl Kraus sarcastically called this jargon Moskauderwelsch, a neologism that blended the name of Russia's capital with *Kauderwelsch*, the German word for gibberish.[19]

In 1926 the writer Heinrich Mann praised the recently founded periodical *AIZ,* which was secretly financed by the Communist International in Moscow, for bringing "to view the proletarian world, which, remarkably, appears to be unavailable in other illus-trated papers." He stressed that "what is happening in life is seen here through the eyes of the workers."[20] Mann and others holding this view were encouraged by the prospect of a "class vision" and more specifically "the working man's eye," which, they believed, could see below the illusory surface of appearances, particularly as that surface was reproduced in mainstream culture.[21]

Although Heartfield had irritated the KPD with his aggressive Dada photomontages, his abiding photo ambivalence enhanced his understanding of this piercing class vision and emboldened him to forge a unique visual culture for the radical left. His first opportunities came in 1921, shortly after Dada's demise. His brother, Wieland Herzfelde, had been directing the left-wing Malik Verlag (Malik Press), which Heartfield had founded during the war. In the immediate aftermath of the failed revolution, Herzfelde began publishing realist novels that revealed the hidden machinations of capitalism and the overlooked heroism of workers in highly accessible journalistic prose. Typically authored by foreign or obscure German writers, this new and unfamiliar "proletarian literature" required keen marketing. Heartfield, who had essentially become Malik's house designer, answered this challenge by composing covers that would attract readers and, at the same time, alert them to the books' unusual content and approach. His task, in other words, was to design a *Sachplakat* for each volume. As his brother later explained:

In 1921, as our press began publishing novels, it required particularly expressive jackets and book covers. These surfaces were meant to prompt not only the few leftist booksellers but also those of a different opinion to display our new publications and reprints in their shop windows. Therefore the books had to be attractive at first sight and at the same time have an agitational effect. For we felt that even people who did not buy one of our books should be influenced by the content as it was expressed on the cover.[22]

This goal forced Heartfield to make his photomontages simple and "laconic," as the Soviet author Sergei Tret'iakov characterized these new works.[23]

Heartfield experimented liberally with his book covers, exploring various typographic styles and even abstract planes of color inspired by contemporary avant-garde painting. Ultimately, however, photography proved most effective for his new *Blickfang*. In 1921 he created a cover for the translation of Upton Sinclair's novel *100%: The Story of a Patriot* that sports an appropriated photographic view down Wall Street (plate 15). In its relative seamlessness, the image visually equates colossal architecture with New York's corridors of economic power. Heartfield's composition graphically affirms this relationship, which is central to Sinclair's story, by stretching the title across the deep concrete canyon where, as it happens, the novel begins. Like the book, Heartfield's cover criticizes American capitalism but by means of an eye-catching photograph instead of prose.

In 1922 Heartfield, who had done a brief stint in the German film industry, realized that his new photomontage technique could be significantly enhanced by the pictorial language of cinema, now popular in Germany.[24] He adapted the film still, the establishing shot, and the movie advertisement to his purposes, employing devices that ordinarily condensed a film's temporal unfolding and character development into a single, well-organized image. His cover for Sinclair's *They Call Me Carpenter* (plate 15), for example, features the stock figures of the overfed businessman, the diva (taken from a still of the screen actress Gloria Swanson), and Jesus himself. New here was the degree to which his stark juxtapositions of these figures suggest the unfolding moral conflicts that drive the novel's social criticism.

Heartfield quickly learned how to restructure other found and commissioned photographs to produce similar filmlike distillations. His cover for Sinclair's *The Jungle* uses the logic of a narrative establishing shot to set the stage for this exposé of horrific abuses in Chicago's meatpacking industry and the debased lives of its laborers. As the city's slaughterhouses and surrounding factories recede in a dynamic diagonal along the length of the dust jacket, so do the bold red

capital letters of the title. Adolf Behne remarked about this distinctive and gripping style: "The photomontage of Heartfield: that is photography plus dynamite."[25]

Thanks in part to these almost incendiary covers, Malik's output of publications soared. The press's translation of Sinclair's 1927 novel *Oil!*, for example, with its two American film-studio portraits (one each on the front and back covers), sold more than one hundred twenty-five thousand copies (plate 15). Noting this success, other leftist artists followed Heartfield's example, and by 1928 Germany's book market was flooded with volumes boasting stunning photomontage covers. Artists and photographers in Czechoslovakia, Hungary, Poland, and the Soviet Union followed suit. Heartfield's style of montage also began appearing in other contexts, becoming practically a ubiquitous feature of Weimar's radical propaganda.

Between 1926 and 1928, the artist himself worked in the Agitation-Propaganda department of the KPD, the party that earlier had condemned his work. KPD posters and magazine covers plastered Germany's urban surfaces, adorned its newspaper kiosks, and even surfaced in Czech left-wing books and magazines (plates 17 and 18). Heartfield's use of photographs enabled him to suggest a specifically leftist vision of a world threatened by capitalist and right-wing illusion. In addition, his skill in the medium brought a vast public audience to modern design based on the overlapping visual languages of cinema, the newspaper, and advertising.

John Heartfield's greatest success came in 1930, when, tiring of internal KPD battles, he moved to the relatively autonomous Neuer deutscher Verlag (or NDV, New German Press), which was headed by the radical-left propaganda master Willi Münzenberg.[26] The charismatic Münzenberg had already hired Heartfield in 1927 to create magazine covers and even the complete visual program for *Deutschland, Deutschland über alles* (Germany, Germany above All), a classic antimilitarist photobook by the country's most notorious satirical essayist, Kurt Tucholsky (plate 19). The Dada-inspired cover for this book, however, did not anticipate what Heartfield soon would do.

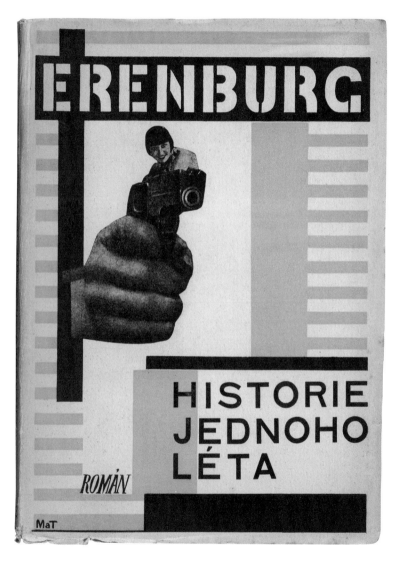

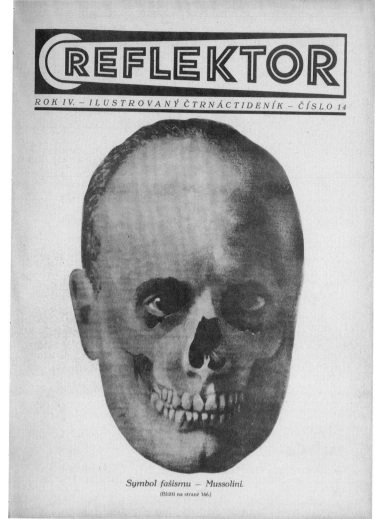

Symbol fašismu — Mussolini.
(Bližší na straně 166.)

17

Otakar Mrkvička (Czech, 1898–1957) and Karel Teige (Czech, 1900–1951), cover for Il'ia Erenburg, *History of One Summer* [*Historie jednoho léta*], 1927; letterpress, 20 × 14.2 cm. Mrkvička and Teige added a female figure to the fragment of a hand and gun from Heartfield's cover for Franz Jung, *The Conquest of the Machines* [*Die Eroberung der Maschinen*], 1923.

18

Karel Teige (?) (Czech, 1900–1951), cover for *Headlight* [*Reflektor*] after John Heartfield (German, 1891–1968), *The Face of Fascism* [*Das Gesicht des Faschismus*], July 15, 1928; lithograph, 37 × 27.6 cm.

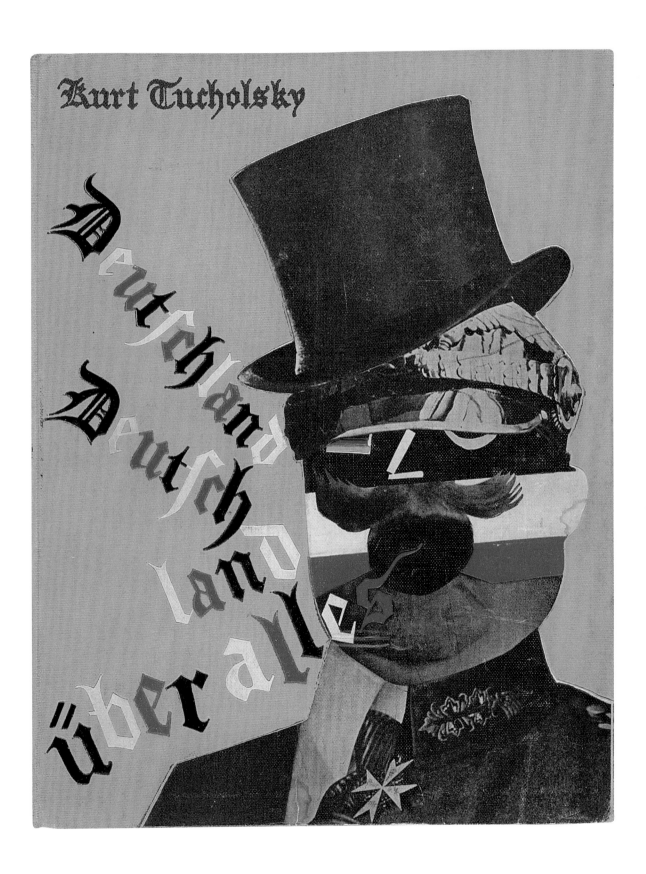

John Heartfield (German, 1891–1968), cover and illustrations for Kurt Tucholsky, *Germany, Germany above All* [*Deutschland, Deutschland über Alles*], 1929; letter-press inset on canvas, 23.8 × 18.6 cm.

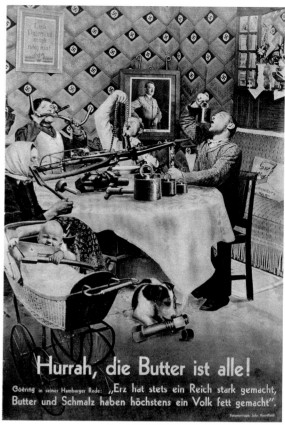

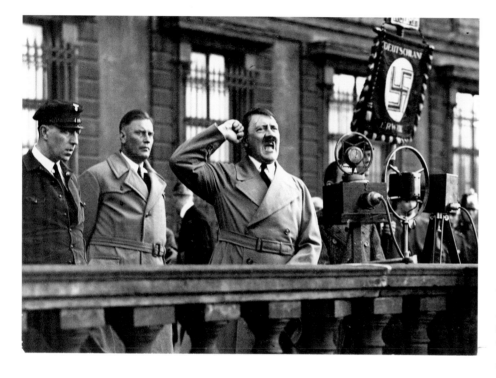

1.3

Press photograph from
a National Socialist Party
rally, 1932; gelatin silver
print, 17 × 26 cm. The
Getty Research Institute,
Los Angeles (920024).

1.4

John Heartfield (German,
1891–1968), cover for
*Workers' Illustrated
Magazine* [*AIZ, Arbeiter-
Illustrierte-Zeitung*],
*Hurrah, There's No More
Butter!* [*Hurrah, die Butter
ist alle!*], December 19,
1935; gravure, 38.1 × 28 cm.

As a contributor to *AIZ,* he could appropriate
on a weekly basis the sorts of subtly propagandistic
press photos that had frustrated him during the war
and process them in what Tret'iakov would call his
"socio-publicist lab."[27] In one case, he took a widely
circulated picture of Hitler speaking at a 1932 National
Socialist Party rally (fig. 1.3), coupled it with the
leader's oft-repeated declaration "Millionen stehen
hinter mir" (Millions Stand behind Me), and—with
a cut-and-paste—transformed the phrase into a
pun indicting German industrialists (plate 14). Hitler's
upraised hand, his signature gesture of power styled
on the imperial Caesar, now showed him to be a puppet
of capital. "Like no one else," wrote the author Oskar
Maria Graf in 1938, "Heartfield shows what is concealed
behind things and appearances."[28]

For Heartfield, the contemporary photograph
obscured as much as it revealed, and his images sought
to jar the viewer into a critical awareness of this fact.
His preference for a sparse distribution of elements
against a murky sepia ground transformed the *Sach-
plakat* format into an aggressive photographic amalgam
that agitated not by appealing to reason but by tapping
deep emotions. Within a year, the circulation of *AIZ*

exploded, and Heartfield photomontages appeared ubiquitously, sometimes in the form of posters directly derived from the magazine's pages. By forcing both communists and non-communists to view matters from a new perspective, Heartfield became a successful advertiser of Weimar radical-left ideology, a wallpaper designer for Weimar's everyday spaces, and, by extension, an architect of political consciousness.[29] He was quick to point out when his opponents, such as the Nazis, were employing a similar tactic. *Millions Stand behind Me* serves as one example. But after he fled the Nazi takeover of the German government in early 1933, his attacks on their propaganda became particularly elaborate. A December 1935 *AIZ* photomontage, *Hurrah, die Butter ist alle*! (Hurrah, There's No More Butter!) (fig. 1.4), shows a family eating government-subsidized armaments instead of food; the harsh message is that fascist weapons and propaganda have saturated the domestic space.[30]

"To make advertisements is to be a social artist," wrote the Hungarian essayist and artist Lajos Kassák in 1926.[31] Referring to the increasingly avant-garde German trade magazine *Die Reklame* (Advertising), Kassák was commenting on the ways cutting-edge artists were using advertising to introduce their aesthetic inventions into quotidian life. That life, so the thinking went, was correspondingly improved by good design. Many such artists entered the field of advertising as novices with these goals of betterment in mind. Heartfield, however, had been there all along. His photobased *Blickfänge* had been impressing and influencing his constituency not just with superb design but with an altogether new manner of perceiving, a manner of casting a critical eye on the day-to-day world.

Notes

1. Heartfield designed front pages for the daily *Die rote Fahne*, plus front pages and interior illustrations for at least two of its special issues, mainly in 1928.

2. Heartfield created sets for productions staged by the left-wing theater director Erwin Piscator between 1920 and 1931.

3. *Die Arena* appeared irregularly in 1926 and 1927. A note on the KPD's membership is in order. Although the party associated the word *worker* with its periodicals, such as this "workers'" sports journal, most KPD members who saw themselves as workers were in fact destitute laborers from Germany's urban underclass. By the late 1920s, the majority of them were unemployed; see Eric Weitz, *Creating German Communism, 1890–1990* (Princeton, N.J.: Princeton University Press, 1997).

4. From the early 1920s to the late 1930s, Heartfield designed covers for Malik Press, which issued this translation of Sinclair's novel, and many other publishers.

5. Toward the end of his life, Heartfield lamented to the West Berlin gallerist Jule Hammer, "I would have become the designer of socialism if they had only let me"; quoted in Peter Sager, "Demontage des Monteurs," *Zeitmagazin*, May 20, 1991. Citation taken from Michael Krejsa, "Wo ist John Heartfield," in *Kunstdokumentation SBZ/DDR, 1945–1990: Aufsätze, Berichte, Materialien*, ed. Günter Feist, Eckhart Gillen, and Beatrice Vierneisel (Berlin: Museumspädagogischer Dienst Berlin, 1996), p. 110 n.2.

6. See Sherwin Simmons, "'Advertising Seizes Control of Life': Berlin Dada and the Power of Advertising," *Oxford Art Journal* 22, no. 1 (1999), p. 119. For the term *Blickfang*, see Heinrich Behrmann, *Der farbige Kartonschnitt als Schaufenster Blickfang* (Hamm: Reimann Verlag, 1937); the periodical *Der Blickfang: Schaufenster und Werbung* (published in Frankfurt am Main from 1951 to 1958); and, more recently, Jürgen Holstein, ed., *Blickfang: Bucheinbände und Schutzumschläge Berliner Verlage, 1919–1933* (Berlin: Holstein, 2005).

7. On the *Sachplakat*, see Jürgen Krause, "Reklame-Kultur," in *1910, Halbzeit der Moderne: Van de Velde, Behrens, Hoffmann und die Anderen*, ed. Klaus-Jürgen Sembach et al. (Stuttgart: Hatje, 1992), pp. 185–91; Kevin Repp, "Marketing, Modernity, and 'the German People's Soul': Advertising and Its Enemies in Late Imperial Germany, 1896–1914," in *Selling Modernity: Advertising in Twentieth-Century Germany*, ed. Pamela E. Swett, S. Jonathan Wiesen, and Jonathan R. Zatlin (Durham, N.C.: Duke University Press, 2007), pp. 39–45; and Frederic Schwartz, *The Werkbund: Design Theory and Mass Culture before the First World War* (New Haven, Conn.: Yale University Press, 1996), pp. 137–43.

8. Lucian Bernhard, quoted in Adolf Behne, "Alte und neue Plakate," in *Das politische Plakat* (Berlin: Verlag das Plakat, 1919), pp. 6–7; trans. Repp, "Marketing, Modernity," pp. 42–43.

9. Gertrud Herzfeld, "Aktennotiz über das KPD-Wahlplakat '5 Finger hat die Hand,'" in *John Heartfield, Der Schnitt entlang der Zeit: Selbstzeugnisse, Erinnerungen, Interpretationen*, ed. Roland März and Gertrud Heartfield (Dresden: Verlag der Kunst, 1981), p. 151.

10. Wieland Herzfelde, *John Heartfield: Leben und Werk*, 3rd ed. (Dresden: Verlag der Kunst, 1976), p. 18.

11. For more on these postcards, see Andrés Mario Zervigón, "Postcards to the Front: John Heartfield, George Grosz, and the Birth of Avant-Garde Photomontage," in *Postcards: Ephemeral Histories of Modernity*, ed. Jordana Mendelson and David Prochaska (University Park: Penn State University Press, 2010), pp. 54–69.

12. John Heartfield, conversation with Bengt Dahlbäck, Moderna Museet Stockholm, August 1967, in März and Heartfield, *John Heartfield: Der Schnitt entlang der Zeit*, p. 464.

13. The first known mention of this new moniker appears in a mid-August 1917 letter from the poet Else Lasker-Schüler to the novelist Franz Jung in which she refers to her young artist friend as "J. H." See Else Lasker-Schüler, *Werke und Briefe: Kritische Ausgabe*, vol. 7, *Briefe, 1914–1924*, ed. Karl Jürgen Skrodzki (Frankfurt: Jüdischer Verlag, 2004), p. 144. John Heartfield remained a pseudonym until the artist officially changed his given name in the new German Democratic Republic after World War II. Shortly before the outbreak of World War I, Heartfield's brother, Wieland, changed his last name to Herzfelde at Lasker-Schüler's suggestion.

14. Richard Huelsenbeck, "En Avant Dada: A History of Dadaism (1920)," in *The Dada Painters and Poets: An Anthology*, ed. Robert Motherwell (Cambridge, Mass.: Harvard University Press, 1989), p. 41.

15. Hugo Ball, *Flight out of Time: A Dada Diary*, trans. John Elderfield (Berkeley: University of California Press, 1996), p. 56.

16. Gertrud Alexander, "Dada. Ausstellung am Lützowufer 13, Kunstsalon Buchard," *Die rote Fahne* (July 25, 1920).

17. In doing so, party leaders were to a certain extent following the model of the German chancellor Otto von Bismarck, who had unintentionally fostered social fragmentation with his antisocialist and anti-Catholic campaigns. By the late nineteenth century, these offensives had led to the establishment of parochial schools, separate socialist magazines, and even sectarian hiking clubs. See Heinrich August Winkler, *Weimar, 1918–1933: Die Geschichte der ersten deutschen Demokratie* (Munich: Verlag C. H. Beck, 1993).

18. Weitz, *Creating German Communism*, p. 257.

19. Friedrich Torberg, ed., *Voreingenommen wie ich bin: von Dichtern, Denkern, und Autoren* (Munich: Langen Müller, 1991), p. 81.

20. Heinrich Mann, as quoted in *AIZ* 1, (probably May 22, 1926); reprinted in Leah Ollman, *The Camera as a Weapon: Worker Photography between the Wars* (San Diego, Calif.: Museum of Photographic Arts, 1991), p. 12. For more on the Communist International's direct financing of *AIZ* and its publishing house, see Sean McMeekin, *Red Millionaire: A Political Biography of Willi Münzenberg, Moscow's Secret Propaganda Tsar in the West* (New Haven, Conn.: Yale University Press, 2003).

21. On working-class vision see, among others, Edwin Hoernle, "Das Auge des Arbeiters" (1930); reprinted as "The Working Man's Eye," in *Germany: The New Photography, 1927–33*, ed. David Mellor (London: Arts Council of Great Britain, 1978), pp. 47–49.

22. Herzfelde, *John Heartfield*, p. 44.

23. Sergei Tret'iakov, *John Heartfield: Monografia* (1936); excerpted as *John Hearfiel: A Monograph* in März and Heartfield, *John Heartfield: Der Schnitt entlang der Zeit*, pp. 297–98.

24. Andrés Mario Zervigón, "'A Political *Struwwelpeter?*': John Heartfield's Early Film Animation and the Crisis of Photography," *New German Critique* 107, 36, no. 2 (Summer 2009), pp. 5–51.

25. Adolf Behne, "Künstler des Proletariats, Nr. 16" (1931); reprinted in März and Heartfield, *John Heartfield: Der Schnitt entlang der Zeit*, p. 186.

26. The NVD, which published *AIZ*, won its autonomy partly because of Münzenberg's force of personality but also because of bankrolling from Moscow's Communist International, as noted earlier.

27. Tret'iakov, *John Heartfield*, in März and Heartfield, *John Heartfield: Der Schnitt entlang der Zeit*, p. 299.

28. Oskar Maria Graf, "John Heartfield. Der Photomonteur und seine Kunst" (1938); reprinted in Peter Pachnicke and Klaus Honnef, *John Heartfield* (New York: Harry N. Abrams, 1992), 207. For a brilliant analysis of Heartfield's *AIZ* photomontages, see Sabine Kriebel, "Manufacturing Discontent: John Heartfield's Mass Medium," *New German Critique* 107, 36, no. 2 (Summer 2009), pp. 53–88. These montages are all carefully reprinted and accompanied by David Evans's useful introduction in *John Heartfield, AIZ: Arbeiter-Illustrierte-Zeitung, Volks Illustrierte, 1930–1938*, ed. Anna Lundgren (New York: Kent Fine Art, 1992).

29. Such skills were of course deployed across the political spectrum, though not taking Heartfield's approach or, necessarily, displaying his kind of skill. In the first months of the Weimar Republic, the expressionist writer Paul Zech headed a publicity/propaganda office for the new social-democratic government staffed by a team of advertisers and avant-garde artists; its aim was to quell the general unrest that had been stirred by the German Revolution. One staffer noted in 1920 that the office produced political posters in the same way as "a new mouthwash or a new film star is placed before the public overnight and hammered into the brain as the latest novelty." See Wilhelm Ziegler, "Reichspropaganda oder Reichsaufklärung" (1920); trans. in Simmons, "Advertising Seizes Control of Life," p. 135.

30. By the time Heartfield created this photomontage, he and *AIZ* were based in Prague, having fled Germany soon after the National Socialists came to power, in early 1933 — a move that led to a sharp drop in *AIZ*'s readership. To a certain extent, this composition can be seen as Heartfield's acknowledgment that the Nazis' propaganda had been as successful as their leaders in conquering Germany.

31. Lajos Kassák, "Die Reklame," in *Das Werk* (Zurich: Schweizer Werkbund Zürich), no. 7 (1926), p. 228.

СПАРТАКИАДА

1928

JARED ASH

2

Gustav Klutsis

THE REVOLUTIONARY ARSENAL OF ARMS AND ART

Gustav Klutsis fervently believed in the potential and purpose of art to organize, influence, and assist in everyday life. An artist who himself explored and sought new forms in art, Klutsis defended every fellow artist's right to experiment, with the aim of creating works that were "'like a rifle, a bullet, with which to strike down the enemy.'"[1] The overwhelming bulk of Klutsis's oeuvre is purposeful; he intended that his postcards, posters, cover designs, and illustrations for newspapers, periodicals, and books would serve collective causes and be consumed by a mass audience. A prodigious worker who sought to match the achievements of modern laborers in his creative production, Klutsis strove to advance the first socialist society and a mighty, industrialized Soviet Union.

Gustav Gustavovich Klutsis was born in 1895 in the small town of Rūjiena, Latvia (a country that was then a province within the Russian empire). One of seven children (he had two brothers and four sisters), he began working at age nine to help support his family after his father, a lumberjack, died in an accident. Encouraged by his drawing teacher, he had demonstrated a talent for art in elementary school. From 1913 through 1915, Klutsis studied under Vilhelms Purvītis at the Rizhskaia gorodskaia khudozhestvennaia shkola (Riga City Art School), where he also completed his secondary education.

In 1915, as German forces were about to invade Riga, the school was closed. Soon thereafter, Klutsis was drafted into the Russian army as an infantryman and sent to Petrograd for military training and service. At the end of his mandatory enlistment, he volunteered for the Ninth Regiment of the Latvian Rifles, a machine-gunners' unit that participated in the storming of the Winter Palace in October 1917. The regiment then guarded Vladimir Lenin and the new Bolshevik government at their headquarters in the Smol'nyi Institute and, in March 1918, guarded government leaders during the transfer of the Russian capital from Petrograd to Moscow as well as in the Kremlin thereafter (fig. 2.1). That summer, Klutsis made a series of sketches of Kremlin alleyways and even of Lenin himself.[2] The young artist was profoundly affected by his proximity to the Soviet leader;

2.1

Karl Ioganson,
Voldemars Andersons,
Kārlis Veidemanis,
and Gustav Klutsis at
the Kremlin in Lenin's
Model-T Ford, Moscow,
summer 1918; gelatin
silver print. Latvian
Museum of War, Riga.

this fostered an indelible mental and emotional association between Lenin, the revolution, and the end of the tsarist regime in Russia.

Klutsis explained his gravitation toward agitational art and support for antiautocratic, populist movements as a reaction to the brutal suppression of the 1905 uprising against Tsar Nicholas II and the retaliation against Latvian groups and individuals who had supported it. Klutsis recalled watching the bombardment of his hometown, neighbors' personal property set ablaze in street intersections, and the execution of insurgents. The retaliation affected Klutsis personally: his eldest brother, Ian, was arrested and sentenced to serve fifteen years in a hard-labor camp, subjecting the family to even greater financial hardship.[3]

Klutsis continued his art education all through his military service. In 1917 and 1918, he studied at the Shkola Vserossiiskogo obshchestva pooshchreniia khudozhestv (All-Russian Society for the Encouragement of the Arts) in Petrograd and created set designs for a local workers' theater. After the regiment moved to Moscow in 1918, he and several fellow artists among the Latvian Rifles—including Voldemars Andersons, Karl Ioganson, and Kārlis Veidemanis, former schoolmates from the Riga City Art School—established a studio in the Kremlin, where later that year they presented the *Vystavka kartin i risunkov krasnykh latyshskikh strelkov* (Exhibition of Paintings and Drawings by the Red Latvian Rifles). On the merits of his displayed work, Klutsis was recommended to the Moskovskoe uchilishche zhivopisi, vaianiia, i zodchestva (Moscow School of Painting, Sculpture, and Architecture), where he studied under Vasilii Meshkov and Il'ia Mashkov.

In August 1919, Klutsis enrolled as a student apprentice in the Svobodnye gosudarstvennye khudozhestvennye masterskie (Second State Free Art Studios,

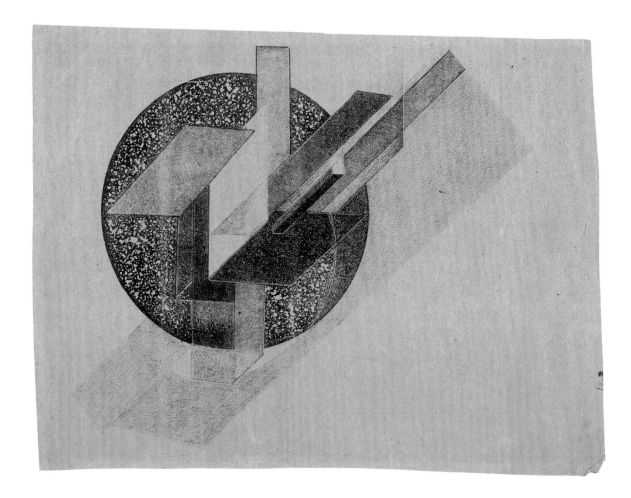

or SVOMAS), which were reorganized in 1920 as VKhUTEMAS, an acronym for Vysshie gosudarst-vennye khudozhestvenno-tekhnicheskie masterskie (Higher State Artistic and Technical Workshops). Between 1919 and 1921, in keeping with evolving tendencies at VKhUTEMAS, Klutsis devoted himself to exploiting primary elements of artistic creation: color, *faktura*, shape, form, and space. He worked in painting, printmaking, drawing, and sculpture— and discovered new relationships among these media.

Works such as *Dinamicheskii gorod* (Dynamic City) (1919, plate 20 and fig. 2.2) reflect Klutsis's common interest with El Lissitzky, Kazimir Malevich, and other contemporaries in envisioning "fantastic constructions" and "fantastic cities" of the future. Recognizing the importance of industry and engineering in raising the new Soviet nation to at least a partially modernized

standard of living, Klutsis and others explored architectural and architectonic forms in drawings and linocuts and experimented with materials that traditionally were associated more with industry and construction than with fine art (plate 21).

Although most of the works Klutsis created between 1919 and 1921 are abstract, several compositions do include figurative, or realistic, images. A second version of *Dynamic City* (1919, fig. 2.3) bridges abstraction and figuration and is a critical element in the story of photomontage in modern art. For the original piece, Klutsis mixed sand and concrete with oil paint, effectively adding elements of the terrestrial world to a floating, apparently otherworldly composition. In the second version, he similarly bridged fantasy and reality by incorporating fragments of photographs of American skyscrapers and workmen. In a 1931 essay he declared

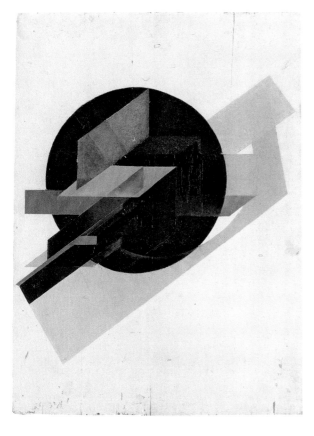

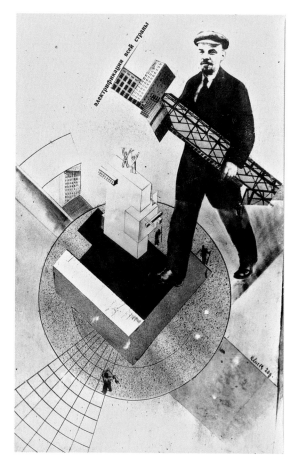

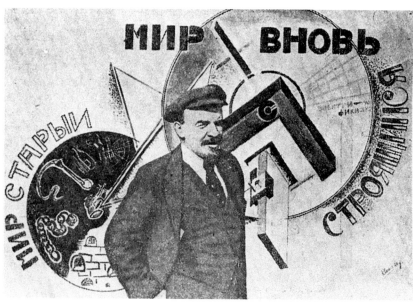

that the photographic version of *Dynamic City* was "the first photomontage work in the USSR."[4] Klutsis characterized the work as an example of "voluminally spatial Suprematism + photomontage" and wrote an inscription that touts it as embodying "the overthrow of non-objectivity and the birth of photomontage as an independent art form."[5]

Klutsis incorporated cut-and-pasted photographic matter in two additional compositions, created in 1920 as studies for posters to commemorate Lenin's fiftieth birthday and the introduction of the leader's "Electrification Plan for the Russian Republic" at the Eighth Congress of Soviets that year: *Elektrifikatsiia vsei strany* (Electrification of the Entire Country) and *Mir staryi i mir vnov' stroiashchiisia* (The Old World and the World Being Built Anew) (figs. 2.4 and 2.5). The contrasts are blatant and unmistakable: an "old world," represented by a whip and chains, faces a new one illuminated by electrification and communism. If in *Dynamic City* the political message remains subtle, *Electrification* stands out as a work in which "specifically agitational content [is] the dominant concern, taking precedence over purely artistic considerations."[6]

In retrospect, Klutsis explained his earliest mature works as driven by the quest for "absolutely new forms, such as had never existed before."[7] He claimed those discoveries were essential in laying the foundation "for a new way of organizing the artistic-productivist object."[8] Klutsis also noted that "following my non-figurative period which ended in 1920–1921 . . . the line of my further development is the line of the development of agitational-mass art, which at that time was called production art."[9] His burgeoning interest in Productivist art parallels that of El Lissitzky, Liubov' Popova, and artists associated with the Pervaia rabochaia gruppa Konstruktivistov (First Working Group of Constructivists), such as Aleksei Gan, Aleksandr Rodchenko, and Varvara Stepanova, who "abandoned easel painting" in 1921, and directed their talents toward designing utilitarian art forms such as textiles, dresses, books, and porcelain.[10]

2.4

Gustav Klutsis (Latvian, 1895–1938), *Electrification of the Entire Country* [*Elektrifikatsiia vsei strany*], 1920; gelatin silver print, 46 × 31 cm. Greek State Museum of Contemporary Art — Costakis Collection, Thessaloniki.

2.5

Gustav Klutsis (Latvian, 1895–1938), photograph of *The Old World and the World Being Built Anew* [*Mir staryi i mir vnov' stroiashchiisia*], 1920; gelatin silver print, 11.9 × 18.2 cm. Greek State Museum of Contemporary Art — Costakis Collection, Thessaloniki.

In 1922 Klutsis began a series of projects in which he directed the artistic idioms of Constructivism and Suprematism toward a specific need: propaganda structures for the Fourth Congress of the Communist International (Comintern) and the fifth anniversary of the October Revolution. The output included poster-display stands (plate 22), propaganda kiosks, and "radio orators" that featured loudspeakers to transmit speeches by Lenin and other officials, as well as other elements including projection screens and/or speakers' platforms. Objects such as *Ustanovka k 4-omu kongressu Kominterna* (Installation for the Fourth Comintern Congress) (1922, plate 23) and *Ekran-tribuna-kiosk k 5-i godovshchine Oktiabrskoi revoliutsii* (Screen-Tribune-Kiosk for the Fifth Anniversary of the October Revolution) (1922,

plate 24) were designed to be collapsible, economical, and lightweight yet durable.[11] Text slogans were integral to the propaganda-structure designs, some of which were reproduced as lithographs and featured as illustrations in books and journals of the day. "Down with art. Long live agitational propaganda!" read one study for a kiosk (fig. 2.6).

Klutsis described his artistic path as a "line that ascends from formalism, technicism, and autotelic forms, to an ideologically rich subject matter. . . . Before me stood the task of transforming the poster, the book, the illustration, the postcard, into carriers of party banners for the masses."[12] Indeed, he made art in all these formats and achieved considerable success in each one. From 1923 to 1927, he focused on designing books

22

Gustav Klutsis (Latvian, 1895–1938), *Project for an Agitational-Propaganda Stand [Proekt agitatsionnoi ustanovki]*, 1922; brush, pen, black ink and red gouache on paper with graphite underdrawing, 20.9 × 29.7 cm.

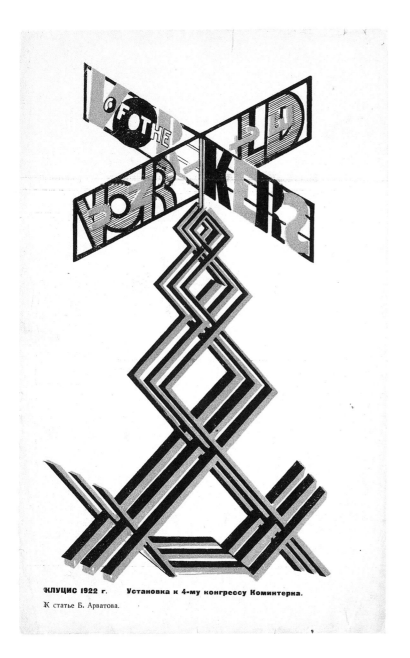

КЛУЦИС 1922 г. Установка к 4-му конгрессу Коминтерна.
К статье Б. Арватова.

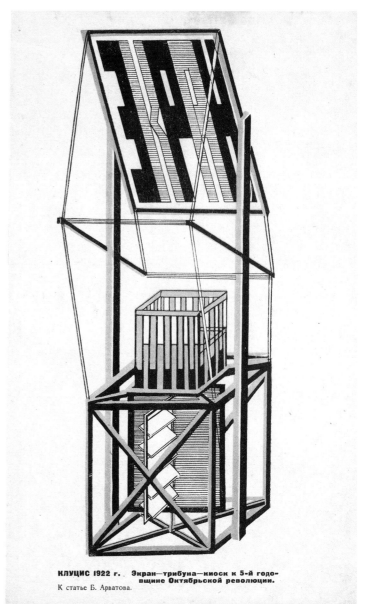

КЛУЦИС 1922 г. Экран—трибуна—киоск к 5-й годовщине Октябрьской революции.
К статье Б. Арватова.

and journals that, for the most part, served the aims of the Communist Party. They included periodicals such as *Proletarskoe studenchestvo* (Proletarian Student Body), *Vestnik truda* (Herald of Labor), and *Molodaia gvardiia* (Young Guard), and books such as *Vecher Frantsuzskoi revoliutsii v klubakh molodezha* (An Evening of the French Revolution in Youth Clubs) (1924), compiled by S. Iudin, and *Organizuem svoi dosug* (Let's Organize Our Free Time) (1927), by B. Galin.[13]

Klutsis's book and journal graphics exhibit many of the attention-grabbing design devices he used in his agitprop stands: hand-drawn block letters, boldly contrasting masses and color schemes (primarily red, black, and white), and a profusion of geometric forms, most notably arrows, arcs, and diagonal lines to add direction and vitality (fig. 2.7). Klutsis even incorporated the stands themselves as design objects, as in his cover for a collection of writings by proletarian authors titled *Pod znakom Komsomola* (Under the Sign of the Komsomol) (1924, plate 25).

His use of photomontage, also seen on the cover of *Under the Sign of the Komsomol*, became a central component in his book and journal designs. Lenin remains a dominant subject, celebrated in a 1924 series of "photo-slogan-montages" for a memorial-tribute issue of *Molodaia gvardiia* published immediately after the leader's death (fig. 2.8); in illustrations for an unpublished version of Vladimir Mayakovsky's 1924 poem "Vladimir Il'ich Lenin" (1925); and in illustrations for Il'ia Lin's book *Deti i Lenin* (Children and Lenin) (1924).[14] While Lenin remained the pivotal feature of Klutsis's montages, the Soviet people became essentially supporting players. The artist began using photographs of "the masses" as thematically, ideologically, and formally rich patterning elements in place of solid fields of color. Crowd scenes are augmented or fragmented to fill and conform to the contours of geometric shapes, such as the diagonal bars in Klutsis's design for the back cover of the tribute book *Pamiati pogibshikh vozhdei* (In Memory of Fallen Leaders) (1927, plate 26).

By early 1924, Klutsis was highly sought after as a book designer, as attested by his wife and frequent

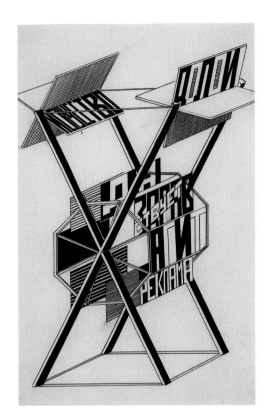

23

Gustav Klutsis (Latvian, 1895–1938), *Installation for the Fourth Comintern Congress* [*Ustanovka k 4-omu kongressu Kominterna*], 1922; letterpress, 25.9 × 16.3 cm.

24

Gustav Klutsis (Latvian, 1895–1938), *Screen-Tribune-Kiosk for the Fifth Anniversary of the Great October Revolution* [*Ekran-tribuna-kiosk k 5-i godovshchine Oktiabrskoi revoliutsii*], 1922; letterpress, 25.8 × 15.6 cm.

2.6

Gustav Klutsis (Latvian, 1895–1938), design for *Propaganda Kiosk, Down with art. Long live agitational propaganda* [*Proekt agitatsionnoi ustanovki. Doloi iskusstvo. Da zdravstvuet agit-reklama*], 1922; ink and gouache on paper, 26.9 × 17.5 cm. Greek State Museum of Contemporary Art — Costakis Collection, Thessaloniki.

2.7

Gustav Klutsis (Latvian, 1895–1938), cover for *Time* [*Vremia*], February 1924.

25

Gustav Klutsis (Latvian,
1895–1938), cover for
Young Guard, *Under the
Sign of the Komsomol*
[*Pod znakom Komso-
mola*], 1924; letterpress,
22.2 × 15 cm.

2.8

Gustav Klutsis (Latvian,
1895–1938), illustration
for *Young Guard: For
Lenin* [*Molodaia gvardiia.
Leninu*], *Downtrodden
Masses of the World:
Under the Banner of the
Comintern, Overthrow
Imperialism*, 1924; letter-
press, 26 × 17.3 cm.
The Museum of Modern
Art, New York.

26

Gustav Klutsis (Latvian,
1895–1938), back cover for
Feliks Kon, ed., *In Memory
of Fallen Leaders* [*Pamiati
pogibshikh vozhdei*], 1927;
lithograph, 34.8 × 26.8 cm.

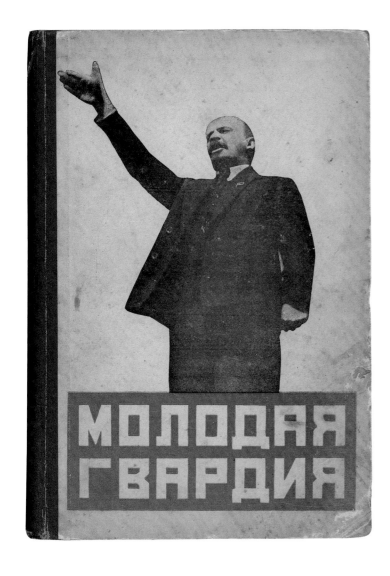

collaborator, Valentina Kulagina, who was an artist-designer in her own right (the couple had met at VKhUTEMAS in 1920 and married the following year):

At present we have work all the time even if Gustav has to work nonstop for days on end. The up side is that books with his covers are getting published one after another, his "glory" is growing, and the editors already send people over to our home to offer him commissions. This entire winter … we've had money and have been eating well … and I'm well-dressed too.[15]

The year before, in 1923, Klutsis and two fellow students had proposed establishing within VKhUTEMAS a "Workshop of the Revolution." With communist ideology as its central precept, the workshop would assess and respond aggressively to artistic needs of the new Soviet society as revealed by the revolution. In an essay titled "Masterskaia revoliutsii" (Workshop of the Revolution), published in the journal *LEF* in 1924 and collectively signed by Klutsis, Viktor Balagin, Sergei Senkin, and an otherwise unidentified author named Kazantsev, the writers criticize the lack of progress and change among established faculty members as well as the school's failure to modify its curriculum to produce artist-engineers. The organizers envisioned their workshop as "a mouthpiece for artistic-revolutionary and communist messages," whose purpose was to develop a cadre of young, socially committed artist-organizers to win over the working class to the side of the revolution through visual means. The essay further refers to "artist-agitators and propagandists, who are able to answer the practical demands of the revolution"; "artists, production workers, who set for themselves the goal of having vast social and cultural influence on the general public"; and "artists, armed to the teeth with all of the latest advances in science and technology."[16]

In addition, this essay suggests the scale and scope of the power, purpose, and responsibility that Klutsis believed artists had in shaping the new Soviet society. He and his fellow workshop organizers recognized an opportunity for artists to become involved in, influence, and systematize a wide range of everyday activities and life in general. This belief is apparent in

Printsipy NOT (Principles of NOT) (c. 1924–25), a diagram in which Klutsis proposed "spheres of the new Socialist society in which the artist can make useful contributions: 1) advertising; 2) daily life; 3) agitational propaganda; and 4) entertainment" (fig. 2.9).[17] NOT, an acronym for Nauchnaia organizatsiia truda (Scientific Organization of Labor), was a method for bringing people closer to industry and technology and, ultimately, convincing them to perceive of labor as the most important aspect of life. NOT was largely championed by the Liga Vremeni (League of Time), an organization devoted to improving productivity through an emphasis on behavioral psychology, the assembly-line methods practiced at Henry Ford's automobile plants, and the scientific-management theories of Frederick Winslow Taylor.

Vremia (Time), issued by the league in 1923 and 1924, was among the first periodicals to reproduce Klutsis's photomontage illustrations and cover designs. In addition to news and reports about the organization's activities and accomplishments, it featured articles about the reorganization of time in all spheres of daily life (cultural, social, recreational, and professional). Essays addressed the pursuit of efficiency in agriculture, art, advertising, industry, the military, and transportation as well as in personal hygiene and the reading of books and newspapers.

In their "Workshop of the Revolution" essay, Klutsis and his coauthors directed readers to the article "NOT i Iskusstvo" (NOT and Art) in the March 1924 issue of *Time* for an extended discussion about how artists utilize "the latest advances in science and technology."[18] Although the author ostensibly was someone named Johnson, it is likely that Klutsis and/or Senkin wrote it. Phrases and ideas that appear in "Workshop of the Revolution" are also found in "NOT and Art," published somewhat earlier. Additionally, the essay refers to, and highlights, works by Klutsis and Senkin. The illustration for the essay, printed inside the front cover of the issue, is by Senkin; Klutsis designed the front cover. The central thesis of the essay is that artists have a responsibility to be not only agitators but also organizers of everyday life in the new society.[19]

For Klutsis, photomontage was the ultimate instrument for organizing, affecting, and shaping consciousness, and he identified it as "the most aggressive and effective means of class struggle."[20] In the 1931 essay "Fotomontazh kak novyi vid agitatsionnogo iskusstva" (Photomontage as a New Kind of Agitational Art), he wrote that "photomontage appeared in the Soviet Union on the 'left' front of art once the vogue for non-figurative art had been overcome" and emerged in response to the inadequacy of "the old kinds of visual art (drawing, painting, engraving)" to meet the "mass agitation needs of the Revolution."

Klutsis identified two distinct trends in the development of photomontage: "advertising/formalist photomontage, which had its origins in American advertising and was promoted in the West by artists associated with Dada and Expressionism"; and "political agitation photomontage, which developed independently on Soviet soil and has its own methods, principles and laws of composition." It was the Soviet trend, he continued, that "has won a full right to be considered a new kind of mass art — the art of socialist construction."[21] In citing photomontage as the most effective form of agitational art, Klutsis pointed to its "realistic representation created with maximum perfection of technique, possessing graphic clarity and intensity of effect." Drawing upon advances in technology and chemistry, practitioners of photomontage could depict "a particular moment in a manner more truthful, more lifelike, more comprehensible to the masses" and "not just capture a visual fact, but fix it precisely."[22] He credited film, which combines multiple frames in an integrated whole, as the "only other art" to which photomontage can be compared.[23] Photomontage, he clarified, is not "solely an expressive composition of photographs. It always includes a political slogan, color, and purely graphic elements."[24]

For the Spartakiada (All-Union Olympiad) in Moscow in 1928, Klutsis was commissioned to design a series of nine postcards dedicated to various athletic events (plates 27 and 28). This format encouraged him to stray from his standard red, black, and white color scheme and employ an expanded palette. Klutsis

2.9

Gustav Klutsis (Latvian, 1895–1938), *Principles of NOT (Scientific Organization of Labor) [Printsipy NOT (Nauchnaia organizatsiia truda)]*, mid-1920s; ink, pencil and watercolor on paper; 50.3 × 59.8 cm. Greek State Museum of Contemporary Art — Costakis Collection, Thessaloniki.

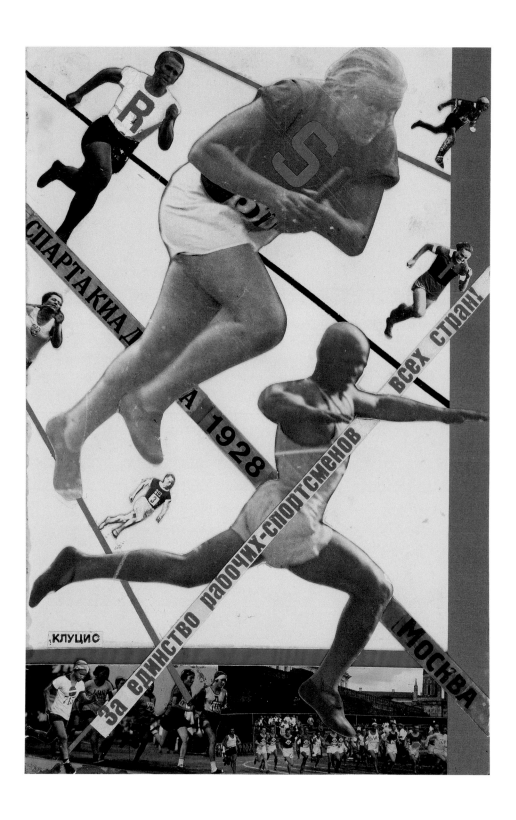

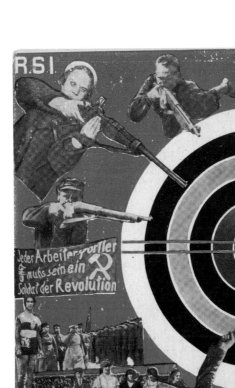

27

Gustav Klutsis (Latvian,
1895–1938), maquette for
postcard commemorating
the Russian *All-Union
Olympiad* [*Spartakiada*],
1928, lithographs
and gelatin silver prints,
20 × 13 cm.

28

Gustav Klutsis (Latvian,
1895–1938), four
postcards commemorating
the *All-Union Olympiad*
[*Spartakiada*]: A. discus;
B. rifle; C. racing;
D. javelin, 1928; letter-
press, 14.8 × 10.3 cm.

29

Gustav Klutsis (Latvian,
1895–1938), *From NEP
Russia Will Come Socialist
Russia [Iz Rossii nepovskoi
budet Rossiia sotsial-
isticheskaia]*, 1930; litho-
graph, 104.1 × 73.3 cm.

2.10

Gustav Klutsis (Latvian,
1895–1938), design
for billboard for the Fifth
Congress of Soviets,
*Storm: Strike on Counter-
revolution (The Latvian
Riflemen) [Shtorm: udar
po kontrrevoliutsii]*,
1918; charcoal, pencil,
cut-and-pasted photo-
graphs and paper
on paper, 40.8 × 51.5 cm.
The Latvian National
Museum of Art, Riga,
Latvia, gift of Valentina
Kulagina.

30

Gustav Klutsis (Latvian,
1895–1938), *In the Storm
of the Third Year of the
Five-Year Plan [Na shturm
3-go goda piatiletki]*,
1930; lithograph, 108.7 ×
73.3 cm.

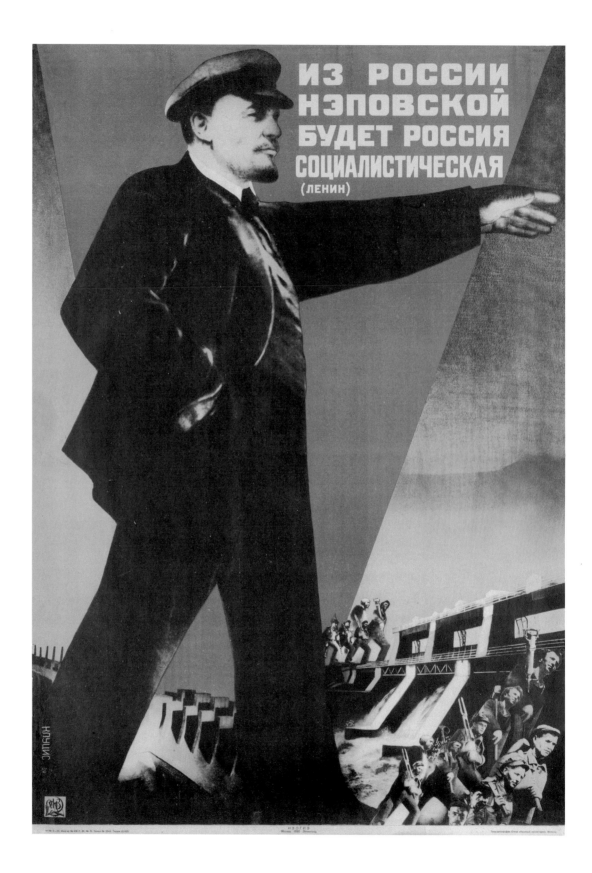

believed that Lenin warranted a place even in these compositions, as a manifestation of the physical agility and strength of both the Soviet people and the socialist way of life.[25]

By 1930, Klutsis was primarily designing posters instead of books and journals. In a diary entry for May 13, 1930, Kulagina noted, "Gustav, I think, is in the prime of artistic creativity right now."[26] Many of the central design elements in posters he produced between 1930 and 1932 had first been employed in his photomontage works of 1918 through 1921. The earlier works were never realized beyond their design state. By contrast, the bulk of his poster designs of the 1930s were printed, often in tens of thousands of copies.

Lenin figured prominently in several posters Klutsis designed in 1930 and 1931. In *Iz Rossii nepovskoi budet Rossiia sotsialisticheskaia* (From NEP Russia Will Come Socialist Russia) (1930, plate 29), which takes its title from a Lenin quotation, the dead leader towers above the world in the same way Klutsis depicted him in the 1920 study *Electrification of the Entire Country*. In *Electrification*, Lenin is the bearer of electricity, but in the 1930 poster it is the workers at his feet who bring electricity to the nation through projects such as the Dneprostroi hydroelectric power station.

Another earlier work and a later poster affirm Klutsis's abiding belief in the responsibility of art to inspire the revolution and class struggle. *Shtorm: udar po kontrrevoliutsii* (Storm: Strike on Counterrevolution) (1918, fig. 2.10), an unrealized design for a panel at the Fifth Congress of Soviets, was intended for display on the façade of the Bolshoi Theater in Moscow. Occasionally subtitled *The Latvian Rifles*, the composition was inspired by his own military experiences in the revolution.[27]

Twelve years later, with *Na shturm 3-go goda piatiletki* (In the Storm of the Third Year of the Five-Year Plan) (1930, plate 30), Klutsis seems to make a formal and ideological reference to the 1918 *Storm*. Steelworkers bear iron poles in the later work, along the same diagonal angle as soldiers bearing and firing their rifles in the earlier piece. Both works address the same struggle in

pursuit of the same ultimate victory: the triumph of communism over capitalism, tyranny, and autocracy and the realization of a vibrant, glorious Soviet nation.

The proletariat figured prominently in posters during the First Five-Year Plan (1928–32), with coal-miners and steelworkers portrayed as the chief heroes on whom the future of Soviet industry depended. Klutsis, who considered his own productivity and output to rival that of prodigious modern laborers, incorporated images of himself dressed as a worker or coalminer into several poster designs.[28] In doing so, he was characterizing himself as what the art historian Jeffrey Schnapp has called the idealized "man of the crowd," who "exemplifies and embodies the values of a revolution in progress."[29] In *Rabochie i rabotnitsy. Vse na perevybory sovetov* (Worker Men and Women: Everyone Vote in the Soviet Elections) (1930, plate 31), Klutsis once again presents at least a part of himself— his hand—as emblematic of the entire proletariat. Originally issued earlier that year with a different slogan as its title (*Vypolnim plan velikikh rabot* [Let's Fulfill the Plan of the Great Projects]), the poster summons to form a collective whole, a message that inspired sim-ilar representations by John Heartfield (see plate 14, p. 32) and other artists.[30]

On March 11, 1931, the Central Committee of the Communist Party issued a resolution, "O Plakatnoi literature" (On Poster Literature), which directed that all poster content, design, and production be centralized and supervised by Izogiz, the Art Division of the State Publishing House, which itself was supervised directly by the Central Committee. Additionally, the resolution stated that committees of peasants and workers would review all proposed posters for approval, on the grounds that the poster represented "a powerful tool in the reconstruction of the individual, his ideology, his way of life, his economic activity" and a means of "entering the consciousness and hearts of millions of people."[31] Prior to the resolution, poster approval had depended upon personal preference, favoritism, caprice, and a fear among publishing officials of violating tenets of a vague, unwritten code of acceptable styles and subjects.

Now, however, the process became even more frustrat-ing, unpredictable, and stifling to creative expression. Because of his commitment to the medium, Klutsis endured the frustrations of repeatedly redesigning his posters to suit the whims of diffident publishing officials. Unless a poster was ultimately accepted and printed, artists were not compensated for their efforts. Klutsis's wife described the situation in her diary: "Given the current state of the poster business, artists really begin to feel like doing things that will remain as they are made: painting, in this respect, lives up to expectations. I'm trying to persuade Gustav to take up painting. Why is he wasting his enormous talent?"[32]

While other artists had begun monument-alizing Lenin, Klutsis portrayed him in *Electrification* in a form so exaggerated that the poster "inaugurated a new era—not fully articulated until the 1930s—which celebrated the leader (*vozhd'*) as a Nietzschean Super-man."[33] As the sociologist Victoria Bonnell notes, the "key elements in the aesthetic of Leniniana" established in 1920 were "the superhuman qualities of the *vozhd'*, his simplicity and humaneness, the popular essence (*narodnost'*) of the *vozhd'*, and his power (*moshch'*)." These attributes were later transferred to Stalin, through whom they acquired unprecedented proportions."[34]

Klutsis's idolatrous treatment of Lenin and Stalin in his posters follows a classic pattern of casting leaders in the mold of Leviathan: "the man of the crowd, at once immanent and transcendent, at once an insider and an outsider, at once Everyman and the exceptional individual."[35] Klutsis presents first Lenin and then Stalin as "the glue that binds the body politic together, the face of the revolution, the nation's head, a transcendental being endowed with superior vision and communication skills that permit the leader to shape the multitude into his own image."[36]

Klutsis responded to Stalin's drive to portray himself as the supreme architect of Soviet revolution by gradually forcing Lenin to share the stage with Stalin or yield it altogether. In *Pod znamenem Lenina, za sotsialisticheskoe stroitel'stvo* (Building Socialism under the Banner of Lenin) (1930), his first poster to

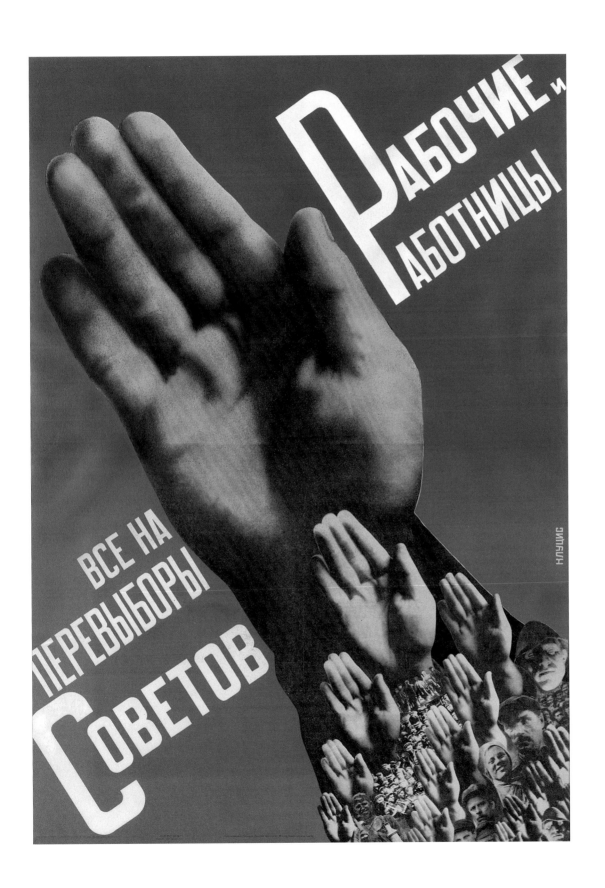

31

Gustav Klutsis (Latvian, 1895–1938), *Worker Men and Women: Everyone Vote in the Soviet Elections* [*Rabochie i rabotnitsy. Vse na perevybory sovetov*], 1930; lithograph, 120 × 85.7 cm.

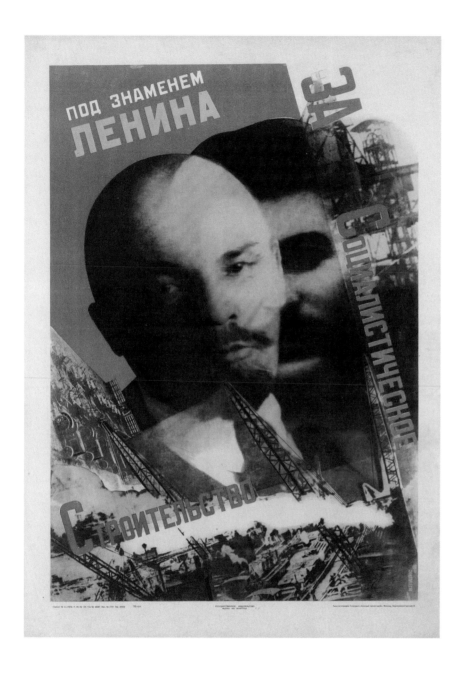

32

include Stalin, Lenin partially obstructs Stalin (plate 32).
By 1933, however, Stalin had displaced not only
Lenin from center stage in nearly all the artist's posters
and other works but also the social class Klutsis had
portrayed as sustaining Lenin's vision: the proletariat.

Stalin-centric posters by Klutsis were reprinted
multiple times within a few years, with print runs
approaching some two hundred thousand. As the design
historian David King notes, "In his photomontage
posters, Klutsis employed to the full his unique ability
to visualize in the most dynamic manner the headlong
rush towards industrialization and collectivization,
and no designer contributed more effectively to the
Stalin Cult."[37]

In addition to posters, Stalin figured promi-
nently in Klutsis's designs for the covers of commemo-
rative issues of *Pravda* and other mass-circulation
periodicals between 1933 and 1937 as well as in the
artist's "monumental photomontage" projects.[38]
Mounted in public squares to commemorate holidays
or great achievements, these massive billboards required
crews of up to two hundred workers to print and
assemble. Among them were portraits of Lenin and
Stalin that measured a full eighty-two feet tall, created
in 1932 to celebrate completion of the Dneprostroi
hydroelectric dam on the Dnieper River in Ukraine.[39]

Tragically and ironically, after years of dutiful
service, Klutsis was arrested and executed. He became
a victim of Stalin's purges not, as might be assumed,
for clinging to avant-garde tendencies or practices but
because of his Latvian heritage. On January 17, 1938,
as he was leaving for New York to assist with the design
of the Soviet Pavilion at the 1939 World's Fair, Klutsis
was detained on the pretense of belonging to a "a
counter-revolutionary, fascist, terrorist organization,"
the Latvian art and culture society Prometheus. He
was shot on February 26, along with sixty-three other
Latvian artists and intellectuals, several of whom,
including Veidemanis and Andersons, had served with
him in the Latvian Rifles.[40] In 1937 and 1938, an esti-
mated seventy thousand Latvians were murdered by
the NKVD as part of a campaign to eradicate non-

Russian ethnicities within Russia and so, the thinking went, reduce the risk of internal political destabilization and anti-Soviet sympathy.

Klutsis claimed to find motivation in the "great words" of the Russian version of "The Internationale," the French anthem of international revolutionary socialism that the Bolsheviks had adopted for the nascent Soviet state: "We will destroy this world of violence down to the foundations, and then we will build our new world. He who was nothing will become everything!"[41] With guns and gouache, Klutsis fought ardently to build that new world—and to inspire others to join in the effort. For nearly his entire career, he maintained his resolve to produce only purposeful art. He clung to the hope of realizing the new Soviet society Lenin had envisioned, regardless of which leader assumed Lenin's place. And he remained true to his conviction that a new society demands innovative and imaginative forms of creation and production.

Notes

1. Gustav Klutsis, "Pravo na eksperiment," ms., n.d., Gosudarstvennyi muzei Maiakovskogo, Moscow; quoted in Larisa Oginskaia, *Gustav Klutsis* (Moscow: Sovetskii khudozhnik, 1981), p. 148.

2. For an account of an interaction and conversation between Klutsis and Lenin, see Oginskaia, *Klutsis*, p. 9. A sketch of Lenin from this series is reproduced in Margarita Tupitsyn, *Gustav Klutsis and Valentina Kulagina: Photography and Montage after Constructivism* (New York: International Center of Photography/Gottingen: Steidl, 2004), p. 15, fig. 3.

3. Gustav Klutsis, "Curriculum vitae," Oct. 8, 1926, Rossiiskii Gosudarstvennyi Arkhiv Literatury i Iskusstva (RGALI), f. 681, op. 1, ed. khr. 1118, 1,3; reproduced in *Gustav Klucis: Retrospektive*, ed. Hubertus Gassner and Roland Nachtigaller (Stuttgart: Gerd Hatje for the Museum Fredericanum, Kassel, 1991), p. 298. See also Oginskaia, *Klutsis*, pp. 8, 164. Tupitsyn suggests that Klutsis felt a further bond to Lenin because the leader's own brother, Aleksandr Ulianov, had also been prosecuted for anti-tsarist activity (*Klutsis and Kulagina*, p. 61).

4. Gustav Klutsis, "Fotomontazh kak novyi vid agitatsionnogo iskusstva" (1931); reprinted as "Photomontage as a New Kind of Agitational Art" in Tupitsyn, *Klutsis and Kulagina*, pp. 237–40; citation on p. 238. Klutsis's claims of invention are not necessarily authoritative. Other artists who were actively producing photomontages in the Soviet Union in the early 1920s include El Lissitzky, Sergei Senkin, Aleksandr Rodchenko, and Petr Galadzhiev. One could agree, however, that his pre–1925 photographic and photomontage works were more overtly dedicated to political themes than those of all these artists except Senkin. Rodchenko's early photomontages and photo collages (1922–23), best represented by his images for Vladimir Mayakovsky's 1923 poem "Pro Eto" (About This), show "no interest in political or documentary subject matter" (Margarita Tupitsyn, *The Soviet Photograph, 1924–1937* [New Haven, Conn.: Yale University Press, 1996], p. 26). Although El Lissitzky created a number of monumental, historically significant Suprematist paintings with slogans that promote Bolshevik and Soviet power in the years following the October Revolution, he made no photographic propaganda before 1928 (ibid., p. 59).

5. Gustav Klutsis, inscription on second version of *Dynamic City*; quoted in Christina Lodder, *Russian Constructivism* (New Haven, Conn.: Yale University Press, 1983), p. 187.

6. Ibid., p. 190.

7. Gustav Klutsis, "Gustav Gustavovich Klutsis" (1937), quoted in Oginskaia, *Klutsis*, p. 11.

8. Klutsis, "Curriculum vitae," quoted in Gassner and Nachtigaller, *Klucis: Retrospektive*, p. 300.

9. Klutsis, "Gustav Gustavovich Klutsis," quoted in Oginskaia, *Klutsis*, p. 14.

10. Various artists associated with the Russian avant-garde such as Aleksandra Exter, Kazimir Malevich, and Olga Rozanova, were involved in textile design and other applied arts even before the Bolshevik Revolution. See Charlotte Douglas, "Suprematist Embroidered Ornament," *Art Journal* 54, no. 1 (Spring 1995), pp. 42–45.

11. Only one of Klutsis's designs, *Internatsional* (The International), was realized and built to scale (nearly twenty feet tall) for the occasion; it was installed in the hotel where the Comintern congress delegates were staying. Wood and paper models of the others were exhibited in the Kremlin during the assemblies. See Oginskaia, *Klutsis*, p. 26, and Angelica Rudenstine, ed., *Russian Avant-Garde Art: The George Costakis Collection* (New York: Harry N. Abrams, 1981), pp. 212–15.

12. Klutsis, "Gustav Gustavovich Klutsis," in Iveta Derkusova, "Tvorchestvo Gustava Klutsisa: sokrovishcha kollektsii Natsional'nogo khudozhestvennogo muzeia Latvii," *Biulleten' Muzeia Marka Shagala: vypusk 16–17* (Vitebsk: Muzei Marka Shagala, 2009); accessed Sept. 1, 2010, via Muzei Marka Shagala Web site: *http://www.chagal-vitebsk.com/node/238*

13. An extensive list of publications he designed is in Oginskaia, *Klutsis*, pp. 178–82.

14. On these works, see Tupitsyn, *The Soviet Photograph*, pp. 11–23, and idem, *Klutsis and Kulagina*.

15. Valentina Kulagina, diary entry, Feb. 12, 1924, trans. in Tupitsyn, *Klutsis and Kulagina*, 175.

16. Viktor Balagin, Kazantsev, Sergei Senkin, and Gustav Klutsis, "Masterskaia revoliutsii," *LEF* 1, no. 5 (1924), p. 155.

17. A full translation of the text in the design is in Rudenstine, *Russian Avant-Garde Art,* p. 431.

18. Balagin et al., "Masterskaia revoliutsii," p. 155.

19. Johnson, "NOT i Iskusstvo," *Vremia,* no. 6 (March 1924), pp. 33–34.

20. Klutsis, "Photomontage as a New Kind of Agitational Art," in Tupitsyn, *Klutsis and Kulagina,* p. 240.

21. Ibid., p. 237. Klutsis's dismissal of German photomontage, specifically the work of John Heartfield, as derivative of Soviet montage, is tainted by rivalrous sentiment. The rivalry seems strongest, however, with Rodchenko and Lissitzky and their "Western" advertising-influenced montages. For more on the Klutsis-Heartfield relationship, see Maria Gough, "Back in the USSR: John Heartfield, Gustavs Klucis, and the Medium of Soviet Propaganda," *New German Critique* 107, 36, no. 2 (Summer 2009), pp. 133–83; and Hubertus Gassner, "John Heartfield's Moscow Apprenticeship," in *John Heartfield,* ed. Peter Pachnicke and Klaus Honnef (New York: Harry N. Abrams, 1992), pp. 256–89.

22. Klutsis, "Photomontage as a New Kind of Agitational Art," in Tupitsyn, *Klutsis and Kulagina,* p. 237.

23. Ibid., 238. For more on the relationship between film and Klutsis's photomontage work, see Tupitsyn, *The Soviet Photograph,* pp. 14ff.; and idem, *Klutsis and Kulagina,* pp. 37–40.

24. Klutsis, "Photomontage as a New Kind of Agitational Art," in Tupitsyn, *Klutsis and Kulagina,* 238.

25. Oginskaia, *Klutsis,* p. 84; quoted in Tupitsyn, *The Soviet Photograph,* p. 49.

26. Valentina Kulagina, diary entry, May 13, 1930, trans. in Tupitsyn, *Klutsis and Kulagina,* p. 197.

27. Given that Klutsis dated this work 1918 and that the date is generally accepted, it remains a mystery why he claimed that the second version of *Dynamic City* (1919) was the first manifestation of photomontage in Soviet art.

28. For examples of such self-insertion, see Tupitsyn, *Klutsis and Kulagina,* plates 40, 58, 85–87. Klutsis first incorporated his own image into a 1924 illustration for an unpublished history of the VKP(b) (All-Union Communist Party [Bolshevik]) by Grigorii Zinoviev. Klutsis presents himself there as a "worker blinded by the deception of the clergy" in a photomontage set within the form of the number 1 from "1905" (date of Russia's first communist uprising), thereby "symbolically lock-[ing] himself inside the very origin of Bolshevik history" (Tupitsyn, *Klutsis and Kulagina,* p. 31). Klutsis further "documented" his workers-peasant lineage by photographing Kulagina and her family (brother Boris, and mother Maria Efimovna), and presenting them as workers and peasants in book and poster designs of the mid-1920s.

29. Jeffrey T. Schnapp, *Revolutionary Tides: The Art of the Political Poster, 1914–1989* (Milan: Skira, 2005), p. 110.

30. See Benjamin H. D. Buchloh, "From Faktura to Factography," *October* 30 (Autumn 1984), p. 110; Schnapp, *Revolutionary Tides;* and Jeffrey T. Schnapp and Matthew Tiews, eds., *Crowds* (Stanford, Calif.: Stanford University Press, 2006).

31. Statement in *Brigada khudozhnikov* (1931), trans. in Victoria Bonnell, *Iconography of Power: Soviet Political Posters under Lenin and Stalin* (Berkeley: University of California Press, 1997), p. 37.

32. Valentina Kulagina, diary entry, Feb. 24, 1932, trans. in Tupitsyn, *Klutsis and Kulagina,* p. 201.

33. Margarita Tupitsyn, "Superman Imagery," in *Nietzsche and Soviet Culture: Ally and Adversary,* ed. Bernice Glatzer Rosenthal (New York: Cambridge University Press, 1994); quoted in Bonnell, *Iconography of Power,* p. 145.

34. Bonnell, *Iconography of Power,* 142.

35. Jeffrey T. Schnapp, "Mob Porn," in Schnapp and Tiews, *Crowds,* p. 4.

36. Schnapp, *Revolutionary Tides,* p. 102.

37. David King, *Red Star over Russia* (London: Tate Publishing, 2009), p. 283.

38. Klutsis's earliest design for *Pravda* was a photomontage illustration of the Politbiuro that appeared on the front page of the newspaper's July 30, 1930, issue. For specific Pravda dates and issue information, as well as other newspapers and periodicals he designed in the 1930s, see Oginskaia, *Klutsis,* pp. 181–82.

39. See Gustav Klutsis, "Mirovoe dostizhenie" (1932); reprinted as "A Worldwide Achievement" in Tupitsyn, *Klutsis and Kulagina,* pp. 241–43.

40. Until 1989, it was officially reported that Klutsis died of heart failure on March 16, 1944 (Tupitsyn, *Klutsis and Kulagina,* p. 234, n. 233). Andersons was arrested in December 1937 and executed on February 3, 1938. Veidemanis was arrested and executed on the same days as Klutsis. See Lidiia Golovkova, "Khudozhnik i Butovskii polygon" (May 2, 2006); accessed Sept. 14, 2010, via Khram Novomuchenikov i Ispavednikov Rossiiskikh v Butove Web site: http://www.martyr.ru/content/view/11/18/; also L. Golovkova, ed., *Butovskii Poligon, 1937–1938: kniga Pamiati zhertv politicheskikh repressij,* 8 vols. (Moscow: Alzo, 1997–2004).

41. Klutsis, "Pravo na eksperiment," quoted in Oginskaia, *Klutsis,* p. 148.

El Lissitzky

ARCHITECTURES OF EVERYDAY LIFE

MARIA GOUGH

Before familiarity can turn into awareness the familiar must be stripped of its inconspicuousness; we must give up assuming that the object in question needs no explanation. —BERTOLT BRECHT, 1940

A few days after having had a lung removed in early March 1924, the Russian artist El Lissitzky sent a postcard to his friend the Dutch architect J. J. P. Oud in Rotterdam (fig. 3.1). On its front a biplane flies at thirteen hundred feet above Locarno, the Italian-speaking Swiss town on Lake Maggiore, at the foot of the Alps, where the artist was hospitalized at the time. The biplane's wings and tail bear the insignia of the Swiss air force — a Suprematist cross, as it were — hovering, circling, and swooping in an antigravitational, unobstructed, and seemingly infinite expanse of air. It was in this Alpine region that Lissitzky — the great painter of *prouns* (plate 33) — would spend the next year or so both treating the pulmonary disease that would continue to plague him for the rest of his life and also pushing his work in multiple directions, including architecture, photography, graphic design, advertising, and the study of the history of mathematics. "Tomorrow I am checking out of the hospital," Lissitzky wrote Oud on the back of the card, "rid of one lung but the other is still there and I hope still 'to breathe' and maybe also to fly."[1]

What is striking about this little communiqué from the realm of everyday life is that, notwithstanding its sender's now compromised capacity to move air in and out of his own body, his first thought post-pneumonectomy runs to the transcendence of all such corporeal and quotidian limitation, sweeping together in a single phrase his dual yearning: on the one hand, his hope still to breathe — that most ordinary physiological process — and, on the other, his hope to fly — perhaps the most exceptional phenomenological experience of his historical moment, and certainly one of the mainstays of the pan-European avant-garde's reach for the future.[2] In a concise if unexpected way, then, the postcard seems to encapsulate

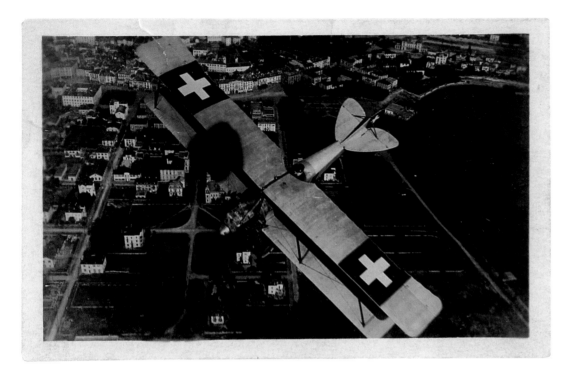

3.1

Postcard from El Lissitzky
(Russian, 1890–1941)
to J. J. P. Oud (recto
and verso), March 13,
1924; gelatin silver print
on cardstock. Van
Abbemuseum, Eindhoven.

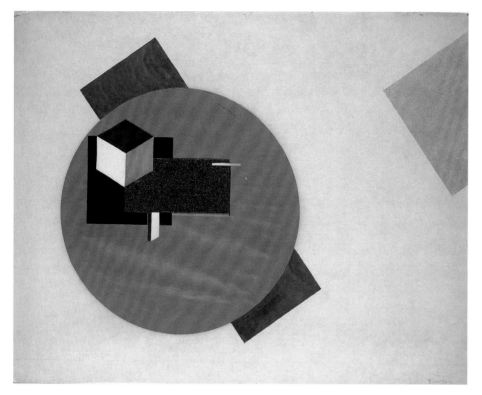

Lissitzky's perpetually utopian position with respect to the role of avant-garde art in everyday life. For this Russian artist, as for so many European avant-garde artists of the 1910s and 1920s, the function of art was to transcend the limitations of everyday life in order to bring about the latter's revolutionary transformation. For them, the concept of "everyday life" was primarily understood in oppositional terms, as that which "advanced art"—defined as formal and technological innovation—was not. Stripped of its own pleni-tude—its location in the space between the subjective, phenomenological, and sensory apparatus of the indi-vidual, on the one hand, and reified institutions, on the other—everyday life was often relegated to the status of utopia's Other.[3]

The historical intertwining of the avant-garde and the everyday becomes an ever more complex matter, however, when discussion moves to the plane of the specific object, whether work of art or material artifact more broadly construed, as Christina Kiaer's original and compelling analysis of the Productivist turn within

Russian Constructivism has brilliantly demonstrated.[4] It is an especially complex matter in the case of Lissitzky, who was antagonistic to this development among his Russian compatriots. ("Primitive utilitarianism is alien to us," he and Il'ia Erenburg wrote dismissively—and rather unfairly—in the inaugural editorial for their trilingual Berlin journal, *Veshch'/Gegenstand/Objet* [Object] [1922]) (plate 34).[5] By examining a range of the artist's work of the 1920s—from a vast glass-and-steel skyscraper project to the hand-held book, and from a venture into commercial advertising to a pro-posal for Communist propaganda—I hope to show that however much the utopian Lissitzky sought to transform everyday life, he most often did so in dialogue with it rather than in opposition to it. Sometimes this meant simply his acknowledging certain exigencies of site, or, say, appropriating the graphic languages of the commercial world. At other times, however, it had to do with his drive to create the very architectures of everyday life, the latter defined not so much in terms of the domestic or private sphere—the focus of much excellent recent discussion—as in terms of our con-temporary systems of communication and mobility.[6] "We are approaching the state of floating in air and swinging like a pendulum," he wrote in an autobio-graphical note in 1926. "I want to help discover and mold the form of this reality."[7]

Lissitzky (born Lazar Markovich Lissitzky in Pochinok, near Smolensk, in 1890) studied architectural engineering at the Technische Hochschule in Darmstadt before World War I. He turned to book design in Moscow in 1916, a field in which he practiced until his premature death from tuberculosis in 1941. While participating in the Jewish Renaissance in Russia and Ukraine as a book illustrator, he also became a painter, initially under the electrifying influence of the Supre-matist Kazimir Malevich at the Vitebskoe narodnoe khudozhestvennoe uchilishche (Vitebsk People's School of Art) in 1919. Over the next five years or so, he pro-duced an extraordinary corpus of abstract paintings to which he gave the name *proun* (an acronym for *proekt utverzhdeniia novogo* [project for the affirmation of the

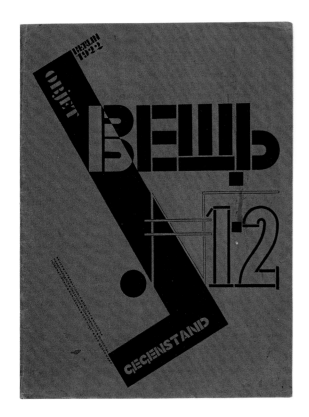

new], pronounced "pro-oon"). Yet any attempt to define the ways in which his work modeled the relationship between art and life must take into account the fact that, with some major exceptions—such as the *prouns,* his children's story *Pro 2* ■ (Pro dva kvadrata or Of Two Squares) (1920; published in 1922), and his speculative *Wolkenbügel* project (1923–25), Lissitzky functioned from the outset primarily as a designer responding to a brief devised by a client, whether that client was an author, publisher, curator, museum director, theater director, company head, or state entity (plates 36–41). In a dialectical spirit, however, he seems to have found the constraint inherent in the designer-client relationship to be liberating. When preparing his design for a "demonstration space" at the Internationale Kunstausstellung in Dresden in 1926, for example, he urged his companion Sophie Küppers to obtain from the co-curator Heinrich Tessenow "precise information" about the space available to him: "I should like to know…as soon as possible, so that I can think out the general concept. I am besieged by various ideas, and the space allotted is bound to impose certain limitations, *within which I can allow my imagination to have full play.*"[8]

The project to which Lissitzky referred in closing his note to Oud ("I hope that I will still have the strength to complete a design on which I have been working already a long time") was probably the *Wolkenbügel,* the major proposal of his Swiss convalescence (plate 35). A neologism that plays on a German word for "skyscraper" (*Wolkenkratzer,* literally, "cloud scraper"), Lissitzky's quirky title translates literally as "cloud hanger" or "skyhook." Comprising a multistory, asymmetrical, steel-and-glass cantilevering structure, the *Wolkenbügel* is elevated a hundred feet or so above ground by means of three giant pylons containing elevators and paternosters.[9] Various perspective and elevation drawings rotate the viewer through 360 degrees around this freestanding structure; no "façade"—if one may still use that term—is the same as another.[10] The *Wolkenbügel* literalizes Lissitzky's utopian desire to leave the ground, and thus to liberate architecture from the Earth's gravitational pull, yet it does so in order to engage with a concrete problem of everyday life in the urban environment.

As an elevated structure, the *Wolkenbügel* belongs to a sprawling branch of visionary art and architecture in the 1920s that, inspired by the advent of the aeronautical age and its relativization of the significance of gravity, proposed the creation of free-floating buildings and flying cities. More specifically, however, the *Wolkenbügel* may be identified as a response to an appeal that Lissitzky had launched in "Wheel-Propeller and What Will Follow," an article he wrote for the September 1923 issue of the journal *G: Material zur elementaren Gestaltung.* There he asserts that systems of human mobility have played a determinative role in shaping the history of architectural form. To support this claim, he sets forth a taxonomy of three states. The first is that of *walking,* wherein movement is "discontinuous" (the foot rises and falls); its corresponding architectural form is the Egyptian pyramid; for that type of structure to reach a height of nearly five hundred feet, a "mountain of stones was piled above a colossal foundation." The second state, Lissitzky continues, develops after the invention of the wheel,

which supplants discontinuous walking with *continuous rolling* (the wheel touches the ground at a "single point"); new "construction systems" are invented, obviating the need for great masses of material, hence the advent of the "Pantheon, aqueducts, great halls, skyscrapers, and the Eiffel Tower." With the gradual increase of wheel speed, however, a new form arises — that of "mobile architecture" (the salon car, sleeping car, dining car, ocean steamer); the form that corresponds to "the human being who travels" is that of the train, "a collective dwelling on wheels."

The third state emerges with the invention of the propeller, by means of which continuous rolling is transformed into *continuous gliding*: "A new energy has to be liberated," Lissitzky asserts, "that will give us a new system of movement (e.g., a movement that is

not based on friction, that provides an opportunity to hover in space without moving)."[11] An architectural form that corresponds to the state of continuous gliding, he suggests, is the 820-foot-tall antenna tower at the *Grossfunkstelle Nauen* (Nauen Transmission Station) in Nauen, Germany, the first complex of such radio towers ever built (fig. 3.2).[12] What fascinates Lissitzky is that the structure "stands on a single point" and is, as such, an inversion—he calls it an "overcoming"—of the gravity-bound mass of the Egyptian pyramid. Fueled by the para-architectural typology of the radio-transmission tower, the *Wolkenbügel*—elevated on pylons ("points," as it were)—may be understood as a proposal for an architectural form that would correspond to the new aeronautical state of motionless floating.

In significant ways, however, Lissitzky's drawings for the *Wolkenbügel* temper the futurist extremes of his utopian vision, suggesting a structure that is also massive and earthbound. When the artist presented the project in Moscow in 1926, he rationalized its elevation as a solution to an urban-planning problem, namely, the need to accommodate more office workers in an already overcrowded "medieval" city.[13] Rather than call for outright razing—a utopian approach if there ever was one—he offered a new typology for the modern office building, wedding his desire to leave the ground with the obdurate horizontality of Ludwig Mies van der Rohe's proposed *Bürohaus aus Beton* (Concrete Office Building) for Berlin (1923).[14] Lissitzky could thus distinguish his proposed solution to congestion from that of the American skyscraper (which, unlike the Nauen tower, rests upon a massive foundation). "So long as a means of utterly free floating has not been invented," he insisted, "we will move...in a horizontal rather than vertical fashion."[15]

By means of photomontage, Lissitzky inserts the *Wolkenbügel* into the urban fabric of Moscow (fig. 3.3). The proposed location is Nikitskaia square, the point where Bolshaia Nikitsakaia street, Nikitskii boulevard, and Tverskoi boulevard all intersect. Streetcars stop adjacent to two pylons; a third pylon descends deep

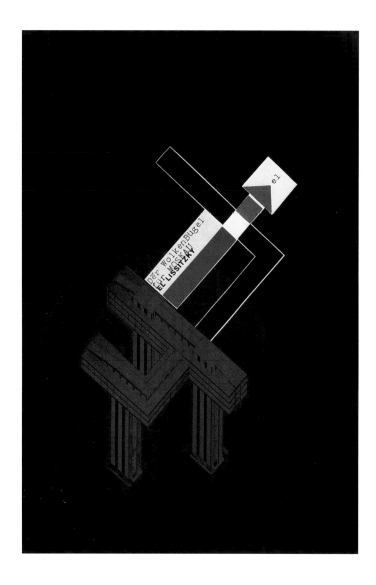

underground, its unseen foot becoming the platform of an as-yet-unbuilt subway station. Workers were to alight from their streetcars or subway cars and ascend directly to their offices: "Everything delivered to the building by horizontal traffic is subsequently transported vertically by elevator and then redistributed in a horizontal direction."[16] Lissitzky ultimately proposed a series of eight *Wolkenbügels* around the city, each punctuating the Boulevard Ring — the inner of the two roads that form a semicircle around the Kremlin — at one of the densely trafficked points where the ring is bisected by a radial road running into and out from the center.

J. Christoph Bürkle has traced a relationship between the *Wolkenbügel* and the artist's *prouns* of 1923 and 1924.[17] Significantly related to both bodies of work is a contemporaneous graphic design for his own letterhead, comprising a red arrow intersected by a black reversed "L," the punch line of which is the play of "negative" and "positive" squares at the point where they intersect. Lissitzky used this letterhead for all correspondence, both professional and personal, from about December 1924 onward. He even incorporated its insignia as a collage element in a *Wolkenbügel*-related *proun* (fig. 3.4) that offers an aerial, axonometric view of the building. Now abutting his utopian project for urban transformation, the letterhead functions almost as a kind of signature to it. Delivered in the commonplace form of stationery, this signature may be understood, in turn, as a graphic personification of the artist himself. In other words, post–pneumonectomy Lissitzky had not only been able to breathe but also had even managed — at least this once — to fly.

II

If the *Wolkenbügel* was an attempt to find the architectural form of the aeronautical age, Lissitzky's designs for Malevich's *O novykh systemakh v iskusstve: Statika i skorost'* (On the New Systems in Art: Statics and Speed) (1919) and Vladimir Mayakovsky's *Dlia golosa* (For the Voice) (1923) were attempts to redefine the architecture of the book (plates 36 and 37). "In this present day and age," he observed, "we still have no new shape for the

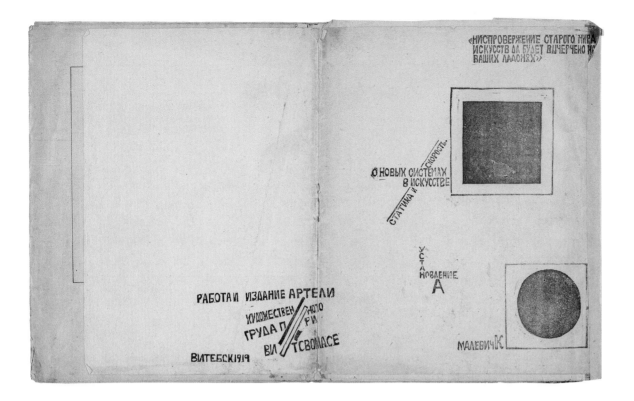

3.4

El Lissitzky (Russian, 1890–1941), *Wolkenbügel*, 1924–25; photocollage with paper, ink, and printed matter. State Tret'iakov Gallery, Moscow.

36

El Lissitzky (Russian, 1890–1941), cover for Kazimir Malevich, *On the New Systems in Art: Statics and Speed [O novykh systemakh v iskusstve: Statika i skorost']*, 1919; lithograph, 23 × 19.1 cm.

book as a body; it continues to be a cover with a jacket, and a spine, and pages 1, 2, 3."[18] Lissitzky's interest in the book was driven by his acute awareness of how its traditional structure seemed at odds with the pulse and direction of contemporary life. In a 1926 essay for the Mainz-based journal *Gutenberg Jahrbuch* on the state of the Soviet book, he addressed the matter directly:

What . . . characterizes the present time is dematerialization. An example: correspondence grows, the number of letters increase, the amount of paper written on and material used up swells, then the telephone call relieves the strain. Then comes further growth of the communications network and increase in the volume of communications; then radio eases the burden. The amount of material used is decreasing, we are dematerializing, cumbersome masses of material are being supplanted by released energies. That is the sign of our time.

Despite this trend toward dematerialization, Lissitzky pointed out that the book "had not yet been supplanted by sound recordings or talking pictures" and therefore was still "waiting" for its reinvention as a print object precisely because of its extraordinary potential for mass communication: "[T]he book-glacier is growing year by year. The book is becoming the most monumental work of art: no longer is it caressed only by the delicate hands of a few bibliophiles; on the contrary,

it is already being grasped by hundreds and thousands of poor people."[19]

Written in Moscow, the *Gutenberg Jahrbuch* essay offers a foretaste of what would become Lissitzky's dominant ambition during his Soviet years. But it is also worth noting that he had written in a similar vein seven years earlier in Vitebsk:

The book has become the monument of the present. But in contrast to old monumental art, it itself goes to the people and does not stand like a cathedral in one place, waiting for someone to approach. The book now expects the contemporary artist to use it so as to make this monument of the future. The artist must assume this task. But he will now be forced to set aside his old instruments, his quill pens, brushes, and little palettes and take up chisel, burin, the lead army of the typecase, the rotary press. All this will then obediently begin to turn in his hands and will give birth to a work not in one copy — not a unique object for the enjoyment of the patron — but in thousands and thousands of identical originals for all.[20]

The reconstruction of the book was among the urgent tasks of the architecture and print workshops at the Vitebsk People's School of Art; Marc Chagall, the school's director, had appointed Lissitzky to head them both in 1918, on the basis of his architectural training and recent experience in book illustration. At Lissitzky's

urging, Chagall invited Malevich to teach at Vitebsk starting in the fall of 1919. The Suprematist had a radicalizing effect on some faculty members and on many students, one result of which was the formation of the Utverditeli novogo iskusstva (or UNOVIS; Society for the Affirmation of the New), a collective devoted to the spread of world revolution through art.

The first book Lissitzky designed and produced in the school's print workshop was Malevich's *On the New Systems in Art* (plate 36).[21] A miscellany of the painter's latest writings and, as such, something of a call to arms, the book — more a booklet or brochure, really — was lithographically printed on inexpensive paper in an edition of 1,000 copies.[22] A rudimentary concertina foldout pasted into the book contains schematic renderings of one alogical painting and three Cubo-Futurist works that predate the artist's Suprematist break of 1915. The book's overall scrappiness was unavoidable given the chronic inadequacy of resources at the school that typically forced the workshop, Lissitzky later wrote, to employ such "primitive mechanical means" as the "typewriter, lithography, etching and linocuts" (176/362). But that scrappiness also was a deliberate throwback to Russian Futurist books of the prewar period, with their raggedy campaign against the luxury *livres de peintres* of Symbolism and Art Nouveau.

That campaign was very much alive in Lissitzky's quest to visualize and spatialize the typography of *On the New Systems in Art.* In a September 1919 letter to Malevich, likely written while he was designing the book, Lissitzky argues that letters and punctuation should be made palpable — the reader should be conscious not just of the thoughts transmitted by them but also of the technology of transmission itself — of the "illustrative nature of the text as such."[23] To foreground the way in which the book "finds its channel to the brain through the eye, not through the ear" (176/362), Lissitzky introduced new graphic devices, such as the setting of *On the New Systems in Art* in three different hand-drawn "faces": Malevich's own hand, very narrowly leaded block letters, and something like a semi-uncial. Later, in his *Gutenberg Jahrbuch* essay, he would acknowledge the pioneering role of F. T.

Marinetti in encouraging the proliferation of multiple typefaces within a single work, citing at length a 1919 redaction of the Italian Futurist's famous call for "typographic revolution," for a "new conception of the pictorial typographic page" (174).[24]

Using linocut, Lissitzky scattered words in a variety of hand-drawn faces, point sizes, and orientations, as well as iconic Suprematist images, across the front and back covers. At the bottom left, for example, three rectangles jostle their way into the bibliographic information ("Work and edition of the artel of artistic labor under the auspices of Vitsvomas Vitebsk 1919"), impeding its legibility. The sheet has been folded not quite in half, making this information wrap around the book's stapled spine. At the upper right of the front cover is the phrase "Let the overthrow of the old world of art be traced on your palms." Functioning here like an epigraph, this phrase would soon become the motto of UNOVIS, appearing on many of its publications, including Lissitzky's own. Adjacent to the hand-drawn black square on the front is the book's main title (which is also that of its main text), its two halves visually intersecting each other. Below that, in a vertical and horizontal formation, appears "Ustanovlenie A" ("Statute A"), the title of a set of instructions and precepts included in the book. Playfully punning on the latter title, Lissitzky arranged the author's name, which appears next to the black circle at bottom right, to read "Malevich K." As Aleksandra Shatskikh notes, by including not only the author's name and the book's title on the cover but also its table of contents and epigraph, Lissitzky disrupts the traditional differentiation of the parts of a book.[25]

If the visualization of typography and the disruption of conventional form were two of Lissitzky's goals for the contemporary book, a third was interactivity. This was exemplified in his design of a collection of poems by Mayakovsky, *For the Voice* (1923) (plate 37), which was published by the Berlin branch of the Russian State Publishing House. Lissitzky's task was to design the volume so as to facilitate the speedy finding of a given poem. This would not only aid the poet when declaiming his own verse at live performances but would also, as the title declared, encourage

El Lissitzky (Russian, 1890–1941), cover and inside page of Vladimir Mayakovsky, *For the Voice* [*Dlia golosa*], 1923; letterpress, 19 × 13.3 cm.

a similar use by others. To that end, Lissitzky eschewed
a table of contents in favor of a thumb index of the
kind found in an everyday address book. Each of the
volume's thirteen poems thus has its own flip tab.
"The book form itself is given a functional shape in
keeping with its specific purpose," Lissitzky wrote, refer-
ring to this assignment. (He was insistent about such
functionalism, later taking a swipe at his friend the
Dutch graphic designer and photographer Piet Zwart
for having redeployed Lissitzky's setting of Mayakovsky's
poem "Svolochi" ["Scum"] in an entirely unrelated
context—a prospectus for the Netherlands Cable
Factory [fig. 3.5].)[26] Measuring just over six by seven
inches, *For the Voice* was small enough to fit in a pocket,
suitable for whipping out at an impromptu poetry
reading—anytime, anywhere. With this new format,
Lissitzky broached the possibility of graphic commu-
nication in the "two-way" sense that Bertolt Brecht
would soon proselytize for the radio, and that the poet
and essayist Hans Magnus Enzensberger would in
the 1960s call "feedback."[27]

Lissitzky's fourth and final aim for contem-
porary book design involved appropriating the forms
and techniques of straightforwardly utilitarian and
commercial genres of printed matter. In his important
statement "Typographical Facts, For Example" (1925),
he proposed that book designers draw upon such non-
or para-literary genres as election propaganda, business
prospectuses, daily newspapers, advertising brochures,
advertisement pillars, and poster walls—just as he
had borrowed from the utilitarian address book for the
Mayakovsky design.[28] (The German typographer and
book designer Jan Tschichold later commented that
Lissitzky had a "tendency to turn a book into a piece
of technical apparatus.")[29] The call to utilize the trap-
pings of commercial print media—one also sounded
by many others such as, most famously, Marinetti—
exemplifies what the Russian Formalist Iurii Tynianov
brilliantly theorized in 1924, in another context, as the
seemingly infinite capacity of literature to reach fur-
ther and further into everyday life—into its backyards
and low haunts—for new forms to make literary.[30]

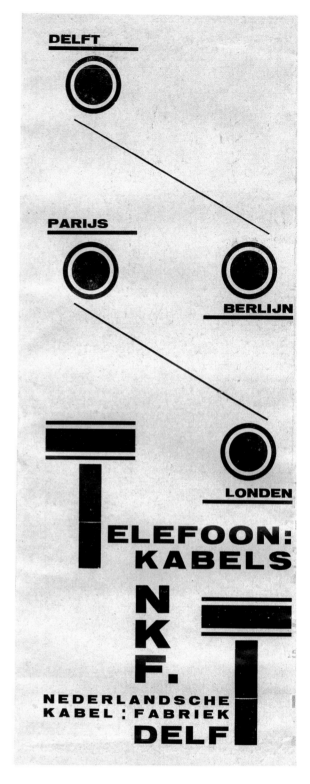

|||

Lissitzky's interest in the commercial world did not end with its potential application to book design. Among his endeavors in Switzerland during the early 1920s was advertising work for Pelikan, a Hanover–based office-supply company that had been founded in the 1870s. This was his first experience with consumer-goods marketing; Kurt Schwitters, who also worked for Pelikan, is said to have introduced him to the firm's Swiss representatives. Earning a monthly retainer of about three hundred marks, Lissitzky made several dozen proposals for promoting the company's ink, carbon paper, typewriter ribbons, and sealing wax in a range of media—photograms, relief sculpture, and graphic, typographic, and package design. Included in this book, for example, are two variations on the half-tone printed wrapper Lissitzky designed for the packaging of Pelikan sealing wax (plate 38). One of these wrapppers—still affixed to what is presumably the original box—is for the packaging of ten bars of bank wax (*Banklack*) in red,

for the sealing of high-security documents; the other is for ten bars of parcel wax (*Postlack*), also in red, for the sealing of coarse paper and cardboard. A blue rectangular plane, bearing the word *Siegellack* ("sealing wax") in yellow upper-case letters, takes up its position at the top left of the white field. At bottom right this color relation is simply reversed in the yellow rectangular plane that hosts the company name—rendered in the signature typeface used by Pelikan in those years. Across the breadth of the box runs a thick red line, in the middle of which appears Pelikan's trademark in the form of a seal. It is difficult not to view the wrapper's planimetric composition in the three primary colors on a white field as a repurposing for everyday commerce of modernist abstraction, that of Piet Mondrian in particular, whose work Küppers was handling in the mid-1920s in her capacity as a dealer in modern art, and whose name arises often in Lissitzky's correspondence around this time.

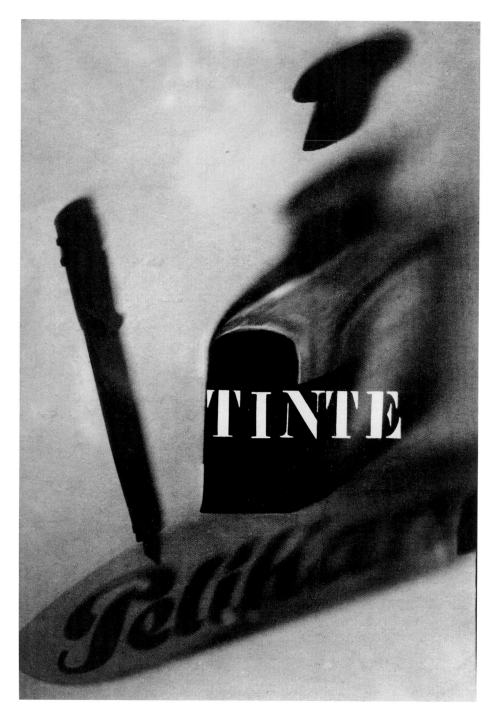

Perhaps the most visually arresting of these proposals were his numerous darkroom experiments with the photogram technique; according to one Schuldt, this was the first use of the latter technique for advertising purposes.[31] With its playful confrontation between matter, on the one hand, and branding on the other, the Pelikan Ink photogram seen here (1924) is a standout example (plate 39). The word *Tinte* (ink), rendered via the semi-mechanical process of stenciling, jumps brightly to the fore, declaring the flatness of the surface on which it rests and pushing the rest of the composition away and into depth. The company logo, by contrast, with its studied mimicry of the handwritten, trails off into a photographic blur, conjuring a dream world of commodity desire that mutes, or is supposed to mute, the cold calculations of capital. Similarly, in a set of five remarkably luminous photograms for Pelikan carbon paper (now preserved in the Russian State Archive for Literature and Art, Moscow), Lissitzky indulges in a cat-and-mouse play with the logo—doubling, shadowing, dragging, and displacing it in a dreamlike dance around the word *Kohlenpapier* (carbon paper).[32]

Although Lissitzky's use of the photogram technique in his self-portrait *Der Konstrukteur* (The Constructor) and in his portraits of artist friends such as Schwitters and Hans Arp (see plates 6–8, pp. 19–21) has been incisively discussed, the Pelikan photographs still remain rather obscure, like the rest of the artist's work for the company.[33] The relative paucity of research on this subject has partly to do with the difficulty scholars have had in reconciling Lissitzky's service to capital with his broadly communist sympathies. As early as 1928, for example, Traugott Schalcher—a journalist on the staff of *Gebrauchsgraphik* (Graphic Design), a Berlin–based international monthly devoted to promoting "art in advertising," remarked: "Here is a poster for the Red Army and cheek by jowl with it the artist calls our attention to Pelikan inks. Such is the singular mixture of Russian and German, mercantile and communistic, in Lissitzky's art."[34] Discomfort with this multiplicity has led to the view that the artist's work

for Pelikan was simply a means to an end — a way to pay for his costly medical treatment and convalescence in Switzerland.[35]

Lissitzky's own position on the matter was ambivalent. On the one hand, he condemned the exploitation of his labor under capitalist relations of production:

Isn't it madness? I can't just weigh out on the apothecary's scales how much I have to produce. No, I am beginning to loathe the whole business. This is the face of capitalism. This is the man who provides my livelihood, "my most esteemed Herr Günther Wagner," who isn't a person at all and has been dead a long time. But in the meantime *the main disadvantage is this: when they have sucked all they want out of me, they will spit me out on the street.* I should like to have some kind of safeguard against this.[36]

On the other hand, in his professional self-presentation during the mid-1920s, Lissitzky often included examples of Pelikan work in his portfolio, and more than once he sought further employment in that arena. For example, on January 4, 1925, he asked Küppers to take *Of Two Squares, For the Voice,* and photographs of various Pelikan proposals along when she went to Berlin to see the "advertising people" on his behalf, adding a request that she inform them about his numerous ideas for "kinetic and sculptural advertising."[37]

Furthermore, although Lissitzky decried the relations of production underpinning his work for Pelikan, he expressed no reservations about his own involvement in the selling of consumer goods or about the mechanics of advertising itself. On the contrary, he was genuinely interested in becoming more involved in this realm of public persuasion, particularly when it involved a mobile subject whose gaze could be arrested by a dynamic composition. (Among the items he sent Tschichold in the summer of 1925, for example, was a design for a wood-panel advertising relief for Pelikan typewriter ribbons that could be installed in shop windows, train-station vitrines, and indeed "wherever there is traffic.")[38] In fact, in the essay "A. and Pangeometry" (1925), he announced that "the only important achievement [has been] that of the modern dynamic advertise-

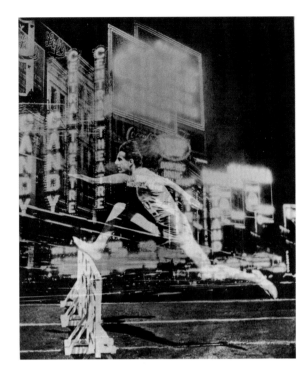

ment, for it was not the product of aesthetic reminiscences but originated from the direct necessity for influencing our psyche."[39] In another essay that same year, he praised "the great anonymous poetry of America — the verses and advertisements written in the night sky of Chicago and New York."[40]

The artist's increasing fascination with kinetic advertising in the metropolis is encapsulated in a work known in English as *Runner in the City* (1926) (plate 40), a darkroom photomontage he made a year or so after his return to Moscow from Switzerland. Originally titled *Rekord* (Record), it offers a utopian fantasy of the human body powered by electricity. In the foreground, an athlete about to clear a track hurdle is arrested by the camera in extenso. His leap is guided by his outstretched left arm, its hand and fingers streamlined to look strangely amphibian. On the one hand, this body in flight is substantial enough to cast an elongated, stainlike shadow across the track. On the other, its substance drains away as it merges with the electrified urban nightscape. The nightscape, which is itself in motion, comprises a double- and prolonged-exposure shot of the heart of New York's theater district, with

its rush of illuminated signs and marquees. Taken in 1923 or 1924 by Lissitzky's Danish-architect friend Knud Lönberg-Holm—who would later partner with Ladislav Sutnar at Sweet's Catalog Service, a major New York advertising agency—it shows the west side of Broadway between Forty-sixth and Forty-ninth streets, dominated by the Central and Strand theaters. Streaking across its lower reaches are the headlights of automobiles and trolleys.

Captivated not only by the spectacular iconography of Lönberg-Holm's photograph but also by its rapid circulation among European illustrated magazines after appearing in the architect Erich Mendelsohn's *Amerika: Bilderbuch eines Architekten* (America: Picture Book of an Architect) (1926), Lissitzky harnessed the profligate illumination and syncopation of Times Square to assist in socialist state-building: *Runner in the City* was a maquette for a monumental *foto-freska* (photo-fresco) the artist proposed for the new Red Stadium sports complex in Moscow. His electrified, record-breaking hurdler was intended to inspire not only star athletes to extraordinary feats on behalf of the world proletariat but also ordinary Soviet workers to participate actively in mass *fizkul'tura* (physical culture). (With this in mind, one notes that he subordinates in a photographic blur the messages of those flashing neon billboards for Coca-Cola and Clicquot Club ginger ale.)

Although neither the stadium nor its photo-fresco was ultimately realized, *Runner in the City* offers significant evidence of Lissitzky's refusal to cede the power of advertising—its influence upon the human psyche, as he had put it in 1925—to capital. On the contrary, the lessons of modern advertising would be put to work repeatedly in his exhibition designs for the Soviet state of the late 1920s and 1930s, beginning in 1928 with the Soviet pavilion at the Internationale Presse-Ausstellung in Cologne, with its flashing *Red Star* and kinetic transmission belts. Lissitzky later designed a catalogue for the pavilion that included an extraordinary concertina-foldout montage of photographic documents that had been on display there (plate 41).

A new and accelerated technology of photographic reproduction turned out to have been, in short, the "invention" for which the printed book had been "waiting." (173/361).

In each of the design endeavors discussed here, Lissitzky sought to transform the architecture of everyday life, whether that of the built environment, the advertisement, the agitational billboard, or the book. In these manifold endeavors, his vision remained relentlessly utopian. At the same time, however, he was also always—or almost always—willing to come to the table to negotiate with a client a set of material or ideological exigencies. His design practice in the 1920s may thus be understood as an ongoing dialogue with the ever-changing landscape of everyday life itself, particularly with respect to its systems of mobility, circulation, and communication. To be sure, Lissitzky wanted to fly, but he also knew that first he had to be able to breathe.

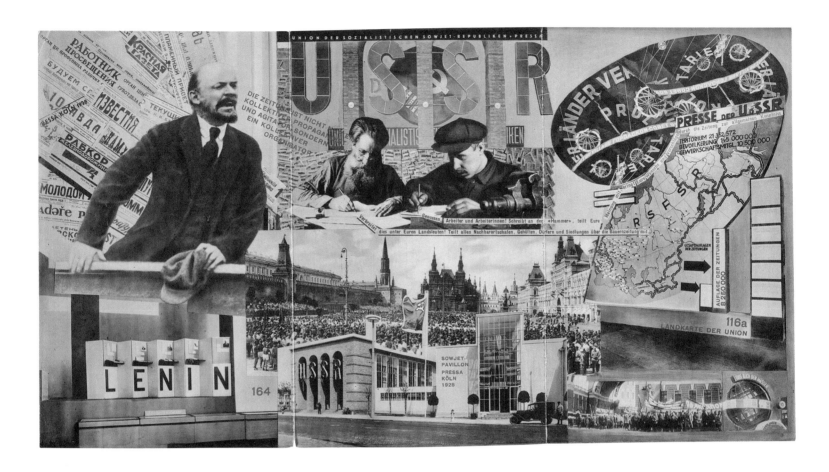

41

El Lissitzky (Russian, 1890–1941), cover and design for *Catalogue of the Soviet Pavilion at the International Press Exhibition "Pressa"* [*Katalog des Sowjet-Pavillons auf der Internationalen Presse-Ausstellung "Pressa"*], 1928: A. cover; B. detail of concertina foldout; letterpress (a); gravure (b), 21 × 15.2 cm, 231.5 cm when extended.

Notes

Warm thanks to Jodi Hauptman for her helpful reading of this essay in draft and to Matthew Witkovsky for our many stimulating conversations about its subject as well as his generous editorial interventions.

1. El Lissitzky, Ospedale La Carità, Locarno, to J. J. P. Oud, Rotterdam, Mar. 13, 1924; Van Abbemuseum, Eindhoven, inv. no. 1582–3.

2. On the topos of flight, see *Daidalos*, no. 37 (September 15, 1990), pp. 23–122; and Jeffrey T. Schnapp, "Propeller Talk," *Modernism/Modernity* 1, no. 3 (September 1994), pp. 153–78.

3. This formulation is drawn from Alice Kaplan and Kristin Ross, "Introduction," *Yale French Studies* 73: *Everyday Life* (1987), p. 3.

4. See Christina Kiaer, *Imagine No Possessions: The Socialist Objects of Russian Constructivism* (Cambridge, Mass.: MIT Press, 2005).

5. El Lissitzky and Il'ia Erenburg, "Blokada Rossii zakonchaetsia" (1922); reprinted as "The Blockade of Russia is Coming to an End," in *The Tradition of Constructivism*, ed. Stephen Bann (New York: Viking Press, 1974), p. 56 (trans. modified).

6. See, for example, *Everyday Life in Early Soviet Russia: Taking the Revolution Inside*, ed. Christina Kiaer and Erich Naiman (Bloomington: Indiana University Press, 2006).

7. El Lissitzky, "The film of El's Life" (1926); trans. Helene Aldwinckle, in Sophie Lissitzky-Küppers, *El Lissitzky: Life, Letters, Texts* (New York: Thames and Hudson, 1980), p. 330. The book was first published in German in 1967 and saw its first English translation in Great Britain the following year.

8. El Lissitzky to Sophie Küppers, February 8, 1926; trans. Aldwinckle, in ibid., p. 74 (emphasis mine).

9. A paternoster, or cycle elevator, is an open-door elevator that slowly loops up and down a building without stopping, allowing passengers to jump on and off at any floor.

10. The best source for reproductions of the *Wolkenbügel* is J. Christoph Bürkle, with an essay by Werner Oechslin, *El Lissitzky: Der Traum vom Wolkenbügel* (Zurich: Ausstellungen ETH Hönggerberg, 1991), pp. 61–75.

11. El Lissitzky, "Rad, Propeller und das Folgende" (1923); reprinted as "Wheel-Propeller and What Will Follow: Our Form-Production Is a Function of Our System of Movement," in *G: An Avant-Garde Journal of Art, Architecture, Design, and Film, 1923–26*, ed. Detlef Mertins and Michael W. Jennings (Los Angeles: Getty Research Institute, 2010).

12. *Festschrift zur Einweihung der Großfunkstelle Nauen am 29. September 1920* (Berlin: W. Simon, 1920); *100 Jahre Funktechnik in Deutschland: Funksendestellen rund um Berlin*, ed. Gerd Klawitter (Berlin: Wissenschaft und Technik Verlag, 1998), p. 25.

13. El Lissitzky, "Seriia neboskrebov dlia Moskvy: *WB1* (1923–25)" (1926); cited in Max Risselada, *Art and Architecture, USSR, 1917–1932* (New York: G. Wittenborn, 1971), pp. 14–15 (trans. modified).

14. Lissitzky refers to Mies's project in his essay "'Americanism' in European Architecture" (1925); trans. Aldwinckle, in Lissitzky-Küppers, *El Lissitzky*, p. 371. See also Maria Gough, "Contains Graphic Material: El Lissitzky and the Topography of *G*," in *G: An Avant-Garde Journal*, pp. 38–39.

15. Lissitzky, "Seriia neboskrebov dlia Moskvy," in Risselada, *Art and Architecture*, p. 14 (trans. modified).

16. El Lissitzky, *Russia: An Architecture for World Revolution* (1930), trans. Eric Dluhosch (Cambridge, Mass.: MIT Press, 1984), p. 56.

17. Bürkle, *El Lissitzky*, pp. 62–63.

18. El Lissitzky, "Unser Buch (U.d.S.S.R)" (1927); excerpted as "Our Book," in Lissitzky-Küppers, *El Lissitzky*, p. 363.

19. Lissitzky, "Our Book," p. 363. Further page references to "Our Book" and its English translation will be made parenthetically within the body of the essay.

20. Lazar Lissitzky, "Novaia kul'tura" (1919); reprinted as "The New Culture," in *Experiment/Eksperiment* 1 (1995), p. 261, trans. Peter Nisbet.

21. Kazimir Malevich, *O novykh systemakh v iskusstve: Statika i skorost'* (*On the New Systems in Art: Statics and Speed*) (Vitebsk: Vitsvomas, 1919).

22. For edition information, see Aleksandra Shatskikh, *Vitebsk: The Life of Art*, trans. Katherine Foshko Tsan (New Haven, Conn.: Yale University Press, 2007), p. 79.

23. El Lissitzky, Vitebsk, to Kazimir Malevich, Moscow, September 12, 1919; Stedelijk Museum, Amsterdam, Khardzhiev Archive, inv. no. 729, fol. p. 1; trans. Kenneth MacInnes, in *In Malevich's Circle: Confederates, Students, Followers in Russia, 1920s–1950s*, ed. Evgeniia Petrova et al. (St. Petersburg: Palace Editions, 2003), p. 52.

24. Significantly, Lissitzky's lengthy quotation from Marinetti's "Révolution typographique et orthographe libre expressive" (in the latter's *Les Mots en liberté futuristes* [Milan: Edizioni Futuriste di Poesia, 1919], pp. 49–50) has been excised in its entirety from all postwar reprintings in German of "Unser Buch," including that in Küppers-Lissitzky's influential monograph first published in Dresden in 1967, as well as from all translations of it into Russian or English; that is perhaps due to Marinetti's embrace of fascism. It is worth noting, however, that in a 1929 Czech translation, it remains intact (El Lissitzky, "Kniha s hlediska zrakového dojmu — kniha visuelní," *Typografia* (Prague) 26, no. 8 [1929], pp. 173–80).

25. Shatskikh, *Vitebsk: The Life of Art*, pp. 75–76.

26. El Lissitzky, "O metodakh oformleniia knigi" (Doklad), n.d. [1928?]; Stedelijk Museum, Amsterdam, Khardzhiev Archive, inv. no. 725, fol. p. 3.

27. See Bertolt Brecht, "Der Rundfunk als Kommunikationsapparat" (1932); reprinted as "The Radio as a Communication Apparatus," in *Bertolt Brecht on Film and Radio*, ed. and trans. Marc Silberman (London: Methuen, 2000), p. 42; and Hans Magnus Enzensberger, "Constituents of a Theory of the Media" (1970), in Enzensberger, *The Consciousness Industry: On Literature, Politics, and the Media*, ed. and trans. Michael Roloff (New York: Seabury Press, 1974), pp. 97–98.

28. El Lissitzky, "Typographische Tatsachen, z.B." (1925); reprinted as "Typographical Facts" in Lissitzky-Küppers, *El Lissitzky*, pp. 359–60, trans. Helene Aldwinckle.

29. Ivan Tschichold, "El Lissitzky (1890–1941)" (1965); excerpted in Lissitzky-Küppers, *El Lissitzky*, p. 389, trans. Mary Whittall.

30. Iurii Tynianov, "Literaturnyi fakt" (1924); reprinted as "The Literary Fact," trans. Ann Shukman, in *Modern Genre Theory*, ed. and intro. David Duff (Harlow, Essex: Pearson Education, 2000), p. 33.

31. Schuldt, "El Lissitzky's Photographic Works" (1965); in Lissitzky-Küppers, *El Lissitzky*, p. 395, trans. Aldwinckle.

32. For reproductions, see Margarita Tupitsyn, *El Lissitzky: Beyond the Abstract Cabinet* (New Haven, Conn.: Yale University Press, 1999), pls. 26, 28–31, 33.

33. See especially Leah Dickerman, "El Lissitzky's Camera Corpus," in *Situating Lissitzky: Vitebsk, Berlin, Moscow*, ed. Nancy Perloff and Brian Reed (Los Angeles: Getty Research Institute, 2003), pp. 153–76. For a rare and compelling analysis of specific Pelikan-related works, see Paul Galvez, "Self-Portrait of the Artist as a Monkey-Hand," *October* 93 (Summer 2000), pp. 109–37.

34. Traugott Schalcher, "El Lissitzky, Moskau," *Gebrauchsgraphik* 5, no. 12 (December 1928), pp. 49–50.

35. Küppers perhaps laid the seed for this view when she stated that the promise of a company retainer served as a "guarantee," for border authorities, that Lissitzky would have enough money to live on were he granted entry into Switzerland; see Lissitzky-Küppers, *El Lissitzky*, p. 37.

36. Lissitzky to Küppers, December 1, 1924; in ibid., p. 54, trans. Aldwinckle (emphasis mine).

37. Lissitzky to Küppers, January 4, 1925; ibid., 57 (trans. modified).

38. Lissitzky to Küppers, January 25, 1925; quoted in Nancy Perloff and Eva Forgács, *Monuments of the Future: Designs by Lissitzky* (Los Angeles: Getty Research Institute, 1998), p. 6. For a photograph of this lost relief, see Lissitzky-Küppers, *El Lissitzky*, pl. 126.

39. El Lissitzky, "A. and Pangeometry" (1925); reprinted in Lissitzky-Küppers, *El Lissitzky*, p. 356, trans. Aldwinckle.

40. Lissitzky, "'Americanism' in European Architecture," p. 369.

G. B. Shaw: Ženění a vdávání

JINDŘICH TOMAN

4

Ladislav Sutnar

WE LIVE HERE AND NOW

Ladislav Sutnar's cover for the inaugural issue of *Žijeme* (We Live) (plate 42), in April 1931, is a striking diagonal composition that foregrounds two middle-aged men, perhaps engineers or architects, who stand near what appears to be a long strip window. The two exude calm and confidence as they gaze beyond the picture frame toward what might be a new construction, or perhaps something in an imagined contemporary utopia. In the distant background are two barely discernible male figures. Their formal attire—one of them wears a top hat—identifies them as anachronistic residue. They truly trail behind, relegated to the lower-left corner of the montage—and, symbolically, to the past.

Žijeme, the flagship magazine of Družstevní práce (or DP, Cooperative Work), was aimed at the Czech middle class. Sutnar's cover is emblematic of the spirit of modernization and progress that a significant segment of that class embraced in the 1930s. At the same time, the montage reflects several European design revolutions that characterized the period. Three of them—the white revolution, the diagonal revolution, and the photographic revolution—converged to become a form of international modernism that the design historian Gert Selle has called "Style circa 1930."[1] As a cultural concept, the white revolution became apparent by the end of the 1920s, when it superseded color-filled projects for buildings and interiors by visionary German architects such as Wenzel Hablik and Bruno Taut. A critic writing for the German design magazine *Die Form,* a periodical with which Sutnar was familiar, contended in 1930 that the color white was no less than "a feature of the philosophy of our time and part of our entire worldview."[2] Indeed, the color became synonymous with several progressive cultural values—from a rejection of dark and dreamy romantic nooks; to an advocacy of a healthy, hygienic life; to an emphasis on transparency, simplicity, and discipline. Because dirt shows distinctly against it, the color white was a reminder of one's duty to help maintain a clean environment.[3]

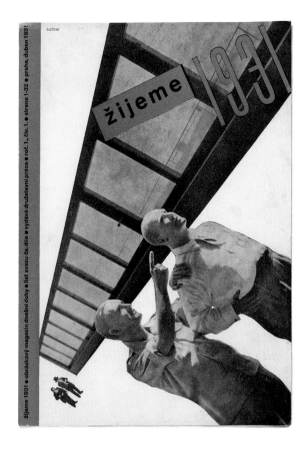

42

Ladislav Sutnar (Czech,
1897–1976), editor,
covers for four issues of
We Live [*Žijeme*]: A. April
[duben] 1931; B. November
[listopad] 1931; C. February
[únor] 1932; D. April
[duben] 1932; letterpress,
25.7 × 17.8 cm.

Radical claims also were made for diagonal composition, which emerged in German and Soviet art and design in the early 1920s. The Czech photo-theorist Lubomír Linhart, following El Lissitzky, Aleksandr Rodchenko, and others, saw in diagonal compositions a radical step toward overcoming bourgeois stasis.[4] Yet it was photography that changed the face of print products most dramatically. The force of mechanically reproduced images represented a fundamental emancipation from what were perceived as lies produced by the human hand. To quote the creator of New Typography and Sutnar's inspiration, Jan Tschichold: "Many are quite reserved as regards hand-drawn images; these often falsified painterly representations of the old days do not convince us any more, and their individualistic pretense is unpleasant for us."[5]

Ladislav Sutnar negotiated these new currents with mastery, acknowledging their international character while giving them a distinct local inflection—one that came to typify the visual and material culture of Czech modernism. By the time he left Czechoslovakia for the United States, in 1939, he had turned his talents to a variety of projects over the course of some fifteen years.[6] Born in Pilsen in 1897, Sutnar attended the Uměleckoprůmyslová škola (School of Applied Arts, or UMPRUM), Prague's leading design school. After graduating, he spent much of the 1920s creating graphics, set designs, puppets, and toys. He began concentrating on typography and book design around the time he secured two prominent institutional positions. The first was with the Státní grafická škola (State School of Graphic Art, or SGS), of which he became director in 1932; the other was with DP, which published *Žijeme*. Sutnar was hired by DP in 1929, as what would today be called an art director, shortly after another key Czech modernist, the photographer Josef Sudek, had joined the staff.

DP provided an ideal platform for attempting a systematic modernization of middle-class culture, and its membership was committed to fomenting change. The association originated in 1922 as a book guild.[7] In the central European tradition, such guilds were, at least in principle, different from book clubs. Guilds ostensibly represented a worldview, while the basic purpose of clubs was to sell books at a discount. The evolution of DP in Czechoslovakia paralleled a similar trend in Germany, where two influential book guilds were founded in 1924: the Bücherkreis and the Büchergilde Gutenberg. Both espoused left-of-center views; the former was linked to the German Social Democrats (SPD), while the latter had roots in the trade unions.

In the last analysis, the words *guild* and *cooperative* were code for alternative economies, producing and distributing goods to a mass clientele independent of the mainstream marketplace. DP books could be sold only to DP members, who eventually numbered in the tens of thousands. Because book guilds, including DP, operated without the constraints of conventional publishing, they remained largely unaffected by the Great Depression and other crises in the publishing industry of the later 1920s and 1930s. Not only did guilds eliminate the role of middlemen, but they also chose authors and designers who represented a reaction against elitist bibliophile societies that distributed small editions of exclusive books to a narrow circle of collectors. By targeting the masses, book guilds thus significantly altered the reading habits of low- and middle-income citizens between the two world wars. DP's corporate structure was notably democratic: members, mostly individuals in the trade, voted on which titles to print, and their candid opinions appeared in DP newsletters. DP survived World War II and expanded exponentially after 1945, only to be curtailed following the Communist takeover of the Czech government in 1948. By then, however, its customer base—an educated, professional middle class, especially women of that class—was no longer influential (figs. 4.1 and 4.2).

In 1929, when Sutnar joined DP, the organization was involved in several projects besides publishing books. For example, its expanding network of stores that specialized in applied arts sold glass, ceramics, and textiles, along with seasonal offerings such as calendars and picture postcards. Modernist art and design set the tone; most products were made in Czechoslovakia,

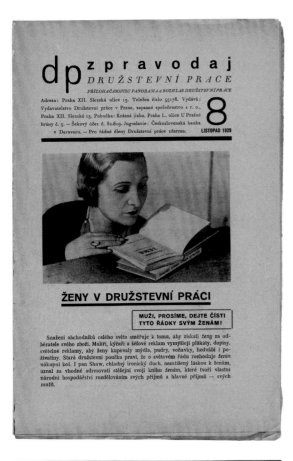

although Bauhaus items also were on sale at one point. Upon his arrival, Sutnar immediately changed the appearance of DP print products, altering them according to a version of New Typography promoted by Jan Tschichold, Kurt Schwitters, and others. Elements of this new graphic approach were already familiar to some Czech modernists, who understood the innovation as more than simply a switch from serif to sans serif typefaces. Instead, New Typography affected page layout, highlighted photography, and reassessed book design overall. Most significantly, New Typography represented a step toward what is now considered to be information design: a juxtaposition of form and content intended to communicate ideas unambiguously. Based on theories articulated by Tschichold in 1925, New Typography quickly gained adherents, including the Czech theorist and designer Karel Teige and the Dutch designer Piet Zwart. The Constructivists El Lissitzky and Lajos Kassák were important precursors of this innovative style.

Sutnar's contribution to New Typography is evident in the book covers he created for volumes of George Bernard Shaw's collected writings, which DP began publishing in Czech in 1929. In these arresting compositions, the artist used white space, diagonal composition, and photography to create radical graphic design (plate 43). Sutnar borrowed photographs of the Irish playwright from their original contexts and situated them in white spaces enlivened with an advanced interplay of bold colors, mostly red and black. At a time when architects, designers, and typographers tended to disparage the publication of books that lacked standard size, Sutnar's DP editions were both affordable and available in a uniform configuration—they represented the standard book.[8]

Ladislav Sutnar's contribution to DP publications was most visible in the design of *Žijeme,* which was published from 1931 to 1933 (see plate 42). Subtitled *Obrázkový magazin dnešní doby* (Illustrated Magazine of Our Times), it promoted a modern approach to daily and domestic life. One contributor, Karel Šourek, summarized the intent of the new monthly this way: "'We

4.1

Ladislav Sutnar (Czech, 1897–1976), *Bulletin DP,* 1929; offset lithograph, 24.2 × 16.2 cm. Private collection.

4.2

Ladislav Sutnar (Czech, 1897–1976), cover for *Panorama,* May 1935; gravure, 24.3 × 17.5 cm. Private collection.

43

Ladislav Sutnar (Czech, 1897–1976), covers for four works by George Bernard Shaw: A. *The Admirable Bashville* [*Drobnosti*], 1930; B. *The Apple Cart* [*Trakař jablek*] and *American Caesar* [*Americký císař*], 1932; C. *Getting Married* [*Ženění a vdávání*], 1931; D. *Captain Brassbound's Conversion* [*Obrácení kapitána Brassbounda*], 1932; letterpress, 19 × 14.2 cm.

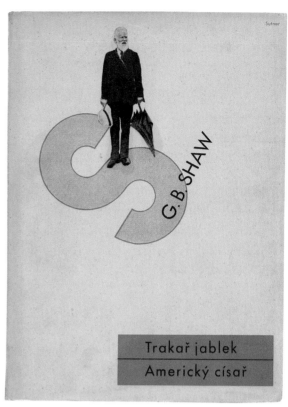

Live 1931' and the entire new architecture is created around the central point of modern civilization—the human habitat, the house, the apartment and their organization, furnishing, and everyday operation. That is, around what older theorists understood as art crafts, art industry."[9] Šourek went on to assert that the new design was an ambitious experiment focused on the viability of modern civilizing concepts: "The reason we have cast off all these ornaments is not because they are barbarous but so we can test the honesty of their foundations."[10] Another commentator, the author Stanislav Lom, declaring that the new design did away with stylistic eclecticism, perceived this process as akin to living in a dictatorship that defines "what is honest and what dishonest, adequate and inadequate, what is genuine truth and what a fake and a lie. But one moves in this dictatorship with the feeling of freedom and ease as never before."[11]

From the beginning, Sutnar conveyed this process visually. The first issue of *Žijeme,* published in the spring of 1931, opens with several pages of photographs he organized that contrast old living conditions with new ones (fig. 4.3). Other publications that promoted the modern lifestyle incorporated similar motifs. For instance, in Adolf Behne's *Eine Stunde Architektur* (Architecture in One Hour) (1928), left-hand pages show ornamentally decorated architecture, while spare contemporary designs appear on right-hand pages. Similar visual devices appear in the German magazine *Das Neue Frankfurt* (published from 1926 to 1931) and in the catalogue that accompanied the legendary 1929 Brno exhibition *Civilisovaná žena* (The Civilized Woman), designed by Zdeněk Rossmann (fig. 4.4). Contrast-based page design serves a didactic purpose that aligns it with the programmatic character of information design. The polarized nature of the oppositions precludes mediation between the past and the future, implying a fundamental rupture in the quality of daily life. The need to accept the new is irrefutable: there is no point in asking questions because the illustrated contrasts speak for themselves.

66

4.3

Ladislav Sutnar (Czech, 1897–1976), inside pages of *We Live* [*Žijeme*], April 1931; offset lithographs, 25.7 × 35.6 cm (open). The Art Institute of Chicago.

4.4

Zdeněk Rossmann (Czech, 1905–1984), inside pages of Božená Horneková et al., eds., *The Civilized Woman* [*Civilisovaná žena*], 1929; offset lithograph, 24.5 × 17.3 cm. The Art Institute of Chicago.

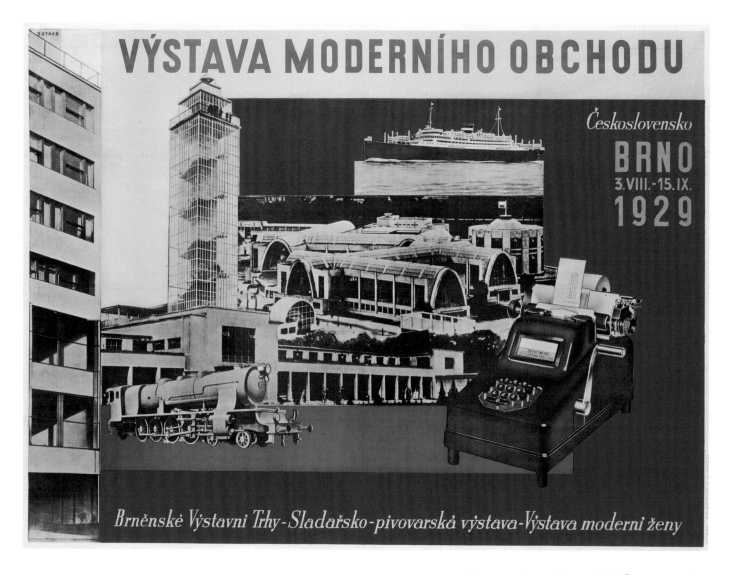

SUTNAR

VÝSTAVA MODERNÍHO OBCHODU

Československo

BRNO
3. VIII.-15. IX.
1929

Brněnské Výstavní Trhy-Sladařsko-pivovarská výstava-Výstava moderní ženy

44

Ladislav Sutnar (Czech,
1897–1976), poster for
*Modern Commerce
Exhibition, Brno [Výstava
moderního obchodu,
Brno]*, 1929; lithograph,
94 × 125.6 cm.

4·5

Ladislav Sutnar (Czech,
1897–1976), advertise-
ment for wooden toys,
late-1920s; rotogravure,
10.5 × 14.5 cm. The
Art Institute of Chicago.

The covers Sutnar designed for *Žijeme* generally
advocate a life of constructive work and healthy, athletic
leisure. Several of them have gymnastic themes. Some
emphasize work, including one taken from a Soviet
movie that shows a smiling laborer and another that
features an earthmover dumping its load. And images
of happy children appear on more than one cover. Most
notable, however, are the inaugural issue (discussed
above), and issue number eight, from November 1931,
which shows two managerial types in fedoras looking
at what appear to be exhibition panels set on a white
stage (plate 42). At the center is a transportation map
of Europe, with Czechoslovakia flanked by a panel

showing the electrically illuminated Prague Castle and, farther back, panels apparently representing Prague's historic architecture. It as if the two men were visiting an exhibition in which a sequence unfolds, almost like a film running backward, from the utopian present (transportation map) toward traditions amenable to modernization (the electrically lit castle) and, at the rear of the stage, the architectural past (old churches).

This cover composition reflects Sutnar's increasing interest in exhibition architecture. At this point in his work, there is no clash between past and present; his imagery does not minimize the past so much as enfold it within the present, accepting its historical value to contemporary life in an affirmative, patriotic way. Readers at that time, who would have remembered schoolbooks replete with national myths, may have appreciated this modernist vision of Czechoslovakia as a country with a rich history that ostensibly has become a modern European state—at least on white paper. At the time issue number eight of *Žijeme* appeared, several state-sponsored exhibitions with nationalistic themes were on view. For example, the convention-center grounds in Brno (still standing today) opened with a show in 1928 celebrating Czechoslovakia's accomplishments in its first decade of independence. Sutnar was not yet an exhibition designer, but he did contribute a montage poster to another major Brno exhibition a year later (plate 44).

Although Sutnar concentrated on producing magazine and poster graphics between the two wars, he also was honing his talents in the applied arts. In the 1920s, he designed costumes for socialist sports festivals and even toys (fig. 4.5). Around 1930, responding to the needs of DP design stores, he created sets of utilitarian tableware, specifically cutlery and tea services intended for everyday use. By retaining the geometric clarity and unadorned style of his print designs, Sutnar associated DP domestic culture with industrial technology. This is apparent from his choice of shiny stainless steel and transparent glass as fabrication materials (plates 45 and 46). Indeed, the tea service appears to be made of laboratory glass. This aesthetic is akin to that

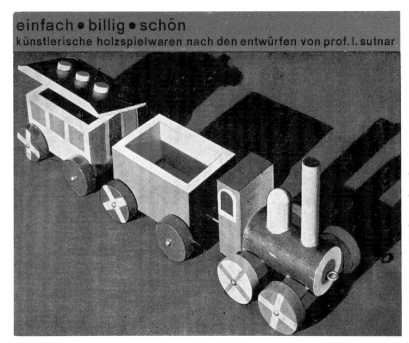

einfach ● billig ● schön
künstlerische holzspielwaren nach den entwürfen von prof. l. sutnar

erzeugung u. alleinverkauf
j. v. stoupa ● prag II ● 55 štěpánská

of chromium-coated tubular steel chairs and the clean, smooth, undecorated surfaces of the Frankfurter Küche (Frankfurt Kitchen), designed in 1926 by the Viennese architect Margarete Schütte-Lihotzky and frequently criticized for its institutional sterility. A German influence is also obvious when Sutnar's tea service is compared with thermally and chemically resistant glass products from the Thuringian manufacturer Jenaer Glaswerke, in particular the tea set designed by Wilhelm Wagenfeld (fig. 4.6). In some instances, even the advertising photographs of DP tableware resemble a German approach (plate 47).

The spherical shapes of the tea and coffee sets and dinner services Sutnar produced for DP between 1929 and 1932 evoke the appealing, somewhat whimsical bulk of toys Sutnar had made earlier. (Compare fig. 4.5 and plate 48.) The color choices also connect the tea services to the toys and are reminiscent of Sutnar's covers for the George Bernard Shaw book covers: forceful accents in primary colors against a white background. Sutnar's cover for Marie Úlehlová-Tilschová's 1937 book *Jak a čím se živit* (How and What to Eat), which depicts a soup bowl and plate, a tureen, a water glass, cutlery,

45

Ladislav Sutnar (Czech,
1897–1976), tea set,
1931; glass. (See checklist,
p. 145, for complete
information.)

4.6

Wilhelm Wagenfeld
(German, 1900–1990),
tea set, 1931; glass.
Museum of Decorative Arts
in Prague (UPM).

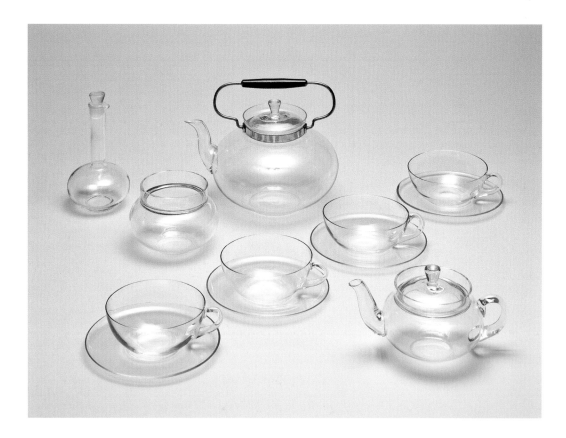

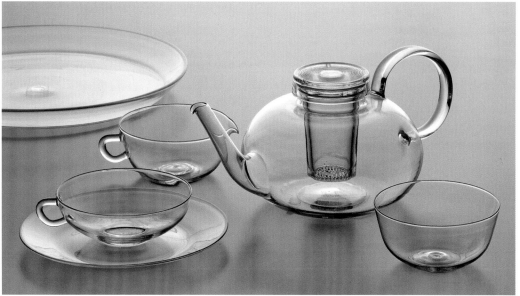

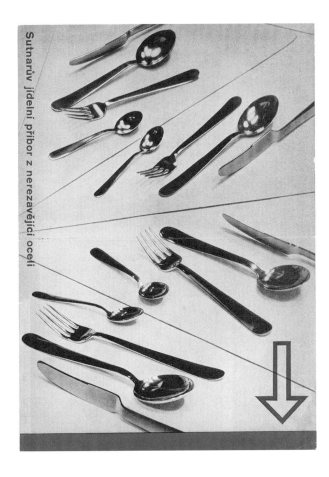

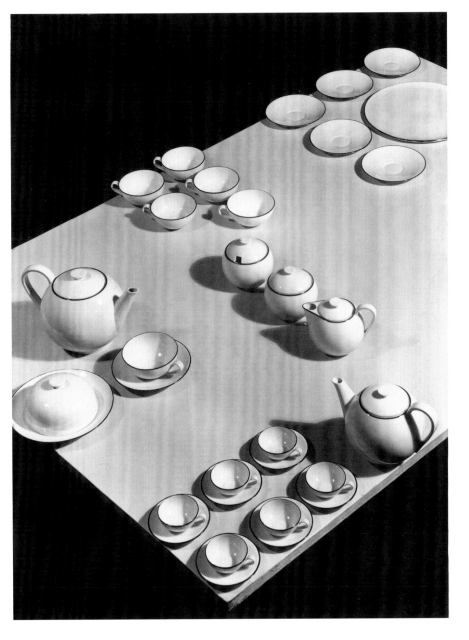

46

Ladislav Sutnar (Czech, 1897–1976), advertising brochure for his stainless steel flatware [*Sutnarův jídelní příbor z nerezavějící oceli*], 1934; letterpress, 23.5 × 16.7 cm.

47

Josef Sudek (Czech, 1896–1976), advertising photograph for Ladislav Sutnar china (with black rim), 1932; gelatin silver print, 23.2 × 17.1 cm.

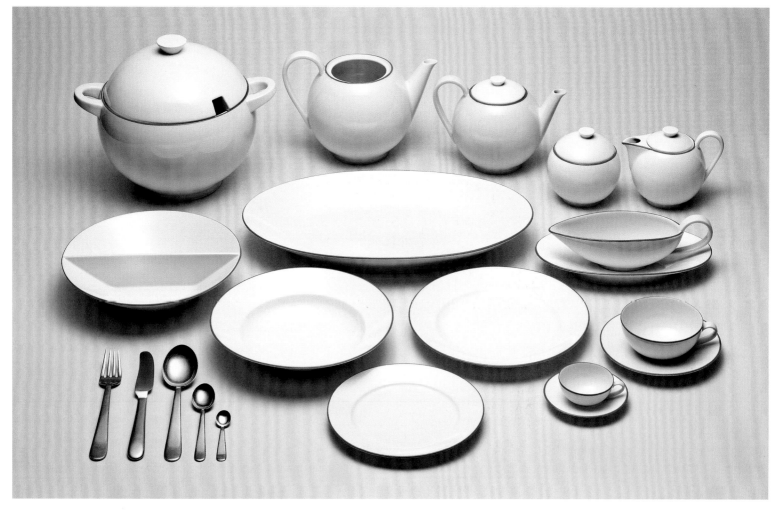

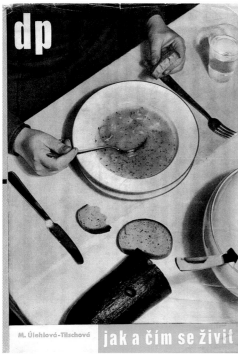

48

Ladislav Sutnar (Czech, 1897–1976), porcelain set (white with red trim) shown with silverware in stainless steel, 1929–1932. (See checklist, p. 147, for complete information.)

4.7

Ladislav Sutnar (Czech, 1897–1976), design for Marie Úlehlová-Tilschová, *How and What to Eat* [*Jak a čím se živit*], 1937; offset lithographs. Private collection.

a loaf of bread on a tablecloth, and human hands poised to eat, conveys a sense of the mundane and practical (fig. 4.7).

As director of the SGS, Sutnar implemented a rigorous educational program for future design professionals.[12] The curriculum he proposed and his editorial statements and designs for DP reveal his conceptual objectives, but information about how the public responded to his efforts is scant. One of several unanswered questions is whether modernist artifacts, such as the porcelain ware, actually were used as intended or were simply displayed in people's homes. Occasional caricatures found in *Žijeme* suggest that some DP members could not overcome old habits and expected decorative tableware (fig. 4.8). Specific reactions in the *Zpravodaj DP* (DP Newsletter) to Sutnar's work were rare. Members generally wrote to comment about the content of books DP published, not about their covers, and about Josef Sudek's photographs.

There were, however, reactions to Sutnar's work in articles written by critics close to the DP management. Václav Vilém Štech, an experienced and versatile art historian, praised Sutnar's "grand porcelain service" in the monthly members' magazine *Panorama.* Reminding readers that Vienna historically had excelled in the field of porcelain, Štech extolled what "we now have"—namely Sutnar. Viennese production had degenerated into kitsch, Štech argued, but Sutnar's porcelain ware embodied "applied design logic." He also lauded the artist's use of the color white:

Porcelain's shining whiteness means cleanliness and decoration at the same time. It thus goes well with the liberated forms of the new service. The borders are marked with color lines which provide the forms with an effective counterpart to large white surfaces. Yes, color changes the spirit, it adds a certain gaiety to the simple earnestness of white pieces.[13]

Karel Teige, the leading Czech proponent of avant-garde art, expressed a reaction to Sutnar's work in language reflective of DP philosophy. Teige's statements formed the opening lecture for an exhibition of Sutnar's work at the DP gallery in Prague in January

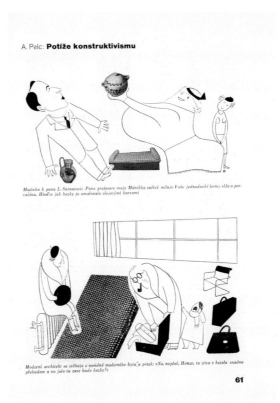

A. Pelc: **Potíže konstruktivismu**

Matinka k panu L. Sutnarovi: Pane profesore moje Manička zulívě miluje Vaše jednoduché formy skla a porculánu. Hleďte jak hezky je omalovala olejovými barvami

Moderní architekt se stěhuje z neméně moderního bytu a praví: »No, neplač, Honzo, tu zima v hotelu snadno přebudem a na jaře tu zase bude hezky!«

61

4.8

Antonín Pelc (Czech, 1895–1967), illustration for *Žijeme* [*We Live*], *The Troubles of Constructivism* [*Potíže konstruktivismu*], 1932; letterpress, 25.7 × 17.8 cm. The Art Institute of Chicago.

and February of 1934. Unlike Štech, Teige said little about Sutnar in concrete terms. He labeled the pieces on display "the most consequential, mature and cultivated works brought by the international movement of New Typography." He concluded his general remarks about innovative typography by denying that such work—Sutnar's included—was art; for Teige, art had no place in typography, photography, architecture, or design. He called for giving up this "old-fashioned idealistic myth that provided a deceptive aura to our work" and instead restated the practical, immediate goals of DP:

Our task is something like service to the public, a service that does not want to be just subservient to moneymaking. A service to social progress, cultural development. A service *here and now*. Let us not delude ourselves that we are creating art works that will be appreciated only by the future. Our world is the present day, *the present day marching towards the future.*[14]

Teige's estimation of Ladislav Sutnar's contribution to DP highlights a fundamental perspective—that of the present. It seems likely that Sutnar would have agreed with the context in which Teige bid him to work—the "*here and now.*"

Notes

1. Gert Selle, *Geschichte des Design in Deutschland* (Frankfurt am Main: Campus Verlag, 1997), pp. 226–42.

2. J. E. Hammann, "Weiß, alles weiß: Von der Wertstellung der Farbe Weiß in unserer Zeit," *Die Form* 5 (1930), pp. 121 ff.

3. For more about the color white within the DP context, see H. [Karel Herain], "Bílá barva," *Žijeme* 1, no. 10 (January 1932), p. 271.

4. The role of the diagonal in interwar design is addressed in Jindřich Toman, *Foto/montáž tiskem — Photo/Montage in Print* (Prague: Kant, 2009), p. 313.

5. Jan Tschichold, "Was ist und was will die Neue Typographie?" in *Eine Stunde Druckgestaltung* (Berlin: Verlag des Bildungsverbandes der deutschen Buchdrucker, 1930), p. 8.

6. Sutnar came to the United States on the eve of World War II, officially serving as a coorganizer of Czechoslovakia's pavilion at the New York World's Fair (1939–40). In reality, however, he was a political refugee from the Nazis, owing to his engagement in the Socialist Party. It took some sixty years to tie Sutnar's Czech and American worlds together in an exhibition and accompanying book. See Iva Janáková, ed., *Ladislav Sutnar– Prague–New York–Design in Action* (Prague: UPM and Argo, 2003).

7. For an account of DP with sections in English, see Lucie Vlčková, ed., *Družstevní práce–Sutnar, Sudek* (Prague: UPM and Arbor Vitae, 2006).

8. For the concept of the standard book, see Toman, *Foto/montáž tiskem*, pp. 161–63.

9. Karel Šourek, "Jde vskutku jen o civilizaci?" *Žijeme* 1, no. 3 (June 1931), p. 87.

10. Ibid., p. 88.

11. Stanislav Lom, "Ve znamení osobnosti a všeobecnosti," *Žijeme* 1, no. 4/5 (July–August 1931), p. 98.

12. See Matthew S. Witkovsky and Jindřich Toman, "Scratching the Surface of Czech Photography," in Ladislav Sutnar and Jaromír Funke, *Photography Sees the Surface* (Ann Arbor: Michigan Slavic Publications, 2004), pp. 33–37.

13. V. V. Štech, "O porculánu," *Panorama* 11 (1933), p. 96.

14. Karel Teige, "Ladislav Sutnar a nová typografie," *Panorama* 12 (1934), pp. 11, 13.

5

Karel Teige

CONSTRUCTION, POETRY, JAZZ

MATTHEW S. WITKOVSKY

Of all the networked figures in the interwar avant-garde, Karel Teige was one of the most well connected. Teige repeatedly discussed the work of El Lissitzky, John Heartfield, and (to a lesser degree) Gustav Klutsis; wrote an extended homage to his close colleague Ladislav Sutnar; and together with Piet Zwart became a guest exhibitor for several years with the German collective Ring neue Werbegestalter (Circle of New Advertising Designers).[1] He traveled to Moscow in 1925, lectured at the Dessau Bauhaus in 1929 and 1930, and attended important exhibitions by Sutnar and Heartfield in Prague in 1934. Meanwhile, the monthly magazine *ReD* (*Revue Devětsilu,* or the *Devětsil Revue*), which he edited from 1927 to 1930, brought an array of European works in reproduction to a Czech readership (plate 49). He was also committed to revolutionary progress. Teige wrote extensively on architecture, graphic design, and photography, and from his earliest days he promoted daily life as an arena worthy of serious attention from artists, to effect needed social reforms and to change the basis of artistic practice. His various activities and writings during the 1920s and 1930s make him the most important theoretical figure in the history of Czech modernism.

Born in Prague in 1900, Teige articulated a general theory of art and life from around 1922 under the twin headings of Constructivism, an international wave of which he was an early and vocal exponent, and Poetism, an indigenous "ism" that constituted the major Czech contribution to the international avant-gardes. The two terms were initially indissociable. Together they constituted a "holistic gesture," as the literary historian Peter Zusi has described it, a dialectical unity that would replace the outworn ideal of Art with a complete and innovative worldview, as implied by Teige's title for a 1928 collection of his essays, *Stavba a báseň* (Construction and Poetry*)* (plate 50).[2] Constructivism meant purposeful creative work, unburdened by aesthetics, historicism, or individual sentiment, while Poetism was an emancipatory state of creative play. According to one of his earliest formulations, "Poetism is the crown of life; Constructivism is its basis."[3]

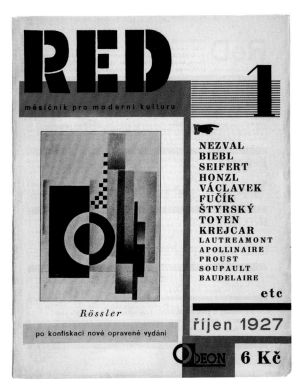

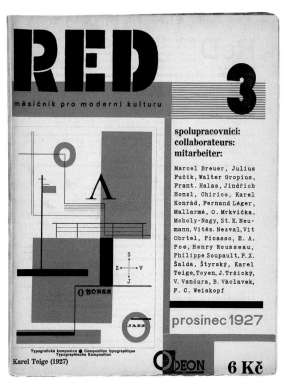

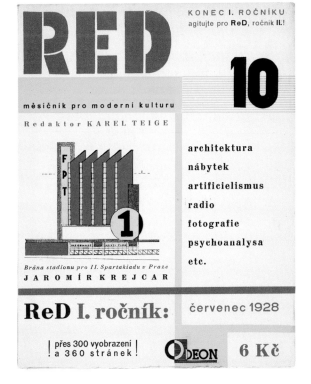

49

Karel Teige (Czech,
1900–1951), editor and
designer, four covers
for *ReD* (*Revue Devětsilu*):
A. October [říjen] 1927;
B. December [prosinec]
1927; C. July [červenec]
1928; D. January [leden]
1929; letterpress,
23.5 × 18.2 cm.

karel teige

stavba a báseň

edice olymp
svazek
7-8

praha
1927

Such a schematic exposition could not hold, and as Teige increased his demands for Constructivist discipline — no aesthetics, but only the dictates of function; no considerations of history or posterity, but only of present needs; no assertion of an individuated self, but only concern for the common good — Poetism seemed to fracture and fail. Zusi has perceptively shown how Teige's dualist thinking, intended to make new a society that had reduced art to decoration and repressed labor at its margins, was riven by its own logical dilemmas. Yet perhaps the two strains did in fact interact rather than simply complement each other. At places in Teige's theory and his works, poetry becomes the stuff of construction, or constructive work begets poetry. Poetism and Constructivism, it turns out, meet in and through the everyday. A desire to be inspired by everyday life and also to operate in it is perhaps the trait that most succinctly unifies Teige's many essays on architecture, literature, fine art, typography, photography, and film. Teige arguably achieved his Constructivist-Poetist universe, meanwhile, in the works illustrated on these pages — that is, in the discipline of graphic design.

Teige's particular understanding of "everyday life" engaged the industrial economy not so much in its commodities as in its sites of labor or spectacle.[4] His earliest statements against art and for life were cast in such terms. "In front of the museum rises a wide and empty factory building," he wrote, "the city's industrial zone; we have only to cross the threshold and we are in the middle of a chaotic, breathless present, bursting with countless forms and immediate realities."[5] Urbanism and housing reform occupied him greatly from the mid-1920s, and he contributed to international debates about domestic living space with his 1932 book *Nejmenší byt* (The Minimum Dwelling) (plate 51).[6] The present essay, however, privileges Teige's fascination with popular leisure activities: jazz musicians, circus and vaudeville performers, cinema and radio, and vernacular printed matter, all emerge as attractions in his writings and graphic works. The manufactured objects in these entertainment routines are stage props not intended for sale: ocean liners, airplanes, traffic signals, and posters.

Teige developed his ideas within the Umělecký svaz Devětsil (Devětsil Artistic Union), a group founded in the fall of 1920 at a café in downtown Prague. Its somewhat ironic name suggests an array of forces, and indeed Devětsil's loose membership swelled over the decade of its existence to include poets and writers, architects, talents in theater and music, painters, and even a professional photographer.[7] Teige soon became its main spokesperson, an unofficial position he held until the group gradually disbanded after 1930.

Teige's first significant essays date to the spring of 1921. In "Obrazy a předobrazy" (Figures and Pre-figurations), he predicted a future when art and life would merge: whether poets or factory workers, scientists or soldiers, the new generation he envisaged "doesn't realize theories but rather creates a new world."[8] The stridency of such claims alternated with a lyrical voice that was frequently echoed in the art and literature of Devětsil. In "Figures and Prefigurations," for example, when he suggests the subjects of creation in the world to come, Teige's sweeping declarations are transmuted into soothing, idyllic visions: "New

50

Karel Teige (Czech, 1900–1951), *Construction and Poetry* [*Stavba a báseň*], 1927; letterpress, 24.2 × 16 cm.

51

Karel Teige (Czech, 1900–1951), author and designer, cover for *The Minimum Dwelling* [*Nejmenší byt*], 1932; letterpress, 25 × 18.1 cm.

landscapes with tall, full-grown trees and palms, incredible vegetation, clouds, geysers and waterfalls, and with intoxicating views! Postcards from cities suffused with their particular, nostalgic and incomprehensible atmosphere. . . . New genres, excerpts from our dreams and fantasies, stories of the heart warmed through with love and shared hardship."[9]

The sheer delight in modernity that animates these lines would find its visual equivalent in a genre of photomontage that Teige dubbed *obrazové básně* (picture poems). Devětsilers in Prague and Brno made several dozen picture poems during the 1920s, mostly for print reproduction.[10] In the December 1923 inaugural issue of *Disk,* the first magazine he designed alone for Devětsil (plate 52), he referred to poems "that read like modern paintings. Modern paintings that read like poems." He assured readers of a second issue—the magazine's final number, as it turned out, delivered in the spring of 1925—with actual examples that "solve problems common to painting and poetry."

The identity between painting and poetry rested, in Teige's analysis, on mechanical image production, which in turn opened onto the realm of contemporary daily life. Photomechanical imagery, he believed, celebrates the "life of the street, sports, biomechanical beauty, the movies. Aesthetics are becoming photogenic and vitalist." As a result, painting would become a rarefied specialty, while (photo)graphic, reproducible pictures would captivate a mass audience. In a proclamation that points to his own future career, Teige asserted that graphic design would determine the course to come for art and poetry: "A picture is either a poster, public art like the movies, sports, or tourism—then its place is in the street; or it is poetry, purely creative poetry, without literariness—then its place is the book, a book of reproductions, like a book of poems."[11]

Posters and book-poems of reproductions: this is the map of Teige's subsequent activities as a graphic artist and as a theorist of art and the everyday. His own picture poems, magazine layouts, and book designs (which he called "posters for books") were made with as much concern for attracting new audiences—pedes-

Karel Teige (Czech, 1900–1951), design for two issues of *Disk*: A. cover, December 1923; B. inside pages, April 1925; letterpress, 29.2 × 21.5 cm (closed), 29.2 × 43 cm (open).

5.1

Jaromír Krejcar (Czech, born Austria, 1895–1949), sketch for the Olympic building in *Life: Anthology of the New Beauty* [*Život: Sborník nové krásy*], 1922; letterpress, 25.4 × 18.7 cm. The Art Institute of Chicago.

trians and the reading public—as with introducing new subjects or formal devices. His ideas, meanwhile, developed along the dualistic model sketched earlier: "The street" should be a space of utility, while "purely creative poetry," freed not only of literary weight but also of utilitarian obligations, could be encapsulated in the presumably private space of the book. As conceived by Teige, however, "the street" and all it contains—movies, sports, tourism—would not be merely the inspiration for poetic creation but its proper location—equally suited to poster displays as new buildings. More boldly, architecture might henceforth be "built" by posters, and by poetry. Andrew Herscher has surmised, for example, that the architect Jaromír Krejcar, a Devětsil member, created sketches for urban buildings as "architectural picture poems," surfaces covered in foreign-language signs that registered (to Czech audiences) as a collage of optical and phonic material (fig. 5.1). Herscher has argued that Krejcar's early architecture, thoroughly grounded in Teige's theories, makes collage an integral feature of building, promoting advertising billboards as an element of urban design.[12]

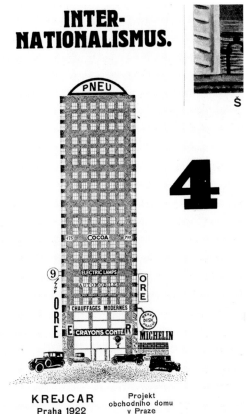

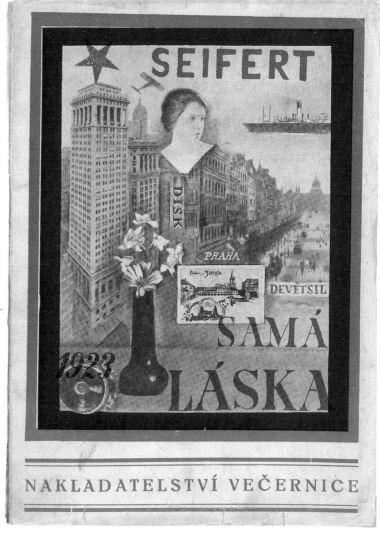

53

Karel Teige (Czech, 1900–
1951), Bedřich Feuerstein
(Czech, 1892–1936),
Jaromír Krejcar (Czech,
born Austria, 1895–1949)
and Josef Šíma (French,
born Bohemia, 1891–1971),
cover for Jaromír Krejcar,
editor, *Life: An Anthology
of the New Beauty*
[*Život: Sborník nové
krásy*], 1922; letterpress,
25.4 × 18.7 cm.

54

Otakar Mrkvička (Czech,
1898–1957), cover for
Jaroslav Seifert, *Only Love*
[*Samá láska*], 1923;
letterpress, 19.5 × 14 cm.

5.2

Man Ray (American,
1890–1976), *Lampshade*,
1921; gelatin silver print.

Krejcar published his early architectural drawings in Devětsil's groundbreaking anthology *Život* (Life), completed in late 1922 and probably published in the spring of 1923. The cover of the anthology has been called the earliest picture poem, a collective creation of Teige, Krejcar, fellow architect Bedřich Feuerstein, and the painter Josef Šíma (plate 53). With sly humor, this authorial quartet made a tire of Czech manufacture, set in front of a Greek column, the inheritor to Western civilization.[13] The cover's conception also implied that new Czech creativity (in the form of the photomontage) would not only fuse painting and poetry—images and words—but also would construct edifices as solid as a classical column on the foundation of "street culture." Simply put, everyday life would be what linked construction to poetry.

An example of a "collage city" in the realm not of building but verse is the cover of Jaroslav Seifert's second anthology of poems, *Samá láska* (Only Love), published in April 1923 almost simultaneously with *Život* (plate 54). Otakar Mrkvička, the designer, would establish a typographic enterprise with Teige the following year. His decision to plaster an urban view with disparate collage elements may reflect the precedent of German Dada, or as Jindřich Toman has suggested, was more likely inspired by humorous postcards—common in central Europe starting around 1900—that used photomontage to create futurist cityscapes.[14] However, Mrkvička does repeat one crucial Dada innovation: self-branding. The names of Devětsil and its not-yet-published journal *Disk* are paraded on the streets and buildings of Wenceslas Square, the main boulevard of downtown Prague, as if this avant-garde startup was in show business. Devětsil's good works are set to roll out, or sail, or fly from Prague to the ends of the earth. Visiting Wenceslas Square seems itself a performance in this context, a suggestion underscored by the inclusion of an unaltered postcard showing Mrkvička's hometown at the center of the composition. All this takes place, as Toman has pointed out, under the transformative symbol of the Communist star. Hedonist verse and revolutionary politics (the poetic

and the constructive) remake the built environment such that the elements of everyday life figure a new world order.

Teige's first mention in print of the term *picture poem*—which could be applied to Mrkvička's cover or to Krejcar's drawings—came in the essay "Foto Kino Film" (Photo Movies Film), in the *Život* anthology. The essay's premise—that film and photography are the most significant forms of visual art in the modern era—anticipates László Moholy-Nagy's 1925 book, *Malerei Photographie Film* (Painting Photography Film), which Devětsil in turn excerpted heavily in its journal *Pásmo* (Zone—the title can also mean "reel" or "roll," as in a film) (plate 55). Teige's essay also contains a prescient commentary on Man Ray's work in photography. On a trip to Paris in the summer of 1922, he had visited Man Ray in his studio, where he saw the photograms soon to be published as *Champs délicieux* (Delicious Fields).[15]

Teige tried to come to terms with the place of photography, and here too he reached for a dualistic schema. On one side stood the prosaic press shot, which he praised as an ideal modern image type: "The perfection of photography increases its beauty, accumulating clarity, veracity, [and] documentary character—characteristics that give photography its raison d'etre.... Yes, in veracity and truthfulness lies the morality of photography." On the other stood the "case of Man Ray," as Teige called it, an artist who has given photography "an independent language, autonomous and fully its own." There are his photographs of objects that subsequently disappeared, such as the record of an unfurled circular lampshade (fig. 5.2): "He photographed these metamechanical constructions, beautifully and carefully, with an exact knowledge of photographic craft, which he uses, incidentally, to earn his daily bread." Then there are the photograms: "These '*direct*' photographs, in which Man Ray made do entirely without negative or camera, are objects in and of themselves, *picture poems* [emphasis added]. The application of this photographic method, utilized in science, has the tonal values of

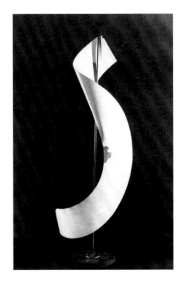

55

Anonymous, covers for
three issues of *Zone*
[*Pásmo*], Artuš Černík,
editor: A. 1, no. 2, 1924–25;
B. 1, no. 5/6, 1924–25;
C. 1, no. 9, 1924–25; litho-
graphs, 47.7 × 31.7 cm.

aquatints, gentle gradations almost unachievable in graphic art. It is in places almost phantasmagorical."[16]

Here, as with the verses by Seifert, we are at the opposite end of the spectrum from constructive work, in the realm of what Teige would soon call "pure poetry." And yet, just as Constructivism built Poetism into its program, so, too, did the poetic depend on constructive elements. Far from "incidental," it was in fact key to Teige's estimation of Man Ray that he used photography "to earn his daily bread" and that a scientific method had been adapted for poetic purposes. This work, like his own nascent graphic design, was grounded in purposeful labor. It was also crucial for Teige that photography was wedded to "veracity and truthfulness."

As Teige refined his theses, his already low tolerance for aesthetics in utilitarian creations waned completely. From his position on the editorial board at *Stavba* (Building), a leading architecture journal, he polemicized with practitioners — including members of ARDEV, the architectural wing of Devětsil — over what he termed residual attachments to "irrational," symbolic expression.[17] "Art, according to Larousse's [etymological] dictionary, is the application of knowledge to the realization of a specific task," he observed in his best-remembered essay, "Konstruktivismus a likvidace 'umění'" (Constructivism and the Liquidation of 'Art') (1925). "Poetic intensity" could be a byproduct of technological phenomena, he asserted, but it must not distract from the job at hand, and certainly should not address actual work in symbolic form: "The machine is not an artistic subject."[18] The separation of construction and poetry must become absolute, guided by purpose: "We will not henceforth waste words speaking abstractly about the relation of form and content: the correct question concerns function alone."[19] Ironically, Teige's bold statements about aesthetic annihilation appeared in the same magazine — the second and final issue of *Disk* — that featured abundant examples of Devětsil picture poems (see plate 52). And it was published a year after Teige had joined with Mrkvička to make graphic design his

de facto profession. Undoubtedly, this coincidence of placement and timing raised questions about labeling design as a purely informational "task" and whether good design could be separated from "pictorial poetry."

Teige, as one of an international New Typography cohort that included Jan Tschichold, Ladislav Sutnar, El Lissitzky, Piet Zwart, and others, did seek to class graphic design as a field of constructive creation. His first extended essay on typography, published in early 1927 under the title "Moderní typo" (Modern Typography), proclaimed the ascendance of Constructivist design principles, and Teige hoped to incorporate this essay into an unrealized project devoted precisely to the relation of Constructivism and typographic innovation.[20] He stressed the practical yet revolutionary aims of eye-catching simplicity, standardization of formats and the consequent cost savings in materials and labor, and clarity in the service of perfected communication. Fantasy and intuition were welcome only within the "regulatory" standards of what Teige called "laws" of sensible design. "Architecture and typography are creations of functional forms," he wrote in one study, "governed by concrete purposes and the state of technological evolution more directly than other branches of so-called art; they [therefore] give the most faithful picture of culture and society in their time." [21]

These pronouncements treat design as the thoughtful fulfillment of any "task," yet Teige did not accept every proffered assignment. He focused his energies on serving the cause of progressive literature or militant politics, frequently contributing to magazines such as *Reflektor* (Headlight), *Levá fronta* (The Left Front), and *Země sovětů* (Land of the Soviets). He made covers for the books of authors he admired, typically Czech, French, and Russian. Andrew Herscher has characterized Teige's turn to hard-edged geometry in the late 1920s as an "architecturalization of the book form," a conflation of two "constructive" realms — building and typography — that can be discerned already in the collectively designed cover for *Život* in 1922.[22]

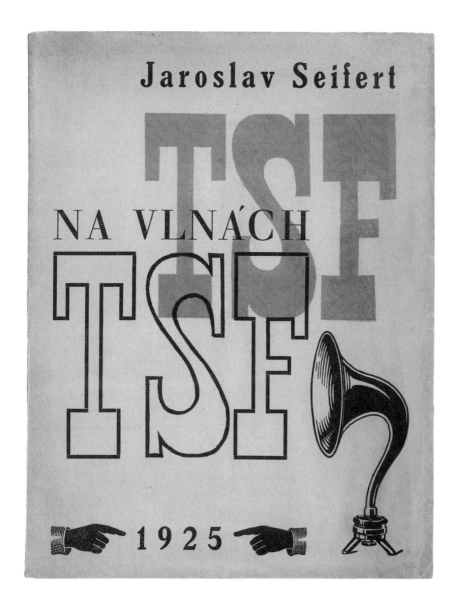

One answer to the problem of typography's possible "digression" from construction to poetry, then, lies in maintaining politically acceptable content; another lies in reinforcing a symbolic functionality through recourse to symbols of real functional structures—although this would be merely rendering "the machine an artistic subject." A third, potentially more satisfying answer lies in regarding typography as a union of the poetic with the constructive. Such a union is demonstrable in Teige's graphic designs, and although he never makes the idea explicit, it is the sense of good typography that he gives most regularly in his writings as well. That merger proceeds once again through "everyday life," and it should be stressed that this is imagined as a sphere of performance and spectacle. It is rhythm that gives the decisive link between Poetism and Constructivism, and it is the rhythm of jazz music, the filmstrip, and the dance hall.

"The typographic realization of text is determined by the character, rhythm, and tempo of that text," Teige wrote by way of introducing a few of his own designs at the end of "Modern Typography" in 1927. Of the ones he discusses, such as the cover for Jaroslav Seifert's *Na vlnách TSF* (On the Airwaves) (plate 56), syncopation and speed are the goals. The abbreviation TSF (*télégraphie sans fil,* or wireless broadcasting), doubled in block and silhouette forms, suggests a two-step pulse, while the Dada-inspired hands on either side of the publication date, 1925, draw the eye to the here and now. This multimeter rhythm is typical of Teige's photomontage designs, which share affinities with Moholy-Nagy's discussions of film and photomontage in *Painting Photography Film*—for example, his plans for a movie inspired by the words "tempo, tempo."

It was not enough to picture the film strip or the radio wave, however; Teige made syncopation, or, as he called it, asymmetry, constitutive of his design work as well. The covers for *Film* (plate 57) and *On the Airwaves,* like those for *Fanfarlo* (plate 58) and *Construction and Poetry* (see plate 50), all feature an off-kilter dynamic of circles and bars. Whether photo-

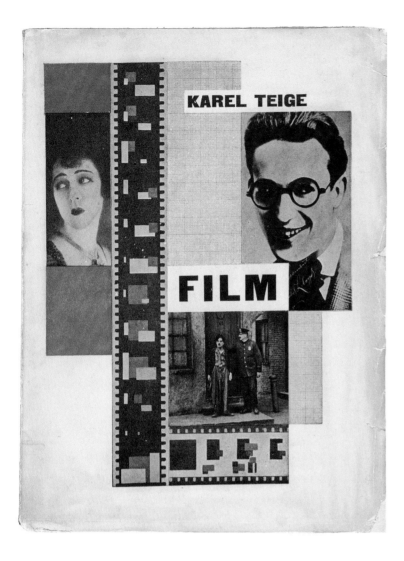

56

Karel Teige (Czech, 1900–
1951), cover for Jaroslav
Seifert, *On the Airwaves*
[*Na vlnách TSF*], 1925;
letterpress, 22.2 × 17.1 cm.

57

Karel Teige (Czech, 1900–
1951), author and designer,
cover for *Film*, 1925;
letterpress, 19.3 × 14.6 cm.

58

Karel Teige (Czech,
1900–1951), cover for
Charles Baudelaire,
Fanfarlo [*La Fanfarlo*],
1927; letterpress,
18.7 × 12.8 cm.

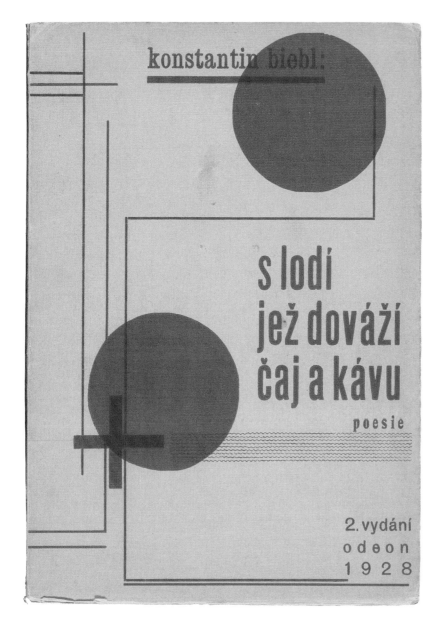

konstantin biebl:

s lodí
jež dováží
čaj a kávu

poesie

2. vydání
odeon
1928

59

**Karel Teige (Czech, 1900–
1951), cover for Konstantin
Biebl, *With the Ship
That Brings Tea and Coffee*
[*S lodí jež dováží čaj a
kávu*], 1928; letterpress
and paper collage,
20 × 14.2 cm.**

graphic or abstract, these covers evoke the boldness of dance hall numbers, such as the "black-bottom fox-trot," that were the rage in Prague in 1925 and 1926. "Jazz is naturalism and symbol at once," wrote a reviewer of "The Chocolate Kiddies," an African-American troupe that visited the city in October 1925, just ahead of Josephine Baker. "Jazz is a music of protest, against the magnates, the Bible readers, the KKK, the [Scopes] monkey trial organizers, the Puritans.... The machine is also a dance."[23] There was no separating the poetic from the constructive, or art from politics, in the realm of the everyday.

Evocative of this triangulation of the constructive and the poetic via a performative everyday are Teige's designs for the Devětsil poet Konstantin Biebl, particularly his books *Zlom* (Rupture) and *S lodí jež dováží čaj a kávu* (With the Ship That Brings Tea and Coffee), both published in 1928 (plates 59 and 60). The planes of shifting color, translucent panes floating around and over lines or bars of dark solidity, seem equally ready for projection as an abstract film or interpretation as a musical score. Bunches of thin, neatly ruled horizontals on these pages recall musical staffs or the railings of ocean liners, while the mixture of lines, dots, circles, and free-floating symbols of punctuation or decoration suggest the charts used by a jazz band—notations to orchestrate a gathering of spirited soloists. Hand-coloring in luxury copies of the two books, which could justly be seen as a capitulation to the bibliophile market, nevertheless reinforces this sense of typography as a somewhat improvisational performance.

But the book that fully thematizes these poetic-constructive connections is *Abeceda* (Alphabet) (1926), one of the most internationally celebrated creations of the Czech avant-garde (plate 61). The project, itself an alliance of Constructivist typography and Poetist verse personified by the popular figure of a dancer, Milča (Milada) Mayerová, summarizes the integrative role of everyday life in Teige's world of construction and poetry. Mayerová poses simultaneously as a "dancing girl" and an avant-gardist, and her costume, with its

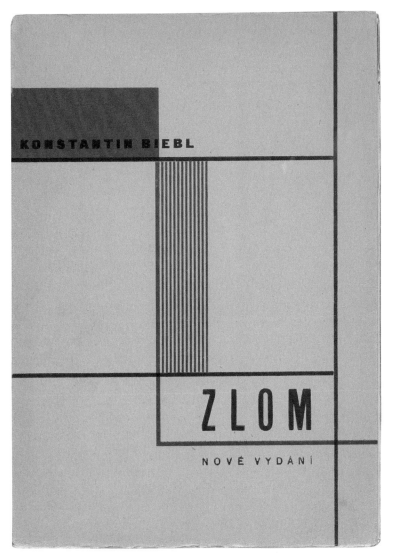

60

Karel Teige (Czech, 1900–
1951), cover and inside
page for Konstantin Biebl,
Rupture [*Zlom*], 1928;
letterpress, 19.7 × 13.9 cm.

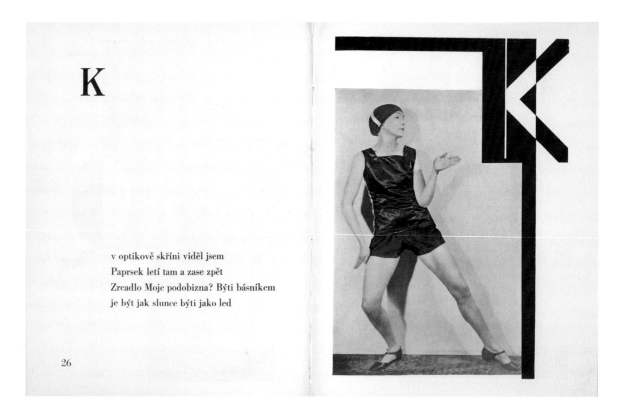

K

v optikově skříni viděl jsem
Paprsek letí tam a zase zpět
Zrcadlo Moje podobizna? Býti básníkem
je být jak slunce býti jako led

26

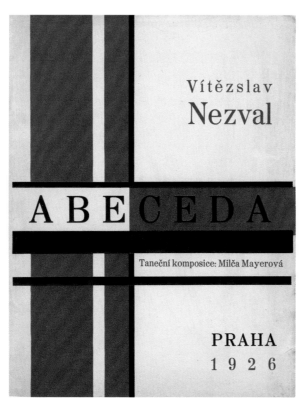

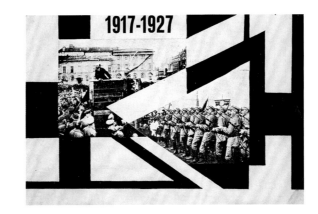

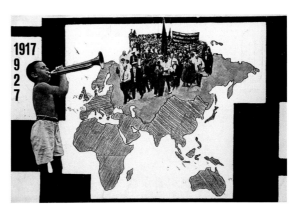

neat button of a cap and efficient white zips, reads as a swimsuit and an abstract typographic design. In creating the book (whose publication she arranged) Mayerová put no distance whatever between the constructive and the poetic: *Alphabet* served functionally as a business card for her new dance school in Prague, and advertised her training in a method based on the written notation of movement. The dance, meanwhile, permitted her the freedom to enact multiple and contradictory roles simply by following "to the letter" the poet Vítězslav Nezval's primer on language as a visual material.[24]

Teige seized on this project and made it a primer of his own, a set of foundational proposals on coordinating photography and type as a cohesive graphic unit. Nezval's poem, with which Teige's outsized block letters operate in tandem, presents readers with snake dancers, acrobats, Indians, and palm readers—a freewheeling circus troupe. Yet the new ABC was flexible, and could serve poetic and political "tasks" alike. Block patterns similar to the letters of *Alphabet* framed postcards advertising celebrations for the tenth anniversary of the Soviet revolution, in Brno in November 1927 (plate 62). Mayerová gave a dance recital during the festivities, and a press report indicates that Teige's photomontages may have been projected as accompaniment.[25] Earlier that year, his page design for letter T, with a caption on Mayerová, had appeared complete on the front page of the same magazine (fig. 5.3).

The cover of *Alphabet*, meanwhile, is a geometric abstraction in the Constructivist idiom that is drained, moreover, of the bright colors typically associated with the books and magazines that movement inspired. At first it seems to bear little relationship to the book's contents. A lattice of black and dark-brown bands is stretched tautly across a field of beige, with all three tones meeting in the one-word title at the center. Further information, likewise organized into rectilinear blocks, comes across clearly and prosaically: the authors' names and their relative importance (Teige modestly absents himself), and place and date

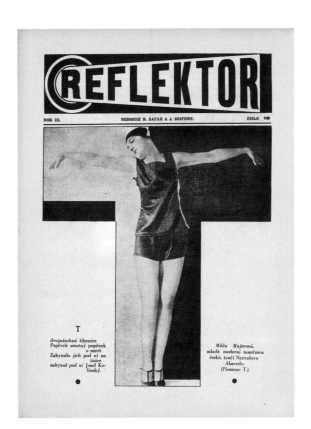

of publication. The neutral bands framing this information give no hint of the hedonistic verses within, much less of their erotic embodiment in the sphere of dance. Nothing in this sober layout evokes a "picture poem"— except the rhythm; it is in this way that the cover comes alive. No two bands—whether black, brown, or beige—are of equal width, and as a result the page ripples. Quick-slow, quick-slow, the bands move, tripping from left to right, at a tempo that suffuses dour orderliness with an incontestable vibrancy. "If the editors of *Reflektor* invite a worker to a rally, they don't ask him to walk there doing the fox-trot," wrote Roman Jakobson in *Pásmo*, arguing for a clear separation between what he called "communicative" and "poetic" functions.[26] Not so if the invitation came from that magazine's typographer.

Notes

1. Jan Tschichold apparently suggested to Zwart on November 30, 1927, that he, Teige, Lissitzky, and Lajos Kassák should become "fraternal spirits" of the Berlin-based organization. Teige showed with the group's members in *Film und Foto, Gefesselter Blick,* and other key exhibitions from 1929 to 1931. This information is reported in Karel Srp, Lenka Bydžovská, and Polana Bregantová, *Karel Teige a typografie: asymetrická harmonie* (Prague: Arbor Vitae, 2009), pp. 138–39.

2. Peter Zusi, "The Style of the Present: Karel Teige on Constructivism and Poetism," *Representations* 88 (Autumn 2004), p. 113.

3. Karel Teige, "Poetismus" (1924); reprinted as "Poetism" in *Karel Teige, 1900–1951: L'Enfant Terrible of the Czech Modernist Avant-Garde,* ed. Eric Dluhosch and Rostislav Švácha (Cambridge, Mass.: MIT Press, 1999), p. 67.

4. On the paradigm of avant-garde identification with "marginal, 'non-artistic' forms of expressivity . . . improvised by other social groups out of the degraded materials of capitalist manufacture," see Thomas Crow, "Modernism and Mass Culture" (1983), revised in *Modern Art in the Common Culture* (New Haven, Conn.: Yale University Press, 1996), pp. 3–37.

5. Karel Teige, "Nové uměni a lidová tvorba" (1921); cited in Rostislav Švácha, "Karel Teige jako teoretik architektury," *Philosophica-Aesthetica* 16 (1995), p. 146.

6. Karel Teige, *Nejmenší byt* (1932); reprinted as *The Minimum Dwelling,* trans. and intro. Eric Dluhosch (Cambridge, Mass.: MIT Press, 2002).

7. The word *devětsil* denotes an ordinary cornflower, *petasites vulgaris.* The word derives from devět + síla, that is, "nine strengths" or "nine forces." For a list of the group's members, see František Šmejkal, *Devětsil* (Oxford: Modern Art Museum, 1990), pp. 106–09.

8. Karel Teige, "Obrazy a předobrazy" (1921), in Teige, *Svět stavby a básně: Studie z 20. let. Vybor z dila I,* ed. Jiří Brabec et al. (Prague: Československý spisovatel, 1966), p. 97 (hereafter cited as Teige I).

9. Ibid., p. 102.

10. Zdenek Primus surveys the picture poems in his essay "Obrazová báseň: entuziastický produkt poetismu," in *Karel Teige, 1900–1951,* ed. Karel Srp (Prague: GHMP, 1994), pp. 48–62; as does Jindřich Toman, *Foto/montáž tiskem — Photo/Montage in Print* (Prague: Kant, 2009), pp. 83–94.

11. Karel Teige, "Maliřstvi a poesie" (1923), in Teige I, p. 495.

12. Andrew Herscher, "Collage City (Prague circa 1925)," paper delivered at Czech Studies Workshop, University of Michigan, Ann Arbor, April 2003.

13. See Matthew S. Witkovsky, "The Cage of the Center," in *Local Strategies, International Ambitions: Modern Art and Central Europe, 1918–1968,* ed. Vojtěch Lahoda (Prague: Artefactum, 2006), pp. 203–210.

14. Toman, *Photo/Montage in Print,* p. 76, ill. pp. 62, 75.

15. Karel Srp describes this trip in "La formazione artistica del giovane Teige (1916–1923)," in *Karel Teige: Luoghi e pensieri del moderno,* ed. Manuela Castagnara Codeluppi (Milan: Electa, 1996), pp. 35, 37.

16. Karel Teige, "Foto Kino Film" (1922), in Teige I, pp. 71–72, 74, 75.

17. On these polemics, see Rostislav Švácha, "Before and after the Mundaneum: Karel Teige as Theoretician of the Architectural Avant-Garde," in Dluhosch and Švácha, *L'Enfant Terrible,* pp. 107–39.

18. Karel Teige, "Konstruktivismus a likvidace 'uměni'" (1925); reprinted as "Constructivism and the Liquidation of 'Art,'" in Teige, *Modern Architecture in Czechoslovakia and Other Writings,* ed. and intro. Jean-Louis Cohen (Los Angeles: Getty Publications, 2000), p. 332.

19. Ibid., p. 335.

20. Srp, Bydžovská, and Bregantová, *Karel Teige a typografie,* pp. 6–7.

21. Teige, "Moderní typografie" (1931); reprinted in Srp, Bydžovská, and Bregantová, *Karel Teige a typografie,* p. 242.

22. Andrew Herscher, "The Media(tion) of Building: Manifesto Architecture in the Czech Avant-Garde," *Oxford Art Journal* 27, no. 2 (2004), pp. 193–217, esp. pp. 200–202.

23. Reiner, "Nigger Kunst [sic]," *Prager Presse,* Oct. 16, 1925, p. 7.

24. See Matthew S. Witkovsky, "Staging Language: Milča Mayerová and the Czech Book *Alphabet,*" *Art Bulletin* 86, no. 1 (March 2004), pp. 114–37.

25. The communist daily *Rovnost* announced Mayerová's forthcoming dance recital on November 3, 1927, and its critic Jaroslav B. Svrček reviewed it on November 8. The advance notice states: "Individual letters that imitate the poem and the dance will be projected simultaneously."

26. Roman Jakobson, "Konec básnického umprumáctvi a živnostnictvi" (1925); reprinted in Jakobson, *Poetická funkce* (Prague: H + H, 1995), p. 564.

J, N Ú, willen náast het officiëele tooneel, aan typeerende en merkwaardige uitingen van NU de gelegenheid geven zich uit te spreken voor hen, die hun tijd willen kennen.

J, N Ú, willen trachten iets te stellen tegenover de tendenz van deze epoche, die haar too-neelkunst overwegend baseert op de literatuur van voorbije perioden.

J, N Ú, willen, dat, wat NU ont-stond, een kans geven..tooneel-spel, film, acrobatie, dans, woord, licht, kleur en klank, voor zoover ze karakteristieke vorm aannamen.

J, N Ú, weten dat ons streven niet anders kan en zal zijn, dan ex-perimenteel.

J, N Ú, hebben vertrouwen in de scheppende kracht van dezen tijd; we weten, dat er belangwekkende uitingen zijn.

J, N Ú, hebben vertrouwen in de daadkracht der jongeren en in hen, die luisteren willen naar wat ONZEN TIJD hun - per tooneel - te zeggen heeft.

WIJ NU

EXPERIMENTEEL
Tooneel EEL

WIJN
OPGERICHT door: Simon Kost
Albert van
Jhr. W. F.
WIJ NU - VOORSTELLIN
PRINCES

ER
ZIJN
3
MOGELIJKHEDEN
VOOR
U

NANCY J. TROY

6

Piet Zwart

ART, OBJECTIVITY, AND THE FUNCTIONALISM OF EVERYDAY LIFE

Although Piet Zwart played a significant role in the development and circulation of European modernist graphic design and photomontage during the 1920s and 1930s, his contribution to the interwar avant-garde has not been widely recognized outside the Netherlands. Born in 1885 in Zaandijk, an industrial town in the polders between Amsterdam and the North Sea, Zwart matured alongside the artists and architects who became famous as members of the Dutch modernist movement known as De Stijl (The Style). He worked in the architectural office of Jan Wils between 1919 and 1921, visited Piet Mondrian in Paris in the mid-1920s, and became a close friend of the Hungarian-born painter and graphic designer Vilmos Huszár, who in 1917 had designed the first cover of the journal *De Stijl.* Zwart's work of the late 1910s and early 1920s often betrays his debt to these more familiar figures, despite the fact that in 1919 he publicly criticized the members of the group for being excessively formulaic. At this time, he responded as much to the expressionist orientation of Hendrik Wijdeveld, editor of the journal *Wendingen,* and other architects of the Amsterdam school as he did to the rectilinear simplicity characteristic of De Stijl. But Zwart never aligned himself with a particular program, and indeed throughout his career he rejected anything that smacked of a prescriptive aesthetic. Even though he wrote a great deal of criticism about contemporary architecture and design during the interwar years, his regular column appeared, beginning in 1926, in *Het Vaderland* (The Fatherland), a progressive-liberal newspaper published in The Hague — not in *Wendingen, De Stijl,* or any other vanguard art journal of the period.

Zwart's relative obscurity may be attributed to his position on the periphery of those Dutch movements that have garnered the lion's share of attention from scholars of international modernism, and to the fact that the principal publications about his work have all appeared in Dutch.[1] Yet Zwart was in fact a central figure in the development and dissemination of modernist design who worked for the elder statesman of Dutch modernist architecture, Hendrik Petrus Berlage, for seven

years after leaving Wils's office. He maintained personal relationships with such internationally influential figures as El Lissitzky, Kurt Schwitters, and Jan Tschichold; participated in numerous exhibitions of the Ring neue Werbegestalter (Circle of New Advertising Designers), established by Schwitters in 1927; taught briefly at the Bauhaus the following year; and, not incidentally, created some of the most compelling works of graphic advertising of the interwar period. Zwart prided himself on being a longtime communist, but he was never an activist and he self-consciously constructed his identity outside the bounds of particular movements, whether political or aesthetic.

In his maturity, Zwart became committed to the principles of functionalism and objectivity, thereby distancing himself from his training and early practice as a decorative artist. Although he lacked formal education in architecture, he preferred to think of himself as an architect rather than an artist or decorator. In statements made throughout his professional career, he pointedly rejected not just ornament and decoration, as did many artists and architects of his generation, but art and aesthetic considerations as well.[2] Writing in 1929 about the prevailing lack of appreciation for contemporary photography in Holland, he declared:

We have struggled over the question of whether photography can be art, and in doing so we have mainly been looking at more or less impressionistic attempts at photography that have almost nothing to do with specifically photographic means.... These questions are unimportant because any argument over a misunderstanding is unimportant. It is only important that we learn to understand the value of the photographic medium for social and scientific life.... Photography is exclusively neither a scientific nor an aesthetic problem, but a problem of a social and economic nature of far-reaching and growing significance.[3]

Twenty years later, he still maintained the same conception of photographic practice as socially imbedded and therefore antithetical to the making of art:

Photography is located on a different meridian than art. Art smuggled into photography: a caricature. The working terrain of photography is material reality; documentary image-making of reality its purpose; democratizing of the world its task; honest enlightenment of the masses its responsibility; programmatic, tendentious falsification of these facts its betrayal. These values have nothing to do with aesthetic intentions.[4]

And yet, surveying Zwart's oeuvre as a whole, it becomes clear that the facility for draftsmanship, composition, and design that he exhibited in his youthful decorative projects for individual patrons continued to characterize his later career as a typographer, photographer, and designer working in the context of advertising and industry. The style of his work changed dramatically with his embrace of mechanical and industrial production. Yet the fervor that animated his rejection of art belies the aesthetic judgments that are everywhere evident in his engagement — as both a designer and a photographer — with the material reality of everyday life. Typically, he did not seek out this reality on the streets or in working-class crowds but in factories he visited in connection with advertising work for major industrial firms. Rather than seeing his mature work, beginning around 1920, as marking a distinct break with his earlier training and projects, as Zwart himself was prone to do, it is appropriate to view the arc of his career as a whole in order to appreciate the continuity that he actively sought to obscure.

Zwart studied painting and decorative art from 1902 until 1907 at the Rijksschool voor Kunstnijverheid (State School for Arts and Crafts), which was housed on the top floor of the Rijksmuseum in Amsterdam. Later in life, he recalled that he had had little to do with the teachers there, but during this period he learned how to make furniture and batiks, designed a loom, and frequently sketched out of doors. He produced numerous studies of plants and flowers that range from naturalistic representations to flattened and simplified exercises based on mathematical ordering systems in the spirit of the architect and decorative artist K. P. C. de Bazel, who was active and influential in the Netherlands from the 1890s through the mid-1920s (fig. 6.1). Several evenings a week, Zwart gave lessons

at the crafts school in Wormerveer, the town where he lived with his parents. Looking back on these experiences, he denigrated his training in the decorative arts, preferring to recall his early self-education in political philosophy, particularly in the writings of G.W. F. Hegel, Friedrich Engels, and, eventually, in the dialec-tical materialism of Karl Marx. He also developed an interest in theosophy and became a vegetarian and teetotaler. After leaving school, he was required to spend two years in the military but refused on principle to become an officer, serving instead as a hospital orderly.

In 1909 Zwart assumed his first professional position, as a drawing teacher at the Industrie- en Huis-houdschool voor Meisjes (Industrial and Domestic Science School for Girls) in Leeuwarden, capital of the northern province of Friesland. The young designer thus found himself in a feminized environment where he was expected to teach drawing and design as well as some art history but also to create decorative patterns that his students could apply to book covers, tea cozies, or coverlets for cradles (fig. 6.2). Many of the floral motifs he produced were borrowed from reproductions in craft journals that often featured work from Germany and Austria. Increasingly, Zwart's attention concentrated on designs of the Wiener Werkstätte. The first furniture he created, dating from 1910–12, reveals the sober, constructive functionalism pioneered by an earlier generation of Dutch designers, including Berlage, De Bazel, and G.W. Dijsselhof. By late 1912, however, his work was oriented more toward the folkloristic decorative style of the Viennese designers Josef Hoffmann, Koloman Moser, and Dagobert Peche. The drawings he made in 1912 and 1913 for the dining room in a monumental townhouse of a Leeuwarden notary and collector—including furniture as well as floor and wall treatments with flower and fruit motifs colored in shades of green, purple, red, and ocher (fig. 6.3)—show the richness of Zwart's decorative inclinations and the elegance of his draftsmanship during this early period, thus revealing a tendency toward sensual pleasure he would later disavow.

Zwart married Marie (Rie) Ketjen, a teacher of cooking and nutrition, in spring 1912. The daughter of a businessman, she enjoyed a relatively privileged (and conservative) upbringing that differed from Zwart's. Together they moved to a house for which Zwart designed various pieces of furniture, including a soberly decorated bookcase and dining-room set that he kept throughout his life.[5] By the fall of 1913, however, he was feeling professionally isolated in Leeuwarden, where he had few contacts with architects and where it was difficult to develop career opportunities beyond the occasional commission for furniture and interiors. He therefore decided to study architecture at the Technische Hogeschool (Technical Institute) in Delft. The couple moved to The Hague suburb of Voorburg, where her money enabled them to buy a comfortable house. Zwart's plan was interrupted when he was briefly mobilized after World War I broke out in August 1914, and he abandoned it when his wife lost her fortune during the conflict.

To make a living, Zwart began creating simple clothing for children, along with pillows, tablecloths, and other decorative objects with embroidered fabrics that he designed in a style reminiscent of Austrian and German craft production while his wife did the needle-work. In 1915 Zwart made the first of numerous designs for women's clothing in a variant of the loosely fitting styles associated with the reform-clothing movement and particularly the Wiener Werkstätte that had become fashionable in the early 1910s. So closely was Zwart bas-ing his work on Wiener Werkstätte precedents that some of the textiles he designed during this period have been described as virtually indistinguishable from those of Josef Hoffmann.[6]

By the end of the war, Zwart's work was exhibiting greater eclecticism as he became interested in the organic, sculptural style that characterized the furniture and interiors of the architects Michel de Klerk and Piet Kramer, members of what by then was being called the Amsterdam School. At the same time, through his membership in the Haagsche Kunstkring (Hague Art Circle)—for which he gave occasional

6.1

Piet Zwart (Dutch, 1885–1977), *Hepatica triloba,* 1903; pencil and watercolor on paper. Gemeentemuseum, The Hague.

6.2

Piet Zwart (Dutch, 1885–1977), designs for border patterns, page from a sketchbook, 1909; watercolor on paper. Gemeentemuseum, The Hague.

6.3

Piet Zwart (Dutch, 1885–1977), design for the dining room of Nanne Ottema, 1912–13; pencil and watercolor on paper. Gemeentemuseum, The Hague.

lectures, mounted a few exhibitions, and designed some printed materials—Zwart came into contact with Vilmos Huszár, who shared his interest in monumental art and in the social role of painting and architecture. He also began publishing criticism, in which, for the first time, he explicitly turned away from the ornamental, decorative orientation that he himself had been advocating for years. In 1919 Jan Wils hired him as a draftsman and furniture designer, a practice Zwart pursued in collaboration with Huszár as well. Around this time his work began more consistently to demonstrate a forthright, functional simplicity that bore less and less evidence of his earlier aesthetic proclivities for either the Wiener Werkstätte or the Amsterdam School.

By the summer of 1921, when Wils had to reduce his office staff and Zwart was among those he let go, Zwart had integrated the formal principles of De Stijl into his own approach to design. Although he had canceled his subscription to the journal a year earlier, he continued to look closely at what appeared in its pages. The influence of De Stijl, and especially of Huszár, is evident in his first independent typographic commission, a series of advertising cards created between 1921 and 1924 for Vickers House, an English industrial manufacturer with several subsidiaries in The Hague (figs. 6.4–6.6). Denser in their presentation than the stationery headings Zwart had previously designed for himself and for Wils, these geometric logos and severe letterforms achieve a striking graphic presence through their compressed arrangement, sometimes in vertical as well as horizontal orientation, across the white field of the small cards. His 1923 advertisement in red and black for a housing office in The Hague conveys an equally powerful graphic message using the same stylistic elements on a slightly larger scale (plate 63). The fact that Zwart was still very much aware of *De Stijl* is evident in a Vickers House ad that borrows directly from a text page of Theo Van Doesburg's adaptation, in Dutch, of El Lissitzky's *Pro 2* ∎

6.4

Piet Zwart (Dutch,
1885–1977), letter card
for Vickers House,
Xylos-Compagnie, Den
Haag, 1921; letterpress.
Gemeentemuseum,
The Hague.

6.5

Piet Zwart (Dutch,
1885–1977), advertising
card for Vickers House,
IOCO rubber floors, c. 1922;
two-color letterpress.
Gemeentemuseum,
The Hague.

6.6

Piet Zwart (Dutch,
1885–1977), advertising
card for Vickers
House, N.E.T.IJ, 1923;
two-color letterpress.
Gemeentemuseum,
The Hague.

VERLOOP Tel 11577

WONING BUREAU

ANNA PAULOWNASTR 49

A HAAG

(Pro dva kvadrata or Of Two Squares), published as a special edition of the journal in October 1922 (see plate 12, pp. 26–27).

At the start of his career in graphic design, Zwart had little knowledge of printing techniques or materials. Of the designs for Vickers House he recalled, "Those were very simple things that I could compose at home with a couple of lines and with a few words added alongside."[7] Although he must have seen van Doesburg's first experiments in Dada typography in the pages of *De Stijl* in 1920, and a poem by Kurt Schwitters that appeared in the magazine the following year, he did not compose words diagonally or in markedly different fonts for his own designs. It would be several years before he inflected the presentation of text with arrows or graphic signs, such as hands with pointing fingers. By that time he had met Schwitters, having attended several evenings of the Dada tour of Holland that the Swiss artist made with Huszár, van Doesburg, and the latter's wife, Nelly, in early 1923. Schwitters's impact on Zwart was swift and strong: he loosened up his sober advertising designs by using multiple letterforms in various weights and colors, confusing the orientations or breaking up text with conflicting directional signals, and spreading individual words across the page.[8] Many of these strategies, based on the deployment of typographic materials as expressive formal elements in their own right, are also present in the graphic designs of Lissitzky, who was the other great influence on Zwart's development as a typographer in the early 1920s.

As soon as van Doesburg met Lissitzky, in Berlin during the winter of 1921–22, articles and statements by the Russian artist began appearing in *De Stijl*. But it was not until October 1922, with the publication of *Of 2 Squares* in *De Stijl* and the simultaneous appearance of Lissitzky's design for a cover of *Wendingen,* that his work became widely known in the Netherlands.[9] The following spring, Lissitzky himself came to Amsterdam to organize an exhibition of Soviet art at the Stedelijk Museum, marking the first opportunity since the October Revolution of 1917 for Dutch audiences to familiarize themselves with recent art of the Russian

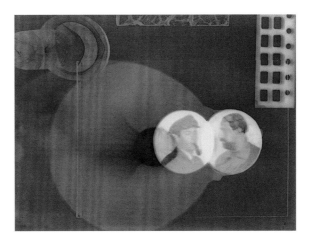

avant-garde. On May 18, 1923, Lissitzky presented a lecture to the Haagsche Kunstkring in which he offered a vision of the end of individual artistic expression that Zwart undoubtedly found sympathetic. Calling for an art of social revolution, Lissitzky argued that collaboration was essential in inventing forms relevant to contemporary social needs. While in The Hague, Lissitzky stayed with Huszár and visited Zwart, who lived nearby. Conversing in German, Zwart showed Lissitzky examples of his typographic work and received in return a copy of a recently published book of Vladimir Mayakovsky poems, *Dlia golosa* (*For the Voice*), for which Lissitzky had created a groundbreaking typographic design (see plate 37, p. 77) whose influence would soon be evident in Zwart's own work. The same would be true of Lissitzky's experiments with cameraless photography, one example of which he made with Huszár (fig. 6.7). That collaborative photogram, which Zwart must have seen, was published in Schwitters's journal *Merz* in the fall of 1923.[10]

By that time, Zwart had been working for Berlage for two years. One of his early projects was for crockery in pressed glass (plate 64), probably the result of an unfulfilled commission Berlage had received from the art patron Hélène Kröller-Müller several years earlier, the design of which he eventually turned over to Zwart. Although Zwart had to retain the six-sided form Berlage previously established for the dishes, and the rather awkward handles of the cups and other

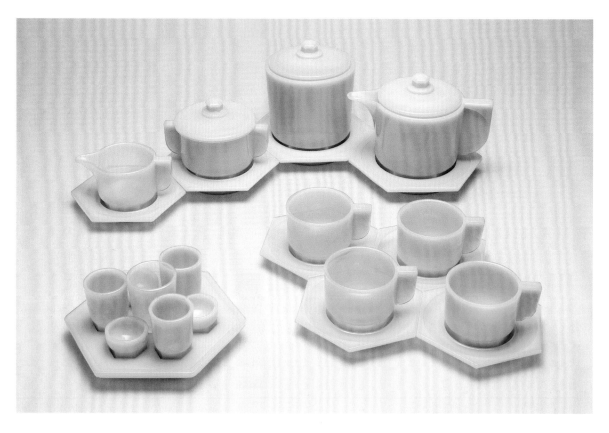

elements of the service were required for technical rea-
sons, the result fits remarkably with Zwart's modernist
ambitions. In particular, he developed standardized sizes
appropriate to mass production; many of the individual
parts were therefore interchangeable, and some could be
stacked atop one another. Although the visual form and
bright yellow color of the service are rather unusual, its
industrial production as well as its functionality make it
comparable to a series of kitchen-storage containers
Theodor Bogler designed at the Bauhaus around the
same time.

It was in 1923, the year he met both Schwitters
and Lissitzky, that Zwart began doing his best-known
typographic work — for the Nederlandsche Kabelfabriek
(or NKF, Netherlands Cable Factory), a firm that made
cables for the telephone and electrical industries. Ber-
lage got Zwart the job through his son-in-law, who was
the company's adjunct director, and hired him to pro-
duce advertisements in technical journals. Zwart turned
out two or three per month over more than a decade,

for a total of about 275; the first ad appeared on
September 26, 1923. Given Zwart's scant prior graphic-
design experience, it is not surprising that for several
years he looked to Schwitters and even more to Lis-
sitzky, whose novel work in the field served as a model
that inspired Zwart's own projects. He borrowed spe-
cific layouts from Lissitzky and explored photography
and photomontage with the latter's prototypes in mind.
He made his first photogram in 1924 (possibly under
Lissitzky's tutelage) and, two years later, bought his first
camera so that he could eventually make his own
photographs rather than depend on the work of others.
Nevertheless, when asked in 1926 to design a catalogue
advertising different kinds of cables manufactured by
NKF, Zwart chose to hire a professional, C. J. de Gilde,
whom he instructed to photograph sharply focused
close-ups and cross-sections of cables that Zwart incor-
porated in many photomontages for the catalogue,
which appeared in 1928 (plates 65 and 66).

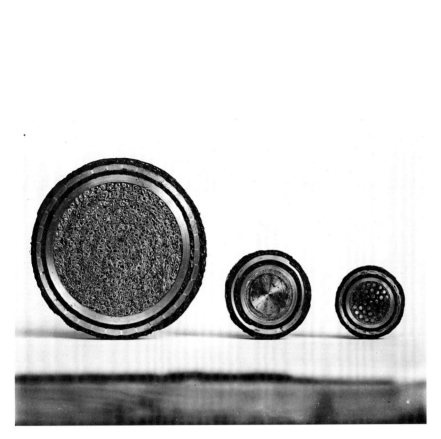

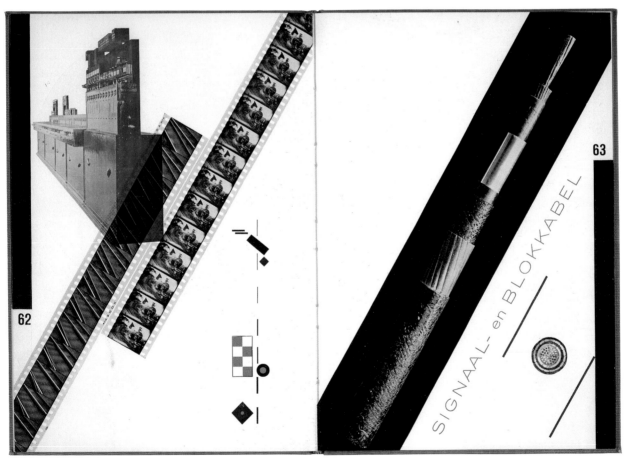

INTERNATIONALE
TENTOONSTELLING
OP FILMGEBIED

ITF

FILM

14 APRIL
15 MEI
1928
GROOTE KONINKLIJKE
BAZAR ZEESTRAAT 82
DEN HAAG

P. ZWART.

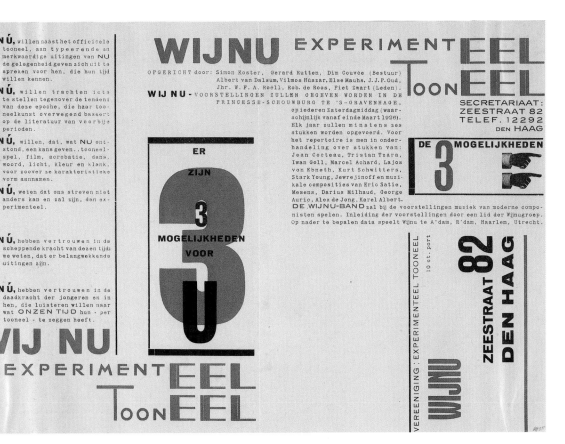

Published in Dutch and English editions, the NKF catalogue represents a high point in Zwart's career as "typotekt," in which he melded his earlier interests in typography and architectural design with his new exploration of photographic media. With its restrained yet vitalizing use of red, yellow, and blue, the publication combines minimal text with crisp images—often diagonally oriented—that emphasize material and functional specificity to convey technical information in a highly dynamic series of double-page spreads sequenced like the frames of a film. One page even incorporates two film strips, just as Zwart did in his poster design, in red and blue on a white ground, for the Internationale Tentoonstelling op Filmgebied (International Film Exhibition), held in The Hague in the spring of 1928 (plate 67). As the exhibition architect, Zwart provided the governing aesthetic of the entire enterprise. In addition to the poster, he created a host of related graphic materials and designed the exhibition building's entrance and interiors, which included a stand for the Kodak company and a café with a Hollywood-themed bar.

Despite these bows to the commercial film industry, Zwart was primarily interested in experimental film, the promotion of which was a goal of the short-lived theater society Wij Nu (Us Now), which he cofounded in 1926. For Wij Nu he created a letterhead whose question marks and exclamation points expressed the group's experimental orientation (see plate 4, p. 17). This was more explicitly declared in a manifesto, which Zwart also designed, in which members rejected traditional theater based, they declared, in the literature of the past (plate 68). Instead they called for a renewal of the "theatrical play, film, acrobatics, dance, word, light, color and sound" in forms expressive of the modern period.

69

Piet Zwart (Dutch, 1885–
1977), covers for two
books in the series *Film:
A Series of Monographs
on the Art of Film* [*Film:
Serie monografieën over
filmkunst*], C. J. Graadt
van Roggen, editor:
A. *The Linen Window* [*Het
Linnen Venster*], 1931;
B. *American Film Art*
[*Amerikaansche Film-
kunst*], 1931; letterpress,
22 × 17.7 cm.

Although Zwart was fascinated by film, unlike a number of typographers and photographers with whom he was in contact, including László Moholy-Nagy and Paul Schuitema, he never became a filmmaker. He did, however, seriously consider writing a book about film advertising that was to have appeared in the Rotterdam series Monografieën over Filmkunst (Monographs on the Art of Film) published from 1931 to 1933. Zwart designed covers not only for his own book, which never materialized, but also for the ten in the series that did appear, creating a standard format that made them recognizable as a group (plate 69). Each cover features a photomontage printed in what looks like a semitransparent screen of blue or red. The title and author's name are in capital letters that run like a strip diagonally across the field, while the series and volume identifications appear in the bottom-right corner. The word *film,* in large lowercase letters, floats across the visually active surface of each design, often touching, and in one case cut off, at the edges of the field.

In 1930 Zwart helped produce several advertising films for the Staatsbedrijf der Posterijen, Telegrafie en Telefonie (Dutch Post, Telegraph, and Telephone Company, or PTT). Seeking to familiarize the public with its growing number of products and services, including airmail routes to the nation's far-flung colonies, the PTT had established a Department for Press and Propaganda in 1927. Zwart's first PTT designs, including posters and brochures combining photomontage and letterpress compositions, date from 1929.

By that year he was making his own photographs, not only in the service of his photomontages and advertising but also as independent works. The various functions were almost always interrelated. Thus some of his most powerful and effective photographs showing details of machinery or massive spools of industrial cables (plates 70–72) were taken in workplaces and factories, and many of these found their way into his advertising designs. In fact, most were made for that pupose. Similarly, an elegant photographic still life of a lone drinking glass beside a cocktail stirrer, both of which cast shadows on a white damask tablecloth

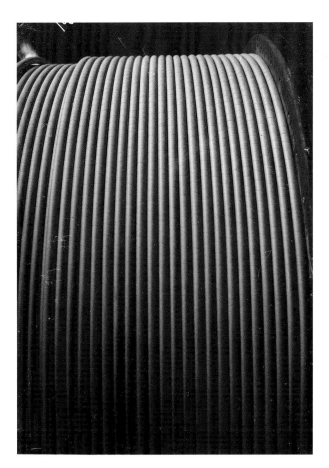

70

Piet Zwart (Dutch, 1885–1977), photograph of cable reel in the Netherlands Cable Factory, 1931; gelatin silver print, 17.1 × 12 cm.

71

Piet Zwart (Dutch, 1885–1977), photograph of a cable machine, 1931; gelatin silver print, 8.2 × 11.1 cm.

(fig. 6.8) was likely made to advertise the crystal service Zwart designed in the late 1920s for NV Kristalunie (Dutch Crystal Union) in Maastricht. Photographs of trees and plants as well as a wide range of other subjects, both natural and manufactured, demonstrate the diversity of Zwart's interests as well as the facility he had developed with the medium by the early 1930s.

For most of that decade, Zwart worked on a booklet to instruct children about how to use the PTT's services. Published in 1938, *Het boek van PTT* (*The PTT Book*) (fig. 6.9) appears to constitute a striking departure from Zwart's earlier graphic advertising, despite its inclusion of numerous photographs and photomontages. The figurative style seems sentimental if not ingratiating, and the text is humorous as well as educational. Yet this book is not so different from the NKF catalogue of 1928; the two publications reflect a concern for such characteristically modernist issues as standardization, mechanization, and the demands these place on a corporation's clients. Various pages in the *PTT Book* are devoted, for example, to explaining how to address and stamp mail for sorting and franking by machine. At the same time, as a visual object filled with colorful illustrations in an endearing and accessible style, the booklet is also reminiscent of figurative drawings Zwart produced before he began experimenting with modernist typography, or committed himself to objective and material reality as isolated through his camera lens.

Although Zwart never abandoned the modernist techniques and strategies to which he had been introduced early in the interwar period, his design work in German-occupied Holland during World War II was necessarily conservative. When he spent several months in an internment camp due to his status as a communist sympathizer, he even rediscovered his ability to render quite beautiful pencil drawings in a naturalistic style that he had abandoned two decades earlier in favor of the mechanistic implications of photography and graphic design (fig. 6.10). Since Zwart made these drawings under conditions over which he had little or no control, it may not be appropriate to categorize them

as works of art that he would have acknowledged as part of his oeuvre. Yet they demonstrate that he retained a lifelong ability to craft an aesthetically pleasing visual object in a decidedly conventional manner. And this in turn suggests why, in coming to grips with the character of his work it no longer seems necessary to distinguish between art on one hand and an objective approach to material reality on the other—despite Zwart's protests to the contrary. Whereas many of his contemporaries used their graphic work to express political convictions about everyday life, Zwart in his work—including the photographs, photograms, and typographic designs—focused on industry not as it affected members of the working classes but as products to be advertised on behalf of his employers. The idea that the pleasing or the beautiful is de facto incompatible with the unmediated functionalism of everyday life is a relic of Zwart's autobiographical narrative that the sustained sophistication and complexity of his work prompts us to recognize as a historical construct worthy of further interrogation.

Notes

1. Kees Broos, former curator at the Haags Gemeentemuseum, where Piet Zwart's archive is housed, has published extensively on the artist. See his catalogue accompanying the first retrospective exhibition devoted to Zwart's work: *Piet Zwart* (The Hague: Gemeentemuseum, 1973). A much more detailed and wide-ranging publication accompanied the retrospective mounted in 2008: Yvonne Brentjens, *Piet Zwart, Vormingenieur: 1885–1977* (The Hague: Gemeente-museum/Zwolle: Waanders, 2008). The present essay owes much to Brentjens's exemplary scholarship. See also Els Hoek, "Piet Zwart and Kurt Schwitters," trans. Mari Shields, in *Kurt Schwitters in Nederland: Merz, De Stijl, and Holland Dada,* ed. Meta Knol (Zwolle: Waanders, 1997), pp. 99–105.

2. Zwart's relationship to art and ornament was more complex than this rejection on principle might imply. As a teacher at the Academie van Beeldende Kunsten en Technische Wetenschappen Rotter-dam (Rotterdam Academy of Fine Arts and Technical Sciences) from 1919 to 1933, he began by giving lessons in the history of style and ornament, later adding a course in ornamental and perspec-tival drawing (Broos, *Piet Zwart,* p. 80.) By the end of the 1920s, however, he had become a strong advocate of art-education reform. His 1931 proposal for the reorganization of the Afdeling Deco-ratie en Kunstnijverheid (Department of Decoration and Industrial Arts) was rejected and eventually led to his dis-missal from his teaching post in Rotter-dam. See Hripsimé Visser, "Practical, Use-ful Photos," in *Piet Zwart,* SMA Cahiers 4 (Amsterdam: Stedelijk Museum, 1996), p. 18, n. 5.

3. Piet Zwart, "De Fifo te Stuttgart" (1929); cited in Kees Broos, "Fifo 1929 — de Nieuwe Fotografie," *Fotografie in Neder-land, 1920–1940,* ed. Flip Bool and Kees Broos (The Hague: Gemeente-museum, 1979), pp. 36–37. This and subsequent translations from Dutch are by the author with assistance from Wim de Wit.

4. Piet Zwart, "De taak der fotografie" (1948); cited in Broos, "Fifo 1929," p. 42.

5. In 1967 he described the chairs as "just good old mahogany furniture. Nothing more." Piet Zwart interviewed by Emy Huf in a television documentary, "De onvergetelijken (Piet Zwart)," quoted in Brentjens, *Piet Zwart,* p. 28.

6. Brentjens, *Piet Zwart,* p. 41.

7. Piet Zwart, 1968, quoted in Broos, *Piet Zwart,* p. 36.

8. Els Hoek has argued that Schwitters was in turn influenced by Zwart's typog-raphy, for example in the summer 1924 issue of his journal *Merz.* See Hoek, "Piet Zwart and Kurt Schwitters," p. 103.

9. Brentjens, *Piet Zwart,* p. 98.

10. Ibid., pp. 126–35.

Translations and orthography: Original language designations are provided for art movements and art-related organizations, exhibitions, and primary source books and periodicals; an accompanying translation is given everywhere except in footnotes, or in cases where the original may readily be understood by English speakers. The names of non-art movements or institutions, such as political parties, are given in their English equivalents. Transliteration from the Russian follows Library of Congress standards, except for the names of individuals still familiar to English speakers under an older spelling.

Citations: Full bibliographic citations are provided in the notes once each chapter. Further references in the same chapter mention only the author and an abbreviated title. Archival and primary references that have been subsequently quoted or reprinted are cited by year of original creation, followed by a full reference to the more recent publication. In the selected bibliography, publications that cover work by more than one artist in the exhibition will be found alphabetically under the first artist's name.

Captions: Titles, when not printed directly on the object, are descriptive (e.g., "advertising photograph for Ladislav Sutnar china") rather than artistic. The photographs and original photomontages in this exhibition were almost all made for reproduction in book or poster projects, and are therefore not titled as independent works of art. Dates are presumed to apply to both the negative and print, except where noted. In the case of books and journals, primacy is given to the designer or illustrator rather than the author or editor.

Dimensions and medium: Dimensions are given in centimeters, with height preceding width. Depth is not given for printed matter except in cases where the publication was boxed or otherwise converted into a sculptural object. Brief descriptions are offered here of the principal techniques discussed in this book.

Letterpress: A general term for printing from an raised surface that has been inked and upon which the paper is impressed. This type of commercial relief printing includes halftone and line block processes. Ink is pressed into the paper from a matrix in such a way that excess ink is "squeezed out" to the edges of the dot, leaving an ink rim and a slight planar distortion, both of which are visible under magnification and easily identify the technique.

Lithograph: A technique that relies on the fundamental properties of oil and water as mutually repellent. Thus, the chemically treated surface of a stone or metal plate will accept ink where oily and repel it where wet. In offset lithography, the image is made on a rubber-blanketed cylinder and then transferred to the paper being printed. Lithographic techniques are planographic, meaning there is no planar distortion and the ink dots have uniform ink distribution and blurred edges.

Gravure: Gravure is a mechanical intaglio process that includes rotogravure, wherein a continuous-tone positive (as opposed to a dot-pattern) is exposed through a gravure screen onto carbon tissue. This is mounted on a copper-plated cylinder to make prints that are easily identifiable by the grid system that comes from the printing screen.

Gelatin silver print and photogram: A print made on paper prepared with light-sensitive silver salts suspended in an emulsion of gelatin. Most twentieth-century gelatin silver prints revealed their images by developing out in a chemical solution. A photogram is made by placing an object directly on a light-sensitive paper or film and exposing it to light. The resulting image, made without the use of a camera, appears as a light form or silhouette against a dark background. Although photograms may be made using a variety of papers, most photograms from the 1920s and 1930s are gelatin silver prints.

Photomontage: A work of cut or torn and pasted photographs or photomechanical prints in ink, such as offset lithographs. Photomontages frequently include hand-drawn or other non-photographic elements. Many, if not most, photomontages from the interwar decades were made specifically for reproduction rather than exhibition as original works of art; actual cut and pasted works, and rephotographed or printed reproductions, are therefore referred to here equally as photomontages.

John Heartfield
(German, 1891–1968)

———

Selbstporträt [*Self-Portrait*], 1919; letterpress, 19.3 × 13.5 cm. The Art Institute of Chicago, on extended loan from Kent C. Chiang, 97.2009. **(Plate 16)**

———

Covers for Upton Sinclair:

Letterpress and lithograph, 18.9 × 13 cm (unless otherwise noted).

Hundert Prozent: Roman eines Patrioten [*100%: The Story of a Patriot*], Berlin, 1921. 18 × 12.9 cm. Private collection. **(Plate 15A)**

Man nennt mich Zimmermann [*They Call Me Carpenter*], Berlin, 1922. The Art Institute of Chicago, Robert Allerton Purchase Fund, 2009.329. **(Plate 15C)**

Nach der Sintflut: Ein Roman aus dem Jahre 2000 [*The Millennium: A Comedy of the Year 2000*], Berlin, 1925. Private collection.

Die Metropole [*The Metropolis*] Berlin, 1925. The Art Institute of Chicago, Robert Allerton Purchase Fund, 2009.330.

Petroleum [*Oil!*], Berlin, 1927. The Art Institute of Chicago, Robert Allerton Purchase Fund, 2009.331. **(Plate 15D)**

Petroleum [*Oil!*], Berlin, 1927. The Art Institute of Chicago, Mary Louise Stevenson Fund, 2009.456.

Der Sumpf [*The Jungle*], Berlin, 1928. Private collection. **(Plate 15B)**

Hundert Prozent: Roman eines Patrioten [*100%: The Story of a Patriot*], Berlin, 1928. Private collection.

Das Geld schreibt [*Money Writes!*], Berlin, 1930. The Art Institute of Chicago, Robert Allerton Purchase Fund, 2009.326.

———

Cover for Fedor Gladkov, *Zement* [*Tsement* (*Cement*)], Berlin, 1927; letterpress, 19.6 × 13.4 cm. The Art Institute of Chicago, Robert Allerton Purchase Fund, 2009.320. **(Plate 73)**

———

5 Finger hat die Hand [*The Hand Has Five Fingers*], 1928; gravure, 98.4 × 71.3 cm. The Art Institute of Chicago, Ada Turnbull Hertle Fund, 2009.290. **(Plate 13)**

———

Karel Teige (?) (Czech, 1900–1951) **after John Heartfield**

Das Gesicht des Faschismus [*The Face of Fascism*], cover for Stanislav K. Neumann, editor, *Reflektor* [*Headlight*] 4, no. 14, Prague, July 15, 1928; lithograph, 37 × 27.6 cm. Private collection. **(Plate 18)**

———

Cover and illustrations for Kurt Tucholsky, *Deutschland, Deutschland über Alles* [*Germany, Germany Above All*], Berlin, 1929; letterpress inset on canvas, 23.8 × 18.6 cm. The Art Institute of Chicago, Robert Allerton Purchase Fund, 2009.333. **(Plate 19)**

Covers for *AIZ* [*Arbeiter-Illustrierte-Zeitung,* or *Workers' Illustrated Magazine*], Berlin and Prague; gravure, 38.1 × 28 cm. The Art Institute of Chicago, Wirt D. Walker Trust, 2009.488. Exhibited: 47 (1929 [cover not by Heartfield]); 28 (1930); 23, 26–28, 30, 32, 35, 40, 44, 48, 51 (1931); 8, 14–15, 17, 26–30, 35–36, 38, 42 **(Plate 14B)**, 44–45, 48 **(Plate 14D)**, 50 (1932); 1 **(Plate 14C)**, 2, 5 (1933); 7, 11, 15–18, 23, 25–26, 30, 40 **(Plate 14A)**, 41, 43, 45, 47 (1934).

———

Untitled (*Lenin over Moscow*), 1931; gelatin silver print, 19.2 × 16.1 cm. The Art Institute of Chicago, Director's Fund, 2009.497. **(Plate 11)**

———

Covers for Jaroslav Hašek, *Dobrý voják Švejk* [*The Good Soldier Schweik*], Prague 1936; letterpress, 20.8 × 13.5 cm. The Art Institute of Chicago, Gladys N. Anderson Fund, 2009.502. Exhibited: complete set in six volumes. **(Plate 9)**

———

Cover for Jaroslav R. Vávra, *Petrolejáři* [*The Oil Men*], Prague, 1937; letterpress, 18.8 × 13.8 cm. The Art Institute of Chicago, Robert Allerton Purchase Fund, 2009.334. **(Plate 10)**

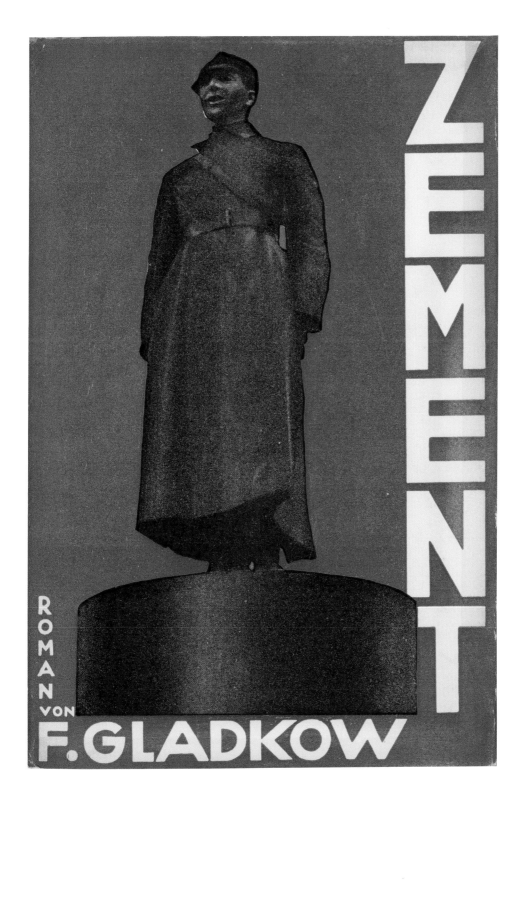

John Heartfield (German,
1891–1968), cover for
Fedor Gladkov, *Cement*
[*Zement* (*Tsement*)],
1927; letterpress,
19.6 × 13.4 cm.

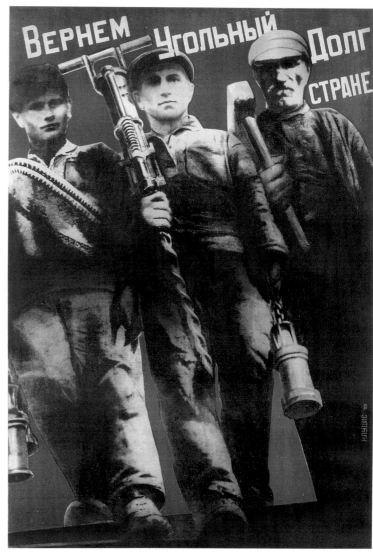

74

Gustav Klutsis (Latvian,
1895–1938), study for
poster *We Shall Fulfill
the Country's Coal Debt*
[*Vernem ugol'nyi dolg
strane*], 1930; gelatin
silver print with red
gouache, 16.1 × 11.2 cm.

75

Gustav Klutsis (Latvian,
1895–1938), *We Shall
Fulfill the Country's
Coal Debt* [*Vernem
ugol'nyi dolg strane*],
1930; lithograph,
104.9 × 73.8 cm.

76

Gustav Klutsis (Latvian,
1895–1938), *Under Threat
by Them Were Built . . .
We Struggled for 15
Years . . . Long Live the
Socialist Enterprise of the
USSR* [*Pod ugrozoj imi
15 let stroilis' my borolis'
da zdravstvuet social-
isticheskoe delo SSSR*],
1932; photomontage
(gelatin silver prints, ink,
pencil, and gouache),
33.5 × 22.8 cm.

Gustav Klutsis

(Latvian, 1895–1938)

Konstruktsiia [*Construction*], 1921; lithograph, 15.2 × 23.3 cm. The Art Institute of Chicago, Edward E. Ayer Fund in memory of Charles L. Hutchinson, 2009.283. **(Plate 21)**

Proekt agitatsionnoi ustanovki [*Project for an Agitational– Propaganda Stand*], 1922; brush and pen, black ink and red gouache on paper with graphite under- drawing, 20.9 × 29.7 cm. The Art Institute of Chicago, on extended loan from Robert and June Leibowits, 126.2009. **(Plate 22)**

Ustanovka k 4–omu kongressu Kominterna [*Installation for the Fourth Comintern Congress*], 1922; letterpress, 25.9 × 16.3 cm. The Art Institute of Chicago, Robert Allerton Purchase Fund, 2009.259. **(Plate 23)**

Ekran–tribuna–kiosk k 5–i godov- shchine Oktiabr'skoi revoliutsii [*Screen–Tribune–Kiosk for the Fifth Anniversary of the Great October Revolution*], 1922; letterpress, 25.8 × 15.6 cm. The Art Institute of Chicago, Wentworth Greene Field Memorial Fund, 2009.258. **(Plate 24)**

Valentina Kulagina (Russian, 1902–1987) after Gustav Klutsis

Dinamicheskii gorod [*Dynamic City*], 1923; lithograph, 18.3 × 23.8 cm. The Art Institute of Chicago, Edward E. Ayer Fund in Memory of Charles L. Hutchinson, 2009.284. **(Plate 20)**

Cover for Young Guard, *Pod znakom Komsomola* [*Under the Sign of the Komsomol*], 1924; letterpress, 22.2 × 15 cm. The Art Institute of Chicago, Wentworth Greene Field Memorial Fund, 2009.249. **(Plate 25)**

Gustav Klutsis and Valentina Kulagina

(Russian, 1902–1987)

Cover for Aleksei Kruchenykh, *Iazyk Lenina: Odinnadtsat' priemov Leninskoi rechi* [*Lenin's Language: Eleven Devices of Lenin's Speech*], Moscow, 1925; letterpress, 18.9 × 14.2 cm. The Art Institute of Chicago, Edward Johnson Fund, 2009.293.

Gustav Klutsis and Ivan Kliun (Russian, 1873–1943)

Cover for David Burlyuk et al., *Zhiv Kruchenykh! Sbornik statei* [*Kruchenykh Lives! A Collection of Essays*], Moscow, 1925; letterpress, 19 × 14.4 cm. The Art Institute of Chicago, Ralph Weil Fund in memory of Sam Carini, 2009.250.

Cover for Feliks Kon, editor, *Pamiati pogibshikh vozhdei* [*In Memory of Fallen Leaders*], Moscow, 1927; lithograph, 34.8 × 26.8 cm. The Art Institute of Chicago, Samuel A. Marx Purchase Fund, 2009.302. **(Plate 26)**

Maquette for postcard commem- orating the *Spartakiada* [*All–Union Olympiad*], 1928; lithographs and gelatin silver prints, 20 × 13 cm. Ne boltai! Collection. **(Plate 27)**

Postcards commemorating the *Spartakiada* [*All–Union Olympiad*], 1928; letterpress, 14.8 × 10.3 cm (each). The Art Institute of Chicago, Frederick W. Renshaw Acquisition Fund, 2009.286. Exhibited: complete set of nine postcards. **(Plate 28)**

Iz Rossii nepovskoi budet Rossiia sotsialisticheskaia [*From NEP Russia Will Come Socialist Russia*], 1930; lithograph, 104.1 × 73.3 cm. The Art Institute of Chicago, on extended loan from Robert and June Leibowits, 128.2009. **(Plate 29)**

Na shturm 3–go goda piatiletki [*In the Storm of the Third Year of the Five Year Plan*], 1930; lithograph, 108.7 × 73.3 cm. The Art Institute of Chicago, on extended loan from Robert and June Leibowits, 129.2009. **(Plate 30)**

Rabochie i rabotnitsy. Vse na perevybory sovetov [*Worker Men and Women: Everyone Vote in the Soviet Elections*], 1930; lithograph, 120 × 85.7 cm. The Art Institute of Chicago, on extended loan from Robert and June Leibowits, 132.2009. **(Plate 31)**

Pod znamenem Lenina, za sotsialisticheskoe stroitel'stvo [*Building Socialism Under the Banner of Lenin*], 1930; lithograph, 100 × 73 cm. The Art Institute of Chicago, on extended loan from Robert and June Leibowits, 125.2009. **(Plate 32)**

Study for poster *Vernem ugol'nyi dolg strane* [*We Shall Fulfill the Country's Coal Debt*], 1930; gelatin silver print with red gouache, 16.1 × 11.2 cm. The Art Institute of Chicago, on extended loan from Robert and June Leibowits, 133.2009. **(Plate 74)**

Vernem ugol'nyi dolg strane [*We Shall Fulfill the Country's Coal Debt*], 1930; lithograph, 104.9 × 73.8 cm. The Art Institute of Chicago, on extended loan from Robert and June Leibowits, 131.2009. **(Plate 75)**

Bor'ba za bol'shevistskuiu uborku urozhaia – bor'ba za sotsializm [*The Campaign for a Bolshevist Harvest is a Campaign for Socialism*], 1931; lithograph, 144.9 × 103.2 cm. The Art Institute of Chicago, on extended loan from Robert and June Leibowits, 130.2009.

Back cover for Pavel Novitskii, editor, *Brigada khudozhnikov* [*Artist's Brigade*], no. 1, Moscow, 1931; letterpress, 21.5 × 18.9 cm. The Art Institute of Chicago, Samuel A. Marx Purchase Fund, 2009.303. **(Plate 5)**

Pod ugrozoj imi 15 let stroilis' my borolis' da zdravstvuet socialisticheskoe delo SSSR [*Under Threat by Them Were Built... We Struggled for 15 Years... Long Live the Socialist Enterprise of the USSR*], 1932; photomontage (gelatin silver prints, ink, pencil, and gouache), 33.5 × 22.8 cm. The Art Institute of Chicago, on extended loan from Robert and June Leibowits, 134.2009. **(Plate 76)**

El Lissitzky

(Russian, 1890–1941)

Cover for Kazimir Malevich, *O novykh systemakh v iskusstve: Statika i skorost'* [*On New Systems in Art: Statics and Speed*], Vitebsk, 1919; lithograph, 23 × 19.1 cm. The Art Institute of Chicago, Mary Louise Stevenson Fund, 2009.480. **(Plate 36)**

Proun, 1920; collage (paper, abrasive paper, gouache, and paint) on board, 29.9 × 37.9 cm. The Art Institute of Chicago, gift of Dorothy Braude Edinburg to the Harry B. and Bessie K. Braude Memorial Collection, 1998.733. **(Plate 33)**

El Lissitzky, designer and co-editor with Il'ia Erenburg, *Veshch'/ Gegenstand/ Objet* [*Object*], no. 1-2, Berlin, 1922; letterpress, 31 × 23.5 cm. The Art Institute of Chicago, Ada Turnbull Hertle Fund, 2009.507. **(Plate 34)**

Cover for Il'ia Erenburg, *Shest' povestei o legkikh kontsakh* [*Six Tales with Easy Endings*], Moscow, 1922; lithograph, 20.8 × 14.4 cm. The Art Institute of Chicago, Robert Allerton Purchase Fund, 2009.311.

Pro 2 ■ [*Pro dva kvadrata,* or *Of Two Squares*], Berlin, 1922; letterpress, stapled along spine, 21.5 × 26.8 cm. The Art Institute of Chicago, on extended loan from Robert and June Leibowits, 122.2009. **(Plate 12A, B)**

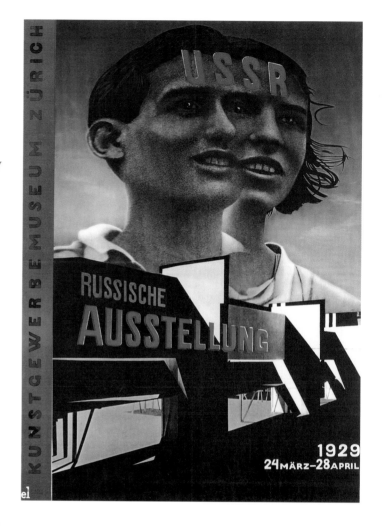

77

El Lissitzky (Russian, 1890–1941), *USSR: Russian Exhibition* [*USSR: Russische Austellung*], 1929; lithograph, 124.3 × 90 cm.

78

El Lissitzky (Russian, 1890–1941), cover and design for *USSR Builds Socialism* [*SSSR stroit sotsializm/USSR baut den Sozialismus/URSS construit le socialisme*], 1933: A. cover; B. endsheets; letterpress, 34 × 26.4 cm; 34 × 52.8 cm when open.

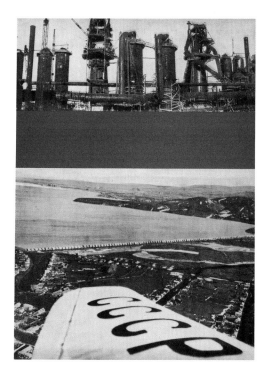

El Lissitzky and Theo van Doesburg (Dutch, 1883–1931), *Van twee kwadraten* [*Of Two Squares*], The Hague, 1922; letterpress, stapled along spine, 27.9 × 22.3 cm. The Art Institute of Chicago, on extended loan from Robert and June Leibowits, 120.2009. **(Plate 12c)**

Cover for Harold Loeb, editor, *BROOM: An International Magazine of the Arts* 4, no. 3, Berlin, 1923; letterpress, 33.4 × 22.9 cm. The Art Institute of Chicago, Mary Louise Stevenson Fund, 2009.458.

Wolkenbügel [*Cloud Hanger*], 1923–25; crayon and graphite on paper, 24.1 × 22.9 cm. Collection of Thea Berggren, Chicago. **(Plate 35)**

Cover and design for Vladimir Mayakovsky, *Dlia golosa* [*For the Voice*], Moscow, 1923; letterpress, 19 × 13.3 cm. The Art Institute of Chicago, on extended loan from Robert and June Leibowits, 124.2009. **(Plate 37)**

Packaging and designs for Pelikan Ink Company, 1923–24; letterpress, box: 8.7 × 21.3 × 4 cm; wrapper: 21 × 29.7 cm; ink rendering: 7.4 × 18 cm. The Art Institute of Chicago, on extended loan from Robert and June Leibowits, 119.2009. **(Plate 38)**

Advertisement for Pelikan Ink Company, 1924; gelatin silver print, 20.8 × 14.3 cm. Collection of Thea Berggren, Chicago. **(Plate 39)**

Hans Arp, 1924; gelatin silver print, 17.9 × 12.9 cm. Private collection. **(Plate 6)**

Selbstbildnis. Der Konstrukteur [*Self-Portrait: The Constructor*], 1924; gelatin silver print, 12.6 × 14.4 cm. Private collection. **(Plate 7)**

Selbstbildnis. Der Konstrukteur [*Self-Portrait: The Constructor*], 1924; gelatin silver print, 9.8 × 11.4 cm. Collection of Thea Berggren, Chicago. **(Plate 8)**

Rekord [*Record* or *Runner in the City*], 1926; gelatin silver print, 11.7 × 9.7 cm. Collection of Thea Berggren, Chicago. **(Plate 40)**

Cover and design for *Union der Sozialistischen Sowjet-Republiken: Katalog des Sowjet-Pavillons auf der Internationalen Presse-Ausstellung, Köln* ("Pressa") [*Union of Soviet Socialist Republics: Catalogue of the Soviet Pavilion at the International Press Exhibition, Cologne ("Pressa")*], Cologne, 1928; letterpress with gravure centerfold insert, 21 × 15.2 cm. The Art Institute of Chicago, Frederick W. Renshaw Acquisition Fund, 2009.482. **(Plate 41)**

Cover for Il'ia Sel'vinskii, *Zapiski poeta* [*Notes of a Poet*], Moscow, 1928; letterpress, 17.2 × 12.6 cm. The Art Institute of Chicago, Robert Allerton Purchase Fund, 2009.313.

Cover for Franz Roh and Jan Tschichold, *foto-auge / oeil et photo / photo-eye,* Stuttgart, 1929; letterpress, 29.5 × 20.7 cm. The Art Institute of Chicago, on extended loan from Robert and June Leibowits, 118.2009.

USSR: Russische Austellung [*USSR: Russian Exhibition*], 1929; lithograph, 124.3 × 90 cm. The Art Institute of Chicago, on extended loan from Robert and June Leibowits, 121.2009. **(Plate 77)**

SSSR na stroike [*The USSR in Construction*], Moscow, December 1931; gravure and lithograph, 40 × 29.8 cm. The Art Institute of Chicago, Frederick W. Renshaw Acquisition Fund, 2009.484.

Cover and design for *SSSR stroit sotsializm / USSR baut den Sozialismus / URSS construit le socialisme* [*USSR Builds Socialism*], Moscow, 1933; letterpress, 34 × 26.4 cm. The Art Institute of Chicago, Ada Turnbull Hertle Fund, 2009.505. **(Plate 78)**

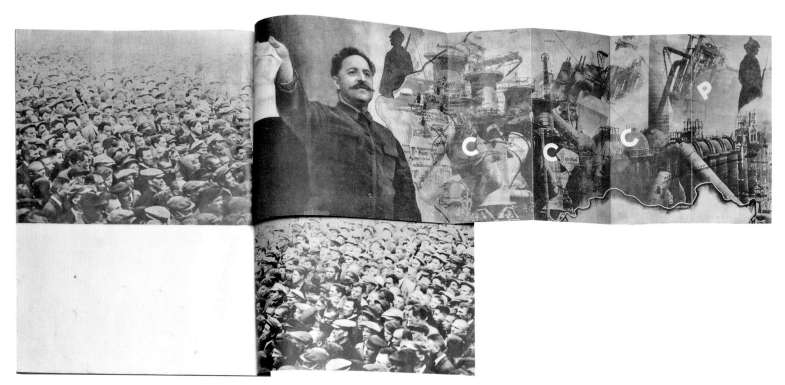

Cover and design for *Industriia sotsializma* [*The Industry of Socialism*], Moscow, 1935; letterpress, 35 × 25.7 cm (each) in a slipcase 36.7 × 27.5 × 5.5 cm. The Art Institute of Chicago, Frederick W. Renshaw Acquisition Fund, 2009.483. Exhibited: complete set in seven volumes. **(Plate 79)**

Ladislav Sutnar

(American, born Bohemia, 1897–1976)

———

Covers for Upton Sinclair:

Lithograph, 18.5 × 13.4 cm (unless otherwise noted).

Jatky [*The Jungle*], Prague, 1929. Private collection. **(Plate 80A)**

Otroctví: Román z občanské války [*Manassas: A Novel of the War*], Prague, 1930. Private collection. **(Plate 80B)**

Jatky [*The Jungle*], Prague, 1931. 19.2 × 13.1 cm. Private collection. **(Plate 80C)**

———

Výstava moderního obchodu, Brno [*Modern Commerce Exhibition, Brno*], 1929; lithograph, 94 × 125.6 cm. The Art Institute of Chicago, Frederick W. Renshaw Acquisition Fund, 2009.297. **(Plate 44)**

Cover and design for *Expoziția cehoslovacă de arhitetura, de industrie artistică și de industrie relativă la construcțiuni / Exposition tchécoslovaque d'architecture et d'industries d'art et de construction* [*Czechoslovak Exhibition of Architecture and Industries of Art and Construction*], Bucharest, 1930; letterpress, 20.8 × 15 cm. The Art Institute of Chicago, Mary Louise Stevenson Fund, 2009.466.

———

Cover and design for Josef Cerman et al., eds., *Panorama,* Prague, 1921–1951; gravure, 24.3 × 17.5 cm. The Art Institute of Chicago, restricted gift of Swann Auction Galleries and Mary Louise Stevenson Fund, 2009.455 (no. 4, 1930).

———

Covers and design for Josef Cerman et al., eds., *Panorama,* Prague, 1921–51; gravure, 24.3 × 17.5 cm. The Art Institute of Chicago, Robert Allerton Purchase Fund, 2009.345 (nos. 7–8 (1930); 2, 12 (1931); 11 (1932); 6 (1934).

———

Covers for George Bernard Shaw:

Letterpress, 19 × 14.2 cm

Drobnosti [*The Admirable Bashville*], Prague, 1930. Private collection. **(Plate 43A)**

Trakař jablek [*The Apple Cart*] and *Americký císař* [*American Caesar*], Prague, 1932. The Art Institute of Chicago, Robert Allerton Purchase Fund, 2009.383. **(Plate 43B)**

Ženění a vdávání [*Getting Married*], Prague, 1931. Private collection. **(Plate 43C)**

Obrácení kapitána Brassbounda [*Captain Brassbound's Conversion*], Prague, 1932. Private collection. **(Plate 43D)**

Muž budoucnosti [*The Man of Destiny*], Prague, 1933. The Art Institute of Chicago, Robert Allerton Purchase Fund, 2009.383.

———

Ladislav Sutnar and Oldřich Starý

(Czech, 1884–1971)

Nejmenší dům [*Minimum Housing*], Prague, 1931; letterpress, 29.7 × 21.2 cm. The Art Institute of Chicago, restricted gift of Anstiss and Ronald Krueck, 2009.388.

———

Ladislav Sutnar, editor, *Žijeme* [*We Live*], Prague, 1931–33; letterpress, 25.7 × 17.8 cm. The Art Institute of Chicago, restricted gift of Mary and Roy H. Cullen; Eric Ceputis and David Williams, 2009.495. All issues exhibited: 1 **(Plate 42A)**, 2–3, 4/5, 6–7, 8 **(Plate 42B)**, 9–10, 11 **(Plate 42C)**, 12 (vol. 1, 1931–1932); 1 **(Plate 42D)**, 2, 3/4, 5–10 (vol. 2, 1932–33).

———

Tea set, 1931; cast glass, 12 pieces total: teapot (no lid, 18.4 × 20.9 cm); 4 saucers (1.4 × 15.1 cm); creamer (10.6 × 17.4 cm); sugar bowl (10.4 × 10 cm); 4 teacups (5.2 × 13 cm); pitcher (16.2 × 8.2 cm). The Art Institute of Chicago, Ada Turnbull Hertle Fund, 2009.554. **(Plate 45)**

———

Josef Sudek (Czech, 1896–1976)

Advertising photograph for Ladislav Sutnar china (with black rim), 1932; gelatin silver print, 23.2 × 17.1 cm. The Art Institute of Chicago, Laura T. Magnuson Acquisition Fund, 2009.494. **(Plate 47)**

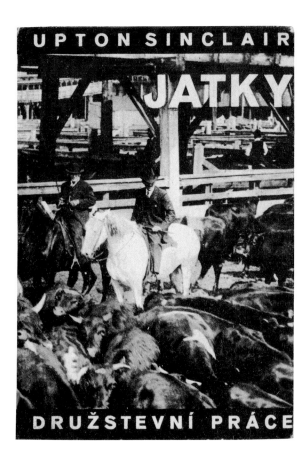

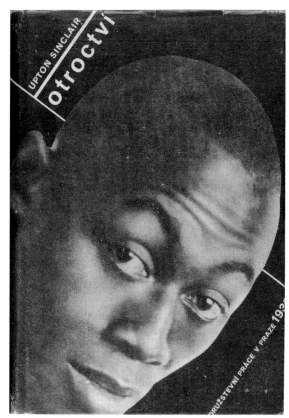

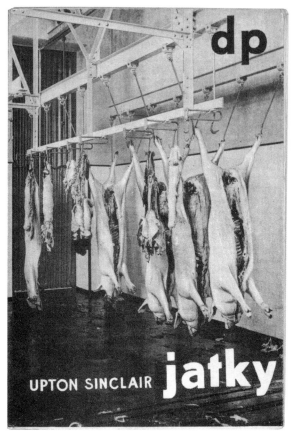

80

Ladislav Sutnar (Czech,
1897–1976), covers for
novels by Upton Sinclair:
A. *The Jungle* [*Jatky*], 1931;
B. *Manassas: A Novel of
the War* [*Otroctví: Román
z občanské války*], 1930;
C. *The Jungle* [*Jatky*], 1929;
lithographs, 18.5 × 13.4 cm.
except *The Jungle* of 1931,
which is 19.2 × 13.1 cm.

Porcelain set (white with red trim), 1929–32; 89 pieces total: 12 plates (2.1 × 18.9 cm); 12 plates (2.6 × 23 cm); 6 bowls (4.7 × 23.3 cm); bowl (3.9 × 24.4 cm); 18 demicups (3 × 8 cm); 8 demisaucers (1.6 × 10.2 cm); 6 saucers (2.1 × 15 cm); 12 coffee cups (4.6 × 11.9 cm); soup tureen (21.8 × 28.9 cm); creamer (10.9 × 13.8 cm); 3 sugar bowls (lid, 10.2 × 9 cm); 2 teapots (lid, 13.6 × 18.9 cm); teapot (no lid, 15.9 × 22.6 cm); divided serving bowl (5.3 × 23.8 cm); serving bowl (5.3 × 23.9 cm); 2 oval platters (4.9 × 39.9 cm); gravy boat (5.7 × 23.4 cm); gravy boat saucer (3.4 × 23.4 cm). The Art Institute of Chicago, Mary Louise Stevenson Fund, 2009.560. **(Plate 48)**

Josef Sudek (Czech, 1896–1976)

Advertising photograph for Ladislav Sutnar china (coffee and dinner set), c. 1932; gelatin silver print, 23.3 × 17.6 cm. The Art Institute of Chicago, Edward Johnson Fund, 2009.498. **(Plate 3)**

Josef Sudek (Czech, 1896–1976)

Advertising photograph for Ladislav Sutnar china (hostess set), c. 1930; gelatin silver print, 16.3 × 23 cm. The Art Institute of Chicago, Ethel T. Scarborough Fund, 2009.499.

Josef Sudek (Czech, 1896–1976)

Advertising photograph for Ladislav Sutnar china (coffee set), c. 1930; gelatin silver print, 16.2 × 21.9 cm. The Art Institute of Chicago, restricted gift of Beth and George Drost, 2009.500.

Flatware set, 1934; stainless steel, 10 pieces total: 2 spoons (13.8 × 2.9 × 1.8 cm); 2 soup spoons (20.4 × 4.6 × 1.8 cm); 2 sorbet spoons (8.8 × 1.8 × 0.8 cm); 2 knives (22.5 × 2.1 × 0.7 cm); 2 forks (20.6 × 2.8 × 1.8 cm). The Art Institute of Chicago, Edward Johnson Fund, 2009.562.

Advertising brochure for *Sutnarův jídelní příbor z nerezavějící oceli* [*Sutnar's stainless steel flatware*], 1934; letterpress, 23.5 × 16.7 cm. The Art Institute of Chicago, Mary Louise Stevenson Fund, 2009.447. **(Plate 46)**

Cover for *Státní grafická skola v Praze, 1932–1933* [*State Graphic School in Prague*], Prague, 1933; letterpress, 21 × 14.8 cm. The Art Institute of Chicago, restricted gift of Thea Berggren, 2009.441. **(Plate 81)**

Covers for Josef Cerman et al., eds., *Magazin DP* [*Magazine of Cooperative Work*], Prague, 1933–37; letterpress, 25.3 × 17.7 cm. The Art Institute of Chicago, Robert Allerton Purchase Fund, 2009.344. Exhibited: 1, 4–5 (1933–34); 1, 9 (1934–35); 1, 9 (1935–36); 1, 9 (1936–37) of 40 issues in all.

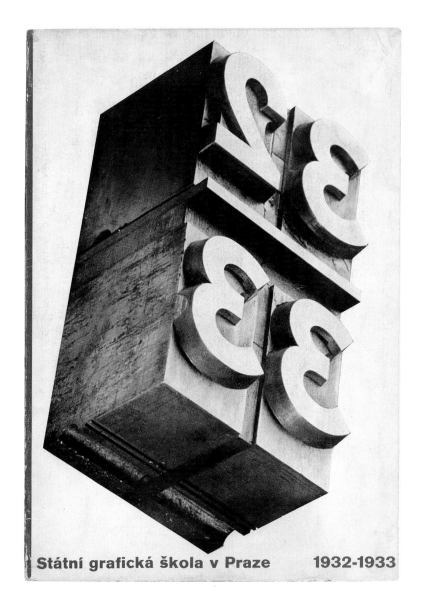

Státní grafická škola v Praze 1932-1933

81

Ladislav Sutnar (Czech, 1897–1976), cover for *State Graphic School in Prague* [*Státní grafická skola v Praze, 1932–1933*], 1933; letterpress, 21 × 14.8 cm.

Karel Teige

(Czech, 1900–1951)

Karel Teige, Bedřich Feuerstein (Czech, 1892–1936), **Jaromír Krejcar** (Czech, born Austria, 1895–1949), **and Josef Šíma** (French, born Bohemia, 1891–1971)

Cover for Jaromír Krejcar, editor, *Život: Sborník nové krásy* [*Life: An Anthology of the New Beauty*], Prague, 1922; letterpress, 25.4 × 18.7 cm. The Art Institute of Chicago, on extended loan from Robert and June Leibowits, 136.2009. **(Plate 53)**

Cover and design for Karel Teige, Jaromír Krejcar, Jaroslav Seifert, and Artuš Černík (for 1925), editors, *Disk* [*The Disk*], Brno, December 1923 and April 1925; letterpress, 29.2 × 21.5 cm. The Art Institute of Chicago, Gladys N. Anderson Fund, 2009.490. **(Plate 52)**

Covers for Jaroslav Seifert:

Město v slzách [*City in Tears*], Prague, 1923; letterpress, 19.4 × 13.9 cm. The Art Institute of Chicago, Mary Louise Stevenson Fund, 2009.419.

Na vlnách TSF [*On the Airwaves*], Prague, 1925; letterpress, 22.2 × 17.1 cm. The Art Institute of Chicago, Mary Louise Stevenson Fund, 2009.417. **(Plate 56)**

Město v slzách [*City in Tears*], Prague, 1929; letterpress, 19.8 × 13.9 cm. The Art Institute of Chicago, Mary Louise Stevenson Fund, 2009.418.

Karel Teige and Otakar Mrkvička (Czech, 1898–1957)

Cover for Jaroslav Seifert, *Samá láska* [*Only Love*], Prague 1923; letterpress, 19.5 × 14 cm. The Art Institute of Chicago, Robert Allerton Purchase Fund, 2009.354. **(Plate 54)**

Artuš Černík, editor, *Pásmo* [*Zone*, or *Reel*], Brno, 1924–26; lithographs, 47.7 × 31.7 cm (1924–25); 31.5 × 23.9 cm (1925–26). The Art Institute of Chicago, on extended loan from Robert and June Leibowits, 148.2009. Exhibited: 1 **(Plate 55A)**, 2–3, 5/6 **(Plate 55B)**, 9 **(Plate 55C)** (1924–25); 3, 5, 6/7, 8, 9/10 (1925–26) of 18 issues in all, some of which are combined.

Karel Teige and Otakar Mrkvička (Czech, 1898–1957)

Cover for Il'ia Erenburg, *Trust D.E.* [*Trest D.E. (D.E. Trust)*], Prague, 1924; letterpress, 20 × 14.4 cm. The Art Institute of Chicago, Helen A. Regenstein Endowment, 2009.432.

Cover for Stanislav K. Neumann, editor, *Reflektor* [*Headlight*] 1, no. 9, Prague, May 15, 1925; lithograph, 37 × 27.6 cm. Private collection. **(Plate 1)**

Film, Prague, 1925; letterpress, 19.3 × 14.6 cm. The Art Institute of Chicago, Helen A. Regenstein Endowment, 2009.422. **(Plate 57)**

Cover for Guillaume Apollinaire, *Sedící žena* [*La Femme assise (The Seated Woman)*], Prague, 1925; letterpress, 20 × 14.2 cm. The Art Institute of Chicago, Robert Allerton Purchase Fund, 2009.352.

Attributed to Karel Teige and Otakar Mrkvička (Czech, 1898–1957)

Cover for Jimmie Dolar [Marietta Sergeevna Shaginian], *Američané v Leningradě: Mess Mend* [*Mess–Mend, ili, Ianki v Petrograde (Mess–mend, Yankees in Petrograd)*], Prague, 1925; letterpress, 18.7 × 13.7 cm. The Art Institute of Chicago, Helen A. Regenstein Endowment, 2009.431. **(Plate 82)**

Cover and design for Vítězslav Nezval with Milča Mayerová, *Abeceda* [*Alphabet*], Prague, 1926; letterpress, 29.6 × 23.1 cm. Private collection. **(Plate 61)**

Cover for F. Slang [Fritz Oskar Hampel], *Křižník Potěmkin* [*Panzerkreuzer Potemkin (The Battleship Potemkin)*], Prague, 1926; letterpress, 18 × 12.9 cm. The Art Institute of Chicago, Helen A. Regenstein Endowment, 2009.421.

Cover for Charles Baudelaire, *Fanfarlo* [*La Fanfarlo*], Prague, 1927; letterpress, 18.7 × 12.8 cm. The Art Institute of Chicago, Mary Louise Stevenson Fund, 2009.406. **(Plate 58)**

Cover for Il'ia Erenburg, *Historie jednoho léta* [*Leto 1925 goda (History of One Summer)*], Prague, 1927; letterpress, 20 × 14.2 cm. Private collection. **(Plate 17)**

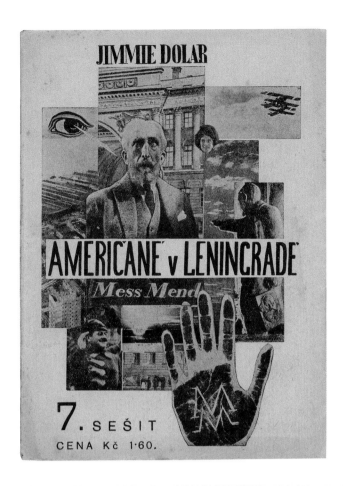

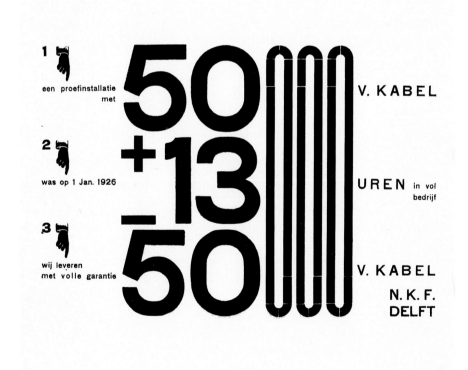

Attributed to Karel Teige

Postcards for the tenth anniversary of the October Revolution, Brno, 1927; letterpress, 9 × 14 cm and 10 × 14 cm. Ne boltai! Collection. Exhibited: two of five postcards total. **(Plate 62)**

Karel Teige, editor and designer

ReD (*Revue Devětsilu*), Prague, 1927–31; letterpress, 23.5 × 18.2 cm. Private collection. Exhibited: all issues: 1–10 (1927–28); 1–10 (1928–29); 1–5, 6/7, 8–10 (1929–31). **(Plate 49)**

Stavba a báseň [*Construction and Poetry*], Prague, 1927; letterpress, 24.2 × 16 cm. The Art Institute of Chicago, Helen A. Regenstein Endowment, 2009.426. **(Plate 50)**

Covers and designs for Konstantin Biebl:

Zlom [*Rupture*], Prague, 1928; letterpress, 19.7 × 13.9 cm. The Art Institute of Chicago, Charles U. Harris Endowed Acquisition Fund, 2009.274. **(Plate 60)**

S lodí, jež dováží čaj a kávu [*With the Ship That Brings Tea and Coffee*], Prague, 1928; letterpress, 29.9 × 14 cm. The Art Institute of Chicago, Irving and June Seaman Endowment Fund, 2009.272.

S lodí, jež dováží čaj a kávu [*With the Ship That Brings Tea and Coffee*], Prague, 1928; letterpress (cover: letterpress and paper collage), 20 × 14.2 cm. The Art Institute of Chicago, Mary Louise Stevenson Fund, 2009.298. **(Plate 59)**

Svět, který se směje. O humoru, clownech a dadaistech [*The Laughing World: On Humor, Clowns, and Dadaists*], Prague, 1928; letterpress, 19.8 × 14 cm. The Art Institute of Chicago, Helen A. Regenstein Endowment, 2009.425.

MSA 1: Mezinárodní soudobá architektura [*MSA 1: International Contemporary Architecture*], Prague, 1929; letterpress, 23.7 × 18.3 cm. The Art Institute of Chicago, Frederick W. Renshaw Acquisition Fund, 2009.515.

Nejmenší byt [*The Minimum Dwelling*], Prague, 1932; letterpress, 25 × 18.1 cm. The Art Institute of Chicago, Helen A. Regenstein Endowment, 2009.424. **(Plate 51)**

Piet Zwart

(Dutch, 1885–1977)

Verloop Woning Bureau [*Rental Housing Office*], 1923; letterpress, 44.6 × 44.7 cm. The Art Institute of Chicago, on extended loan from Robert and June Leibowits, 142.2009. **(Plate 63)**

Piet Zwart and Hendrik Petrus Berlage (Dutch, 1856–1934)

Breakfast service for Leerdam Glassworks, 1923–24; pressed glass, 26 pieces total: teapot (12.8 × 18.8 cm); rusk container (14.3 × 11.6 cm); rusk container with handles (10.4 × 13 cm); saucer (2.1 × 14.7 cm); 5 saucers (2.1 × 16 cm); 3 plates (2.5 × 17.9 cm); 4 teacups (6.2 × 9.9 cm); creamer (no lid, 6.1 × 12.2 cm); spoon beaker (9.8 × 7.2 cm); 3 egg cups (5.8 × 4.4 cm); spoon beaker (6.7 × 5.2 cm); 3 salt containers (3 × 4.4 cm) fitting into a hexagonal plate (2.4 × 19.4 cm). The Art Institute of Chicago, Frederick W. Renshaw Acquisition Fund, 2009.555 and 2009.556. **(Plate 64)**

Advertisement for *Wij Nu. Experimenteel Tooneel* [*Us Now: Experimental Theater*], 1926; letterpress, 29.2 × 42.3 cm. The Art Institute of Chicago, Frederick W. Renshaw Acquisition Fund, 2009.548. **(Plate 68)**

Stationery and envelope for *Wij Nu. Experimenteel Tooneel* [*Us Now: Experimental Theater*], c. 1925; letterpress, 29.3 × 21.1 cm (stationery), 11.4 × 16.1 cm (envelope). The Art Institute of Chicago, Frederick W. Renshaw Acquisition Fund, 2009.549. **(Plate 4)**

Advertisement for *NKF* [*Nederlandsche Kabelfabriek,* or *Netherlands Cable Company*], 1926; letterpress, 20.7 × 21.5 cm. The Art Institute of Chicago, Frederick W. Renshaw Acquisition Fund, 2009.546. **(Plate 83)**

C. J. de Gilde

for Piet Zwart, cross-sections of cables, for use in *NKF* [*Nederlandsche Kabelfabriek,* or *Netherlands Cable Company*], c. 1927; gelatin silver print, 12.4 × 17.1 cm. Bank of America Collection. **(Plate 65)**

J. Hertel, Cas Oorthuys (1908–1975), **Henrik Scholte** (1903–1988), **and Paul Schuitema** (1897–1973), **et al.**

Covers for *Filmliga,* Amsterdam and Rotterdam, 1927–36; letterpress, 31.2 × 24.3 cm (1927–28); 31.8 × 24.3 cm (1928–30); 29.2 × 20.8 cm (1931–32); 29.2 × 19.8 cm (1932–36). The Art Institute of Chicago, Frederick W. Renshaw Acquisition Fund, 2009.510. Exhibited: 1, 3, 11 (1927–28); 3 (1928–29); 3/4, 6–7 (1929–30); 2–3, 8, 11 (1931–32); 6–7, 11 (1932–33); 3, 5 **(Plate 84A)**, 7 (1934–35); 5, 7/8 **(Plate 84B)**, 9–10 (1935–36) of 74 issues in all, some of which are combined.

ITF [*Internationale Tentoonstelling op Filmgebied,* or *International Film Festival*], 1928; lithograph, 108.9 × 78.4 cm. The Art Institute of Chicago, Frederick W. Renshaw Acquisition Fund, 2009.282. **(Plate 67)**

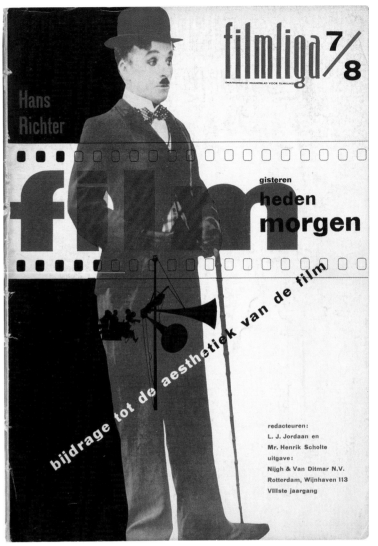

84

Cas Oorthuys (Dutch,
1908–1975), covers for
Filmliga; A. no. 5, 1934–35;
B. no. 7/8, 1935–36;
letterpress, 29.2 × 19.8 cm.

Cover and design for *NKF*
[*Nederlandsche Kabelfabriek,* or
Netherlands Cable Factory],
Delft, 1928; letterpress on canvas,
30.2 × 21.4 cm. The Art Institute
of Chicago, Ada Turnbull Hertle
Fund, 2009.509. **(Plate 66)**

Photographs of cable bitu-
minization, 1931; gelatin silver
print, 12.3 × 17.1 cm. Bank
of America Collection.
(Plate 85)

Photograph of cable reel in
the Netherlands Cable Factory,
1931; gelatin silver print,
17.1 × 12 cm. Bank of America
Collection. **(Plate 70)**

Photograph of a cable machine,
1932; gelatin silver print,
8.2 × 11.1 cm. Bank of America
Collection. **(Plate 71)**

Photograph of a dredger,
1938; gelatin silver print,
12 × 8.9 cm. Bank of America
Collection. **(Plate 72)**

Covers for C. J. Graadt van
Roggen, editor, *Film: Serie
monografieën over filmkunst* [*Film:
A Series of Monographs on the
Art of Film*], Rotterdam; letterpress,
22 × 17.7 cm. The Art Institute of
Chicago, Frederick W. Renshaw
Acquisition Fund, 2009.521.
Exhibited: complete set of 10
volumes: vol. 1: C. J. Graadt van
Roggen, *Het Linnen Venster* [*The
Linen Window*], 1931 **(Plate 69A)**;
vol. 2: Leendert Jurriaan Jordaan,
Dertig jaar film [*Thirty Years of
Film*], 1932; vol. 3: Henrik Scholte,
Nederlandsche filmkunst [*Dutch
Film Art*], 1933; vol. 4: Th. B. F.
Hoyer, *Russische filmkunst* [*Russian
Film Art*], 1932; vol. 5: Simon
Koster, *Duitsche filmkust* [*German
Film Art*], 1931; vol. 6: E. de Roos,
Fransche filmkunst [*French Film
Art*], 1931; vol. 7: J. F. Otten,
Amerikaansche filmkunst [*American
Film Art*], 1931 **(Plate 69B)**; vol. 8:
Menno ter Braak, *De absolute film*
[*The Absolute Film*], 1931; vol. 9:
Constant van Wessem, *De komische
film* [*Comic Film*], 1931; vol. 10:
Lou Lichtveld, *De geluidsfilm*
[*Sound Film*], 1933.

Calendar for Netherlands Cable
Factory, Delft, 1934; letterpress
and steel stand, 17.4 × 12.3 cm, on
stand 20 × 13 × 3.6 cm. The Art
Institute of Chicago, Frederick W.
Renshaw Acquisition Fund,
2009.550. **(Plate 2)**

*Bij brand: Wenken ter voorkoming en
beperking van brandgevaar* [*In Case
of Fire: Hints for the Prevention and
Reduction of Fire*], n.d.; letterpress,
35.9 × 50.6 cm. The Art Institute
of Chicago, Frederick W. Renshaw
Acquisition Fund, 2009.530.

Eigen Reclame–Technische AFD
[*Our Own Technical Advertising
Department*], n.d.; letterpress,
17.8 × 25.6 cm. The Art Institute
of Chicago, Frederick W. Renshaw
Acquisition Fund, 2009.538.

Advertisement for *Machinezetsel
Monotype* [*Monotype typesetting
machine*], n.d.; letterpress,
17.5 × 24.8 cm. The Art Institute
of Chicago, Frederick W. Renshaw
Acquisition Fund, 2009.534.

Avant-Garde Art

Alofsin, Anthony. *When Buildings Speak: Architecture as Language in the Habsburg Empire and Its Aftermath, 1867–1933*. Chicago: University of Chicago Press, 2006.

Anděl, Jaroslav. *El arte de la vanguardia en Checoslovaquia, 1918–1938 — The Art of the Avant-Garde in Czechoslovakia, 1918–1938*. Valencia: Generalitat Valenciana, 1993.

———. *Avant-Garde Page Design, 1900–1950*. New York: Delano Greenidge Editions, 2002.

———. *The New Vision for the New Architecture: Czechoslovakia, 1918–1938*. Zurich: Scalo Verlag, 2006.

Andrews, Richard, and Milena Kalinovska, eds. *Art into Life: Russian Constructivism, 1914–1932*. Seattle: Henry Art Gallery, 1990.

Bergdoll, Barry, and Leah Dickerman. *Bauhaus 1919–1933: Workshops for Modernity*. New York: Museum of Modern Art, 2009.

Bonnell, Victoria. *Iconography of Power: Soviet Political Posters under Lenin and Stalin*. Berkeley: University of California Press, 1997.

Bool, Flip, and Jeroen de Vries. *De Arbeidersfotografen: Camera en Crisis inn de Jaren '30* [Worker Photographers: Camera and Crisis in the 1930s]. Amsterdam: Van Gennep, 1982.

Clegg, Elizabeth. *Art, Design, and Architecture in Central Europe, 1890–1920*. New Haven, Conn.: Yale University Press, 2006.

Dickerman, Leah, ed. *Dada: Zurich, Berlin, Hannover, Cologne, New York, Paris*. Washington, D.C.: National Gallery of Art, 2005.

Dimendberg, Edward, Martin Jay, and Anton Kaes. *The Weimar Republic Sourcebook*. Berkeley: University of California Press, 1994.

Gay, Peter. *Weimar Culture: The Outsider as Insider*. New York: Harper and Row, 1968.

Gray, Camilla. *The Russian Experiment in Art, 1863–1922*. New York: Thames and Hudson, 1986.

Guggenheim Museum. *The Great Utopia: The Russian and Soviet Avant-Garde, 1915–1932*. New York: Solomon R. Guggenheim Museum, 1992.

Herscher, Andrew. "The Media(tion) of Building: Manifesto Architecture in the Czech Avant-Garde." *Oxford Art Journal* 27, no. 2 (2004), pp. 193–217.

Kiaer, Christina. *Imagine No Possessions: The Socialist Objects of Russian Constructivism*. Cambridge, Mass.: MIT Press, 2005.

King, David. *Red Star over Russia*. London: Tate Publishing, 2009.

Lahoda, Vojtěch, ed. *Local Strategies, International Ambitions: Modern Art and Central Europe, 1918–1968*. Prague: Artefactum, 2006.

Lewis, Beth Irwin, Paul Paret, and Peter Paret. *Persuasive Images: Posters of War and Revolution from the Hoover Institution Archives*. Princeton, N.J.: Princeton University Press, 1992.

Lissitzky, El, et al., eds. *ABC, 1924–1928*. Reprint, Baden: Lars Müller Publishers, 1993.

Lodder, Christina. *Russian Constructivism*. New Haven, Conn.: Yale University Press, 1983.

Mellor, David, ed. *Germany: The New Photography, 1927–33*. London: Arts Council of Great Britain, 1978.

Mertins, Detlef, and Michael Jennings, eds. G: *An Avant-Garde Journal of Art, Architecture, Design, and Film, 1923–26*. Los Angeles: Getty Research Institute, 2010.

Ollman, Leah. *The Camera as a Weapon: Worker Photography between the Wars*. San Diego, Calif.: Museum of Photographic Arts, 1991.

Petrova, Evgeniia, et al., ed. *In Malevich's Circle: Confederates, Students, Followers in Russia, 1920s–1950s*. Translated by Kenneth MacInnes. St. Petersburg: Palace Editions, 2003.

Rabinbach, Anson. *In the Shadow of Catastrophe: German Intellectuals between Apocalypse and Enlightenment*. Berkeley: University of California Press, 2001.

Risselada, Max. *Art and Architecture: USSR, 1917–1932*. New York: G. Wittenborn, 1971.

Rowell, Margit, and Deborah Wye, eds. *The Russian Avant-Garde Book, 1910–1934*. New York: Museum of Modern Art, 2002.

Shatskikh, Aleksandra Semenovna. *Vitebsk: The Life of Art*. Translated by Katherine Foshko Tsan. New Haven, Conn.: Yale University Press, 2007.

Swett, Pamela E., S. Jonathan Wiesen, and Jonathan R. Zatlin, eds. *Selling Modernity: Advertising in Twentieth-Century Germany*. Durham, N.C.: Duke University Press, 2007.

Teitelbaum, Matthew, ed. *Montage and Modern Life, 1919–1942*. Cambridge, Mass.: MIT Press and Institute of Contemporary Art, Boston, 1992.

Toman, Jindřich. *Foto/Montáž tiskem — Photo/Montage in Print*. Prague: Kant, 2009.

Troy, Nancy. *The De Stijl Environment*. Cambridge, Mass.: MIT Press, 1983.

Tupitsyn, Margarita. *The Soviet Photograph, 1924–1937*. New Haven, Conn.: Yale University Press, 1996.

Weitz, Eric. *Creating German Communism, 1890–1990*. Princeton, N.J.: Princeton University Press, 1997.

Witkovsky, Matthew S. *Foto: Modernity in Central Europe, 1918–1945*. Washington, D.C.: National Gallery of Art, 2007.

Everyday Life

Arvatov, Boris. "Everyday Life and the Culture of the Thing (Toward the Formulation of the Question)." Translated by Christina Kiaer. *October* 81 (Summer 1997), pp. 119–28. Originally published in 1925.

Boym, Svetlana. *Common Places: Mythologies of Everyday Life in Russia*. Cambridge, Mass.: Harvard University Press, 1994.

Crow, Thomas. *Modern Art in the Common Culture*. New Haven, Conn.: Yale University Press, 1996.

Debord, Guy. *The Society of the Spectacle*. Translated by Donald Nicholson-Smith. New York: Zone Books, 1994. Originally published in 1967.

———. *Comments on the Society of the Spectacle*. Translated by Malcolm Imrie. London: Verso, 2007. Originally published in 1988.

Highmore, Ben, ed. *The Everyday Life Reader*. London: Routledge, 2002.

———. *Everyday Life and Cultural Theory: An Introduction*. London: Routledge, 2002.

———. *Ordinary Lives: Studies in the Everyday*. New York: Routledge, 2011.

Hutchings, Stephen. *Russian Modernism: The Transfiguration of the Everyday*. Cambridge: Cambridge University Press, 1997.

Huyssen, Andreas. *After the Great Divide: Modernism, Mass Culture, Postmodernism*. Bloomington: Indiana University Press, 1986.

Kiaer, Christina, and Eric Naiman, eds. *Everyday Life in Early Soviet Russia: Taking the Revolution Inside*. Boomington: Indiana University Press, 2006.

Schnapp, Jeffrey T., and Matthew Tiews, eds. *Crowds*. Stanford, Calif.: Stanford University Press, 2006.

John Heartfield

Bathrick, David, Andreas Huyssen, and Anson Rabinbach, eds. *Dada and Photomontage across Borders*. Special issue of *New German Critique* 107, vol. 36, no. 2 (Summer 2009).

Doherty, Brigid. "'See: We Are All Neurasthenics!' Or, the Trauma of Dada Montage." *Critical Inquiry* 24, no. 1 (Autumn 1997), pp. 82–132.

Evans, David. *John Heartfield, AIZ: Arbeiter-Illustrierte-Zeitung, Volks Illustrierte, 1930–1938*. Edited by Anna Lundgren. New York: Kent Fine Art, 1992.

Herzfelde, Wieland. *John Heartfield: Leben und Werk* [John Heartfield: Life and Work]. 3rd ed. Dresden: Verlag der Kunst, 1976.

Kriebel, Sabine. "Photomontage in the Year 1932: John Heartfield and the National Socialists." *Oxford Art Journal* 31, no. 1 (2008), pp. 97–127.

März, Roland, and Gertrud Heartfield, eds. *John Heartfield, Der Schnitt entlang der Zeit: Selbstzeugnisse, Erinnerungen, Interpretationen* [John Heartfield: The Cut Along Time. Personal Testimonies, Memories, Interpretations]. Dresden: Verlag der Kunst, 1981.

McMeekin, Sean. *Red Millionaire: A Political Biography of Willi Münzenberg, Moscow's Secret Propaganda Tsar in the West*. New Haven, Conn.: Yale University Press, 2003.

Mülhaupt, Freya, ed. *John Heartfield: Zeitausschnitte; Fotomontagen 1918–1938* [John Heartfield: Cut-outs from Time; Photomontages 1918–1938]. Ostfildern: Hatje Cantz, 2009.

Pachnicke, Peter, and Klaus Honnef, eds. *John Heartfield*. New York: Harry N. Abrams, 1992.

Zervigón, Andrés Mario. *Agitated Images: John Heartfield and German Photomontage, 1920–1938*. Los Angeles: Getty Research Institute, 2006.

Gustav Klutsis

Gassner, Hubertus, and Roland Nachtigaller, eds. *Gustav Klucis: Retrospektive*. Stuttgart: Gerd Hatje for Museum Fredericanum, Kassel, 1991.

Oginskaia, Larisa. *Gustav Klutsis*. Moscow: Sovetskii khudozhnik, 1981.

Tupitsyn, Margarita. *Gustav Klutsis and Valentina Kulagina: Photog-raphy and Montage after Constructivism*. New York: International Center of Photography, and Gottingen: Steidl, 2004.

El Lissitzky

Bürkle, J. Christoph. *El Lissitzky: Der Traum vom Wolkenbügel* [El Lissitzky: The Dream of the Cloud Hanger]. Zurich: Ausstellungen ETH Hönggerberg, 1991.

Galvez, Paul. "Self-Portrait of the Artist as a Monkey-Hand." *October* 93 (Summer 2000), pp. 109–37.

Lissitzky, El. *Russia: An Architecture for World Revolution*. Translated by Eric Dluhosch. Cambridge, Mass.: MIT Press, 1984. Originally published in 1930.

Lissitzky-Küppers, Sophie, ed. *El Lissitzky: Life, Letters, Texts*. Translated by Helene Aldwinckle and Mary Whittall. Greenwich, Conn.: New York Graphic Society, 1968.

Perloff, Nancy, and Brian Reed, eds. *Situating Lissitzky: Vitebsk, Berlin, Moscow*. Los Angeles: Getty Research Institute, 2003.

Tupitsyn, Margarita. *El Lissitzky: Beyond the Abstract Cabinet*. New Haven, Conn.: Yale University Press, 1999.

Ladislav Sutnar

Sutnar, Ladislav, and Jaromír Funke. *Photography Sees the Surface*. Translated by Jindřich Toman and Matthew S. Witkovsky. Ann Arbor: Michigan Slavic Publications, 2004. Originally published in 1935.

Janáková, Iva. *Ladislav Sutnar–Prague–New York–Design in Action*. Prague: UPM [Museum of Decorative Arts in Prague] and Argo, 2003.

Vlčková, Lucie, ed. *Družstevní práce–Sutnar, Sudek*. Prague: UPM [Museum of Decorative Arts in Prague] and Arbor Vitae, 2006. Texts in Czech and English.

Karel Teige

Codeluppi, Manuela Castagnara, ed. *Karel Teige: Luoghi e pensieri del moderno* [Karel Teige: Places and Thoughts of Modernity]. Milan: Electa, 1996.

Dluhosch, Eric, and Rostislav Švácha, eds. *Karel Teige, 1900–1951: L'Enfant Terrible of the Czech Modernist Avant-Garde*. Cambridge, Mass.: MIT Press, 1999.

Nezval, Vítězslav, with Milča Mayerová. *Alphabet*. Translated by Jindřich Toman and Matthew S. Witkovsky. Ann Arbor: Michigan Slavic Publications, 2001. Originally published in 1926.

Šmejkal, František. *Devětsil: Czech Avant-Garde Art, Architecture and Design of the 1920s and 30s*. Oxford: Modern Art Museum, 1990.

Srp, Karel, ed. *Karel Teige, 1900–1951*. Prague: Galerie hlavního města Prahy, 1994.

Srp, Karel, Lenka Bydžovská, and Polana Bregantová. *Karel Teige a typografie: Asymetrická harmonie* [Karel Teige and Typography: Asymmetric Harmony]. Prague: Arbor Vitae, 2009.

Teige, Karel. *Modern Art in Czechoslovakia and Other Writings*. Edited by Jean-Louis Cohen. Los Angeles: Getty Publications, 2000.

Witkovsky, Matthew S. "Staging Language: Milča Mayerová and the Czech Book Alphabet." *Art Bulletin* 86, no. 1 (March 2004), pp. 114–37.

Zusi, Peter. "The Style of the Present: Karel Teige on Constructivism and Poetism." *Representations* 88 (Autumn 2004), pp. 102–24.

Piet Zwart

Brentjens, Yvonne. *Piet Zwart, Vormingenieur: 1885–1977* [Piet Zwart, Engineer of Form: 1885–1977]. The Hague: Gemeentemuseum, and Zwolle: Waanders, 2008.

Broos, Kees. *Piet Zwart*. The Hague: Gemeentemuseum, 1973.

Hoek, Els. "Piet Zwart and Kurt Schwitters." In *Kurt Schwitters in Nederland: Merz, De Stijl, and Holland Dada*, edited by Meta Knol, pp. 99–105. Zwolle: Waanders, 1997.

In this catalogue, all works by John Heartfield are © 2011 Artist Rights Society (ARS), New York/VG Bild-Kunst, Bonn. All works by Gustav Klutsis are © 2011 Estate of Gustav Klutsis/Artists Rights Society (ARS), New York. All works by El Lissitzky are © 2011 Artists Rights Society (ARS), New York/VG Bild-Kunst, Bonn. All works by Piet Zwart are © 2011 Artists Rights Society (ARS), New York/c/o Pictoright Amsterdam.

In addition, the following credits apply to all images in this catalogue for which separate acknowledgment is due.

Fig. 1.1: Digital image © The Museum of Modern Art, New York/Licensed by SCALA/Art Resource, NY. © 2011 Artists Rights Society (ARS), New York/VG Bild-Kunst, Bonn. Fig. 1.3: The Getty Research Institute, Los Angeles (920024). Fig. 1.4: Bildarchiv Preussischer Kulturbesitz/Art Resource, NY. © 2011 Artists Rights Society (ARS), New York/VG Bild-Kunst, Bonn. Fig. 2.1: The Latvian Museum of War, Riga. Figs. 2.2, 2.4–6, and 2.9: Greek State Museum of Contemporary Art—Costakis Collection, Thessaloniki. Figs. 2.3 and 2.10: The Latvian National Museum of Art, Riga. Fig. 2.7: Productive Arts, Bratenahl, Ohio USA. Fig. 2.8: Digital image © The Museum of Modern Art, New York/Licensed by SCALA/Art Resource, NY. Fig. 3.1: Van Abbemuseum, Eindhoven. Fig. 3.3: Russian State Archive for Literature and Art, Moscow. Fig. 3.4: State Tret'iakov Gallery, Moscow. Figs. 3.5, 6.1–6 and 6.9–10: Gemeentemuseum, The Hague. Fig. 4.6: Museum of Decorative Arts in Prague (UPM). Fig. 6.8, pls. 6–8, 35, 39–40, 65, 70–72, 85: Jamie Stukenberg, Professional Graphics Inc.

Пролетарии всех стран, соединяйтесь!

Пролетарі всіх країн, єднайтеся!

Пралетары ўсіх краёў, злучайцеся!

პროლეტარებო ყველა ქვეყნისა, შეერთდით!

Bøten dønja praletarlarь brləşegez!

Çer çvzynyn pьroletarlarь birikkile!

Bøtə dønja pьralitardarь beregegeđ!

Bytyn dynja proletarlarь, birləşiniz!

Быдэс дуннеись пролетар'ёс, агазе кариське!

Cir ystynyң prolətarlarь pьrьklənər!

Пĕтĕм тĕнчери пролеттарисем, пĕрлешĕр!

Çer ysynin prolətarlarь birikkleger!

‏פראָלעטאַריִער פון אלע לענדער, פאַראײניקט זיך!‏

Barь dojdu вьralьtaarьjata, qolbolun

Workers of the world unite!

Prolétaires de tous les pays, unissez-vous!

Proletarier aller Länder, vereinigt euch!

Proletärer i alla länder, förenen eder!

Proletarer i alle land foren dere!

Kaikkien maiden proletaarit, yhtykää!

Visu zemju proletareeši saveenojatees!

Világ proletárjai egyesüljetek!

ՊՐՈԼԵՏԱՐՆԵՐ ԲՈԼՈՐ ՅԵՐԿՐՆԵՐԻ, ՄԻԱՑԵՔ:

Prolətarhoj həmməj hylom jək boşit!

Пролетариjи д'gylle әтрәвәти, хаjидуп!

Весе масторонь пролетарийтне пурнаводо вейс!

萬 國 無 產 社 團 結 セ ヨ

全 世 界 無 產 階 級 聯 合 起 來